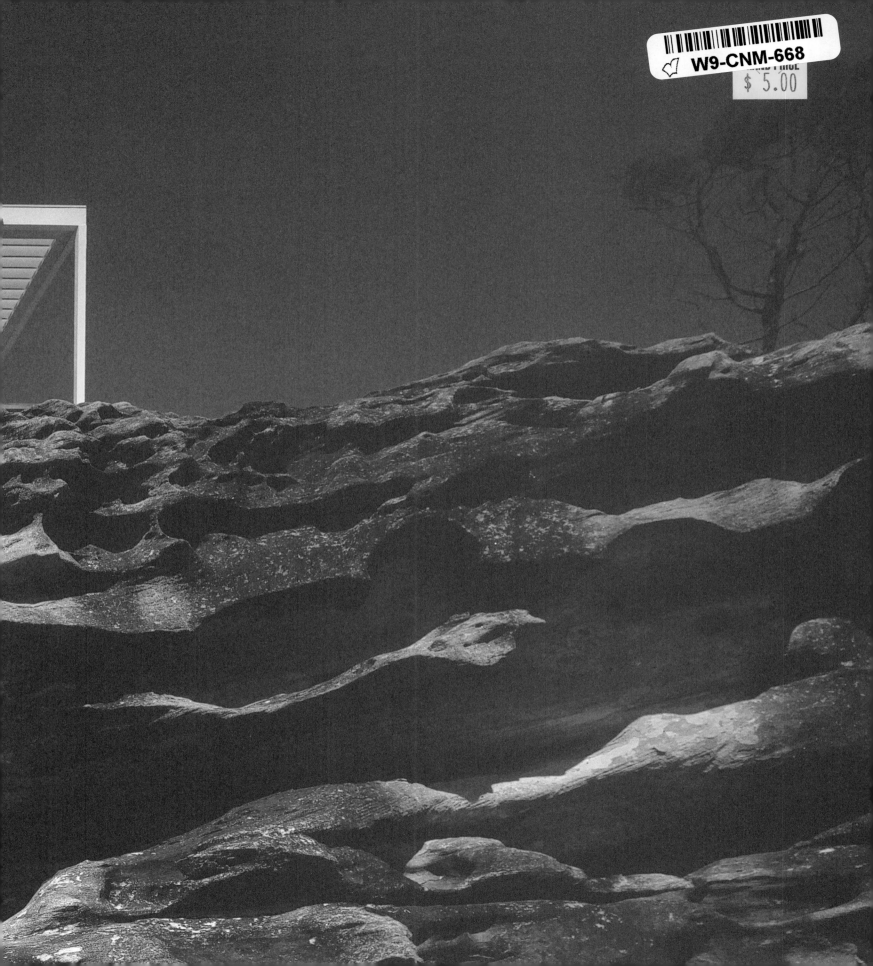
$ 5.00

Houses on the Edge

Houses on the Edge

Edited by Alejandro Bahamón

HARPER DESIGN international

An Imprint of HarperCollins*Publishers*

Edition and Text: Alejandro Bahamón

Editor in Chief: Haike Falkenberg

Art Director: Mireia Casanovas Soley

Graphic Design & Layout: Gisela Legares Gili

Translation: Wendy Griswold

Copyright © 2003 by Harper Design International and LOFT Publications

First published in 2003 by:
Harper Design International, an imprint of HarperCollins Publishers
10 East 53rd Street
New York, NY 10022

Distributed throughout the world by:
HarperCollins International
10 East 53rd Street
New York, NY 10022
Tel.: (212) 207-7000
Fax: (212) 207-7654

HarperCollins books may be purchased for educational, business, or sales
promotional use. For information, please write:
Special Markets Department
HarperCollins Publishers Inc.
10 East 53rd Street
New York, NY 10022

Library of Congress Control Number: 2003112563

ISBN: 0-06-054473-2
DL: B-35.577-03

Editorial project

LOFT Publications
Via Laietana, 32 4º Of. 92
08003 Barcelona. Spain
Tel.: +34 932 688 088
Fax: +34 932 687 073
e-mail: loft@loftpublications.com
www.loftpublications.com

Printed by:
Anman Gràfiques del Vallès, Spain

First Printing, 2003

Loft affirms that it possesses all the necessary rights for the pub-
lication of this material and has duly paid all royalties related to
the authors' and photographers' rights. Loft also affirms that it
has violated no property rights and has respected common law,
all authors' rights and all other rights that could be relevant.
Finally, Loft affirms that this book contains no obscene nor slan-
derous material.

Whole or partial reproduction of this book without editors author-
ization infringes reserved rights; any utilization must be previ-
ously requested.

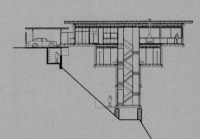

On the edge

An extreme position, both physical and historical, is the point of departure and unifying theme of this collection. Using twenty-three case studies, this book reviews the concepts that, at the turn of the twenty-first century, were typical of housing construction on dramatic sites at the edges of steep slopes. These two extreme determinants, one historical and the other physical, give birth to a vast and rich repertoire of formal, functional, and structural solutions to architectural problems.

The legacy of the modern movement

The close relationship between setting and architecture has always been an important factor in the design of any type of project. But it is in the home, the first and principal habitat built by man, that this relationship is strongest. Every feature of the environment, including the climate, the views, the vegetation, and the orientation, is a design tool that can help ensure that the project meets the plan requirements, the spaces have their own character, and the structure as a whole makes a strong statement.

One of the most important figures of modern architecture is Frank Lloyd Wright, and one of his most significant contributions is organic architecture, the architectural paradigm that seeks to harmoniously integrate man-made structures with nature. The Kaufman House, popularly known as Fallingwater, is one of the strongest testaments to his architectural ideal. While countless modern architectural referents exemplify the origins of this compromise between the natural and man-made environments, we use this one because of its strong influence on later generations, its widespread fame among the general public, and the similarities of its natural setting to those of the houses studied in this volume. The Kaufman house is Wright's best-known work. It is a home in the Pennsylvania hills that is built over a waterfall and is perfectly adapted to the rocky contours. Its success in making nature a part of the construction is attested to by the intimacy the inhabitants share with the vegetation and the exterior landscape. Its position vis-à-vis the waterfall makes it a mandatory reference for this collection.

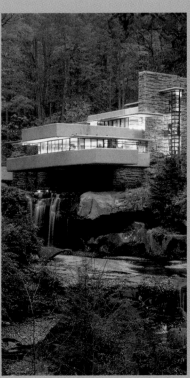

Foto © Paul Rocheleau

Designing for the plot

The principal design determinants, in addition to the client's personal plan, are the circumstances of which the house is built. In the examples provided here, the plots have features that, while enriching the home, make design and construction difficult. These sites are located at the edges of steep, often rocky, slopes and though they may enjoy vast panoramic views as well as views created by the slopes, they may be difficult to access or subject to difficult climactic conditions. The architects' solutions involve placement on the site, the internal arrangement of the home, the structural system, or the materials used for finishing. While all the examples share certain physical similarities, the individual characteristics of each site call for solutions as diverse as they are appropriate to the location. Burying the structure in the ground to disguise it in the topography (slope . house hintersdorf, in Austria, by lichtblau . wagner), sheathing the home in copper to camouflage it amid the vegetation (villa man-bow, in Japan, by Satoshi Okada), using very light metal frameworks that have a minimal impact on the terrain (Kronenberg Beach House, in Australia, by Alexander Tzannes), and implementing solid concrete foundations on which the house rests (Tree House, South Africa, by Van der Merwe Miszewski) demonstrate the variety of solutions that can be found for similar types of architectural projects.

Tradition and innovation

In this overview of contemporary architectural work around the world, the reader will find that concepts introduced approximately a century ago, at the dawn of the modern movement, are linked to particular social, geographic, and technological situations. These links have led to new approaches in housing and have become a useful tool for approaching a project of this nature, not only for architects but also for anyone with an interest in the subject. The final objective will always be to find the ideal location for an architectural work in a natural setting with great potential.

Architect: **Marte.Marte Architekten** Collaborators: **Robert Zimmermann, Michelangelo Zaffignani, Konrad Klostermann**

Location: **Dafins, Austria** Area: **1,680 square feet** Date: **1999** Photography: **Ignacio Martínez**

House in Dafins

Page 12:
Despite the severity of the unfinished concrete exterior, the house blends with the landscape, achieving a delicate balance between strength and lightness and emphasizing the relationship between the inside and the outside.

The removal of portions from the cubic form, which is the basic compositional element, produces many openings that, in addition to relating one space with another, flood the spaces with light so they change as the day progresses.

This building, partially buried in the mountains, sits high on a hill in the Vorarlberg region of Austria and has a splendid panoramic view of the Rhine Valley. The sturdy, solid appearance of the concrete, which forms its framework and completely covers the exterior, contrasts with the transparency achieved by the large windows, the interior patios, and the spacious terraces that crisscross this composition of filled and empty spaces. In this case, the plan of a house starts with a basic object and becomes the ideal pretext for the creation of an architectural discourse on the relationship between interior and exterior.

The house is below the access road, from which a small path branches off. It leads to a front patio that is formed by a raised, graveled area; an earth-retaining wall; a tree off to one side; and the entrance to the home. This patio starts below the house, producing a generous opening that ends with a large glass door. The simple cube that is the starting point, parts of which are drawn out or pierced, becomes a composition of great formal and functional richness.

All the interior walls, as well as the flooring and false ceiling, are painted white. This simple step, in conjunction with the rich volumetric play of the patio openings, transparencies, and double heights in the interior, creates a sequence of spaces that are defined more by the absence of reference points than by the furnishings themselves. The use of each room is determined by the effect of the light or its relationship to the exterior. Subtle nuances, such as the change to an opaque finish for the kitchen fittings or the low windows in the bedrooms, create the differences in each space.

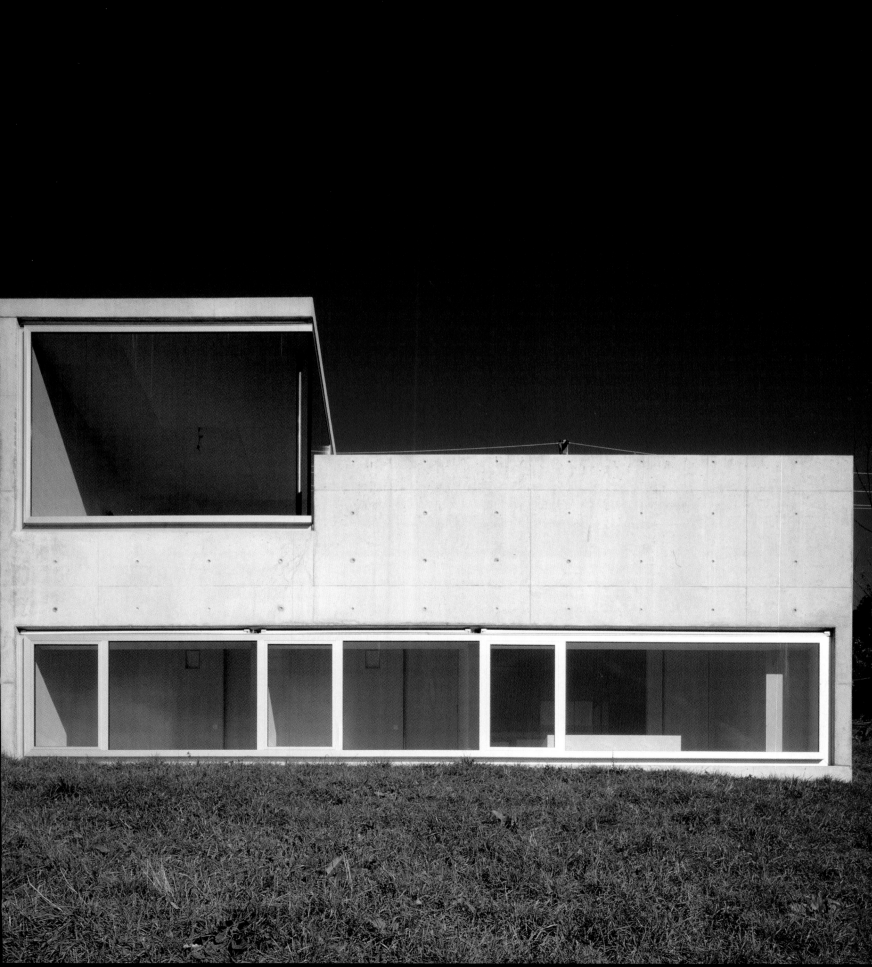

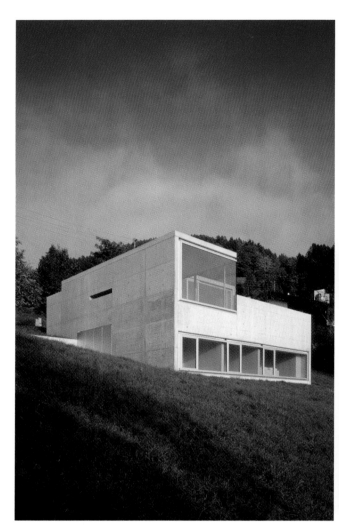
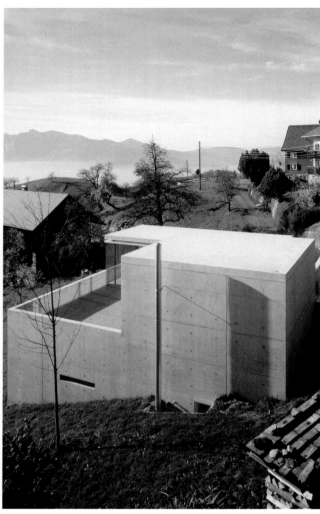
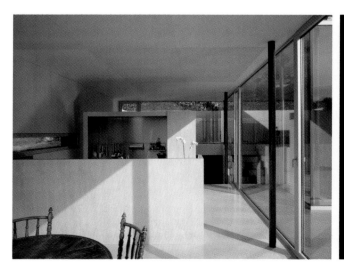
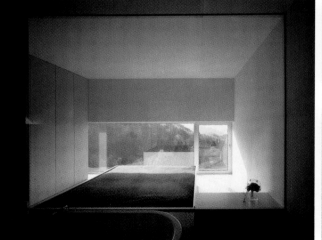
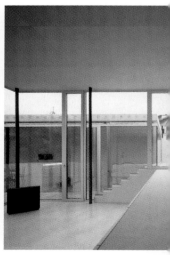

Site plan

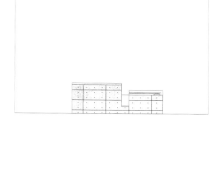

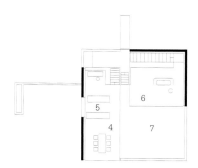

1

2 2 3

Lower floor plan

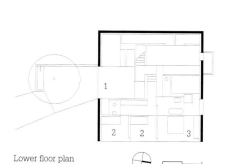

0 2 4

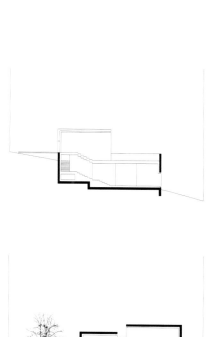

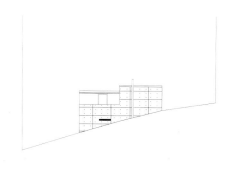

5

6

4 7

Upper floor plan

1. Access
2. Bedroom
3. Master bedroom
4. Dining room
5. Kitchen
6. Living room
7. Terrace

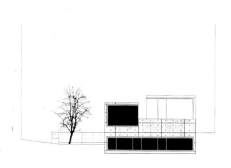

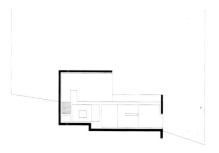

Sections

Elevations

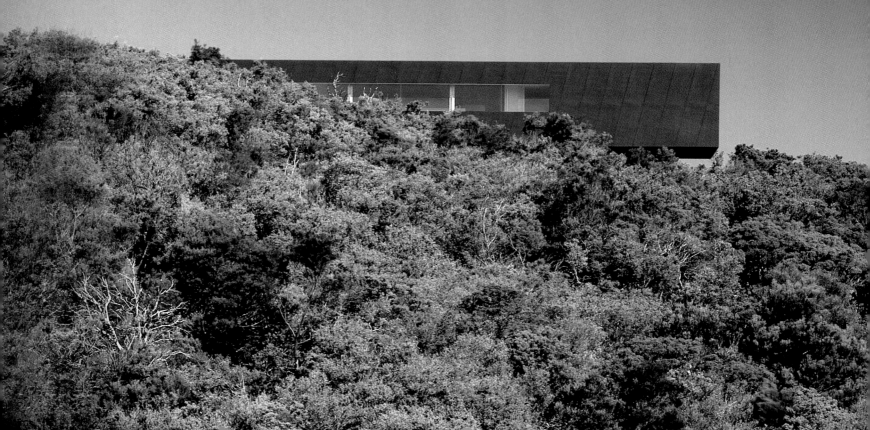

Architect: **Denton Corker Marshall**

Location: **Cape Schanck, Victoria, Australia** Area: **2,475 square feet** Date: **1999** Photography: **Tim Griffith**

Emery Residence

Page 18:
Inside, the walls are finished with white-painted plaster, and boxes covered with wood veneer serve as furniture, dividers, and closets.

Page 19:
The project's severity and clarity earned it the Robin Boyd Award, granted by the Royal Australian Institute of Architects for the best residential architecture of 2000.

This house is located atop a very steep hill and enjoys a splendid panoramic view of the ocean, just a few miles south of Melbourne, Australia. The horizontal lines of the panoramas are an obligatory referent at this point. To the northwest, the beaches of the Mornington Peninsula unfold, and to the southeast is Cape Schanck. The house is shaped like a rectangular box and rises above the medium-size trees that cover the site, taking advantage of the views. Strong winds were also a determinant of the composition, since the house had to have a tranquil, peaceful interior.

The composition consists of a black, orthogonal volume that is clear yet mysterious, supported by another, smaller box with two columns in front. Its simplicity is enriched with subtle details, such as the division of the main unit into two sections, which gives the illusion of having been twisted in opposite directions; the striated outer finish; the narrow openings to the exterior; and the diagonal chimney. As a result, the structure looks less like a house than a highly dynamic object rotating on its own axis.

The plan is divided into two floors that are marked by the two main units, each accommodating different functions. On the upper level are the living room, dining room, and kitchen, while the lower floor, sheltered by the vegetation, is reserved for the bedrooms. The structure itself consists of a steel frame that supports reinforced concrete slabs. Thin sheets of concrete cover the exterior, and large windows are located at each end of the box. Both the proportions and the structural system were designed to withstand inclement weather while allowing for a bright, open plan.

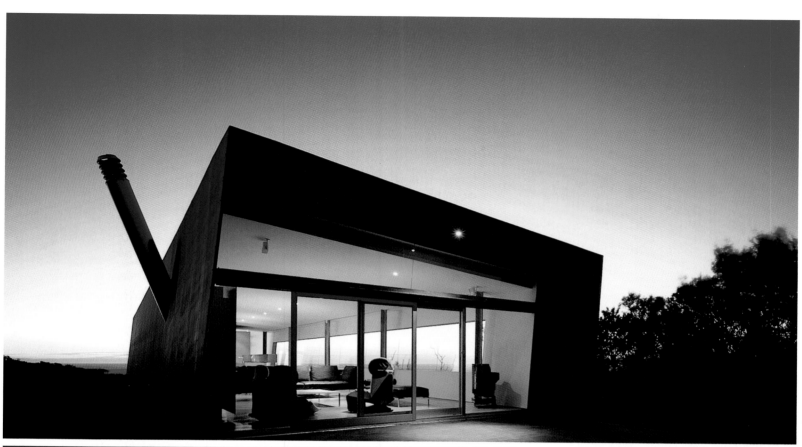

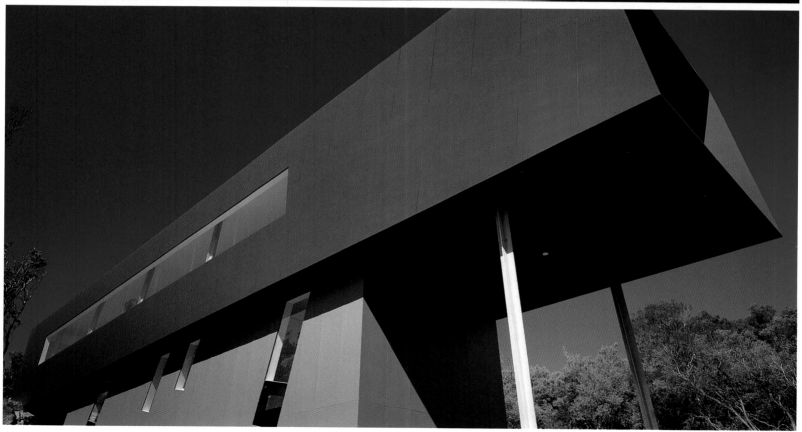

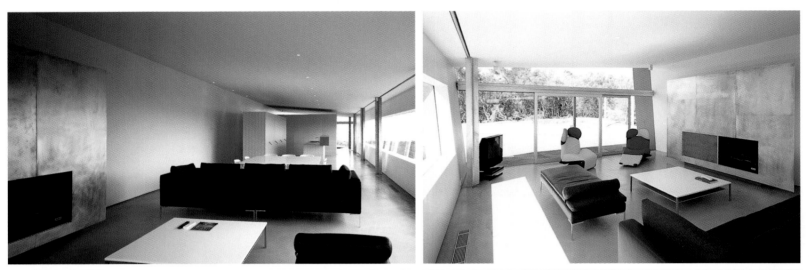

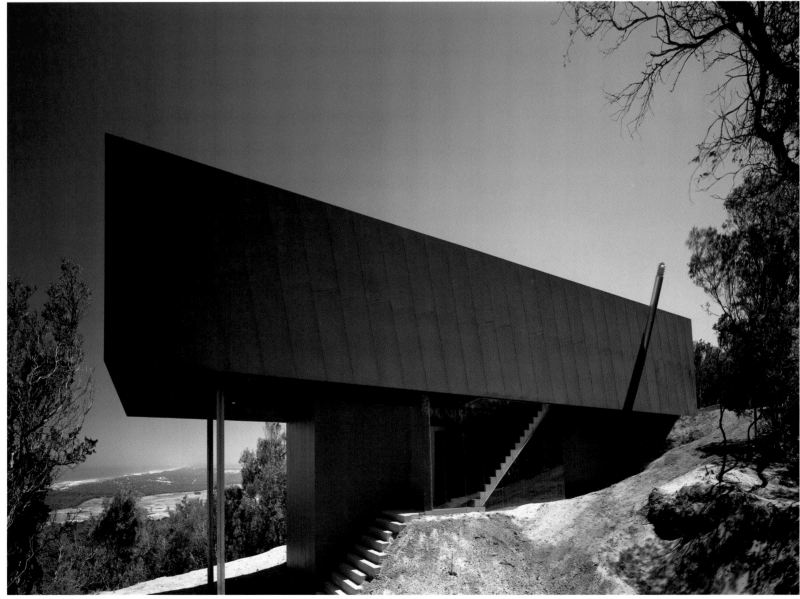

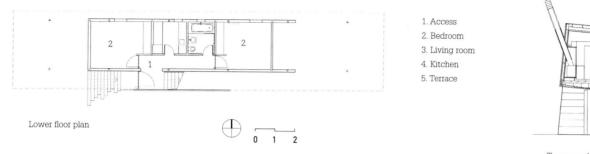

Lower floor plan

1. Access
2. Bedroom
3. Living room
4. Kitchen
5. Terrace

0 1 2

Transversal section

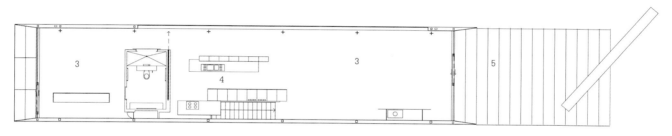

Upper floor plan

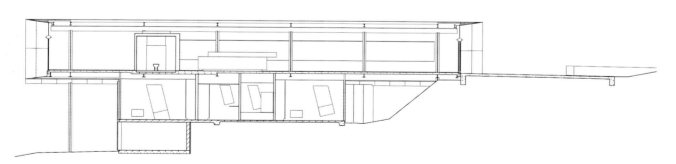

Longitudinal section

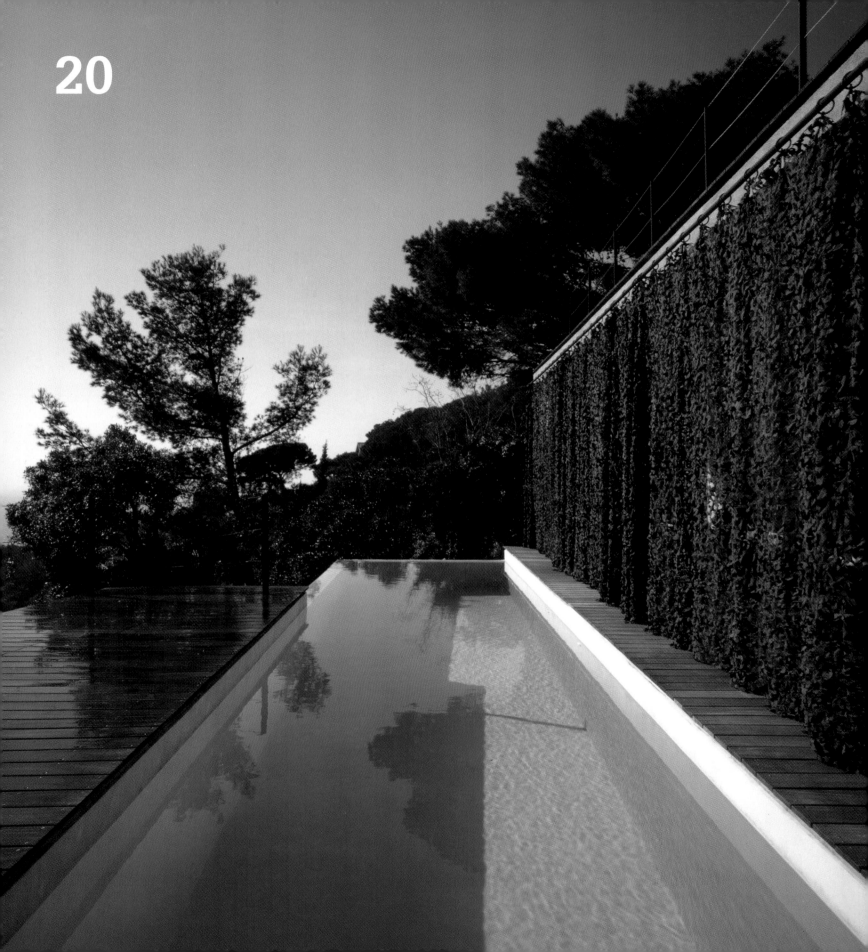

Architect: **Rudy Ricciotti Architecte** Collaborator: **Sidonie Daher**

Location: **Chemin du Roucas Blanc, Marseille, France** Area: **3,154 square feet** Date: **2000** Photography: **Christian Michel**

Le Goff Villa

Page 24:
An outdoor curtain, made of French
Navy tank camouflage netting,
protects the main facade from the
sun during the day and provides
privacy at night.

In addition to solving the problem of adapting a single-family home to the physical features of the plot, the designers had to ensure that this house would accommodate a private collection of contemporary art. The house was situated on the highest point of the site, where one can see the forest up close and have a panoramic view of the Mediterranean Sea in the distance.

The building is laid out in a simple L shape, which hugs the main terrace and the long, narrow swimming pool. The longer section houses the living room, which is about 65 feet in length and also functions as the art gallery, while the shorter section contains the kitchen, dining room, and a small bathroom. The swimming pool, which is parallel to the living room, reinforces the dramatic effect of this space, marked by the continuous wall and the polished concrete-and-quartz floor. An upper level in the shorter section contains the bedrooms, and a second terrace on the living room roof provides magnificent vistas.

The framework and structural system emphasize the nature of the home and its placement on the lot. There are two L-shaped structural walls in front, with a subtle gap marking the main entrance. In the back, toward the terrace and swimming pool, the framework becomes a series of posts that open up the facade, making it completely transparent. Fluorescent lighting emphasizes the structural elements and the objets d'art in the living room/gallery.

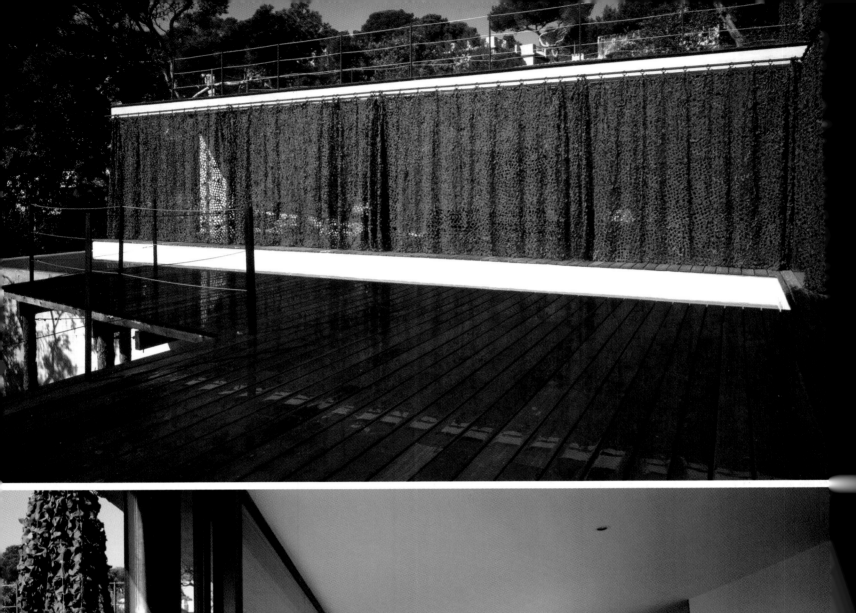
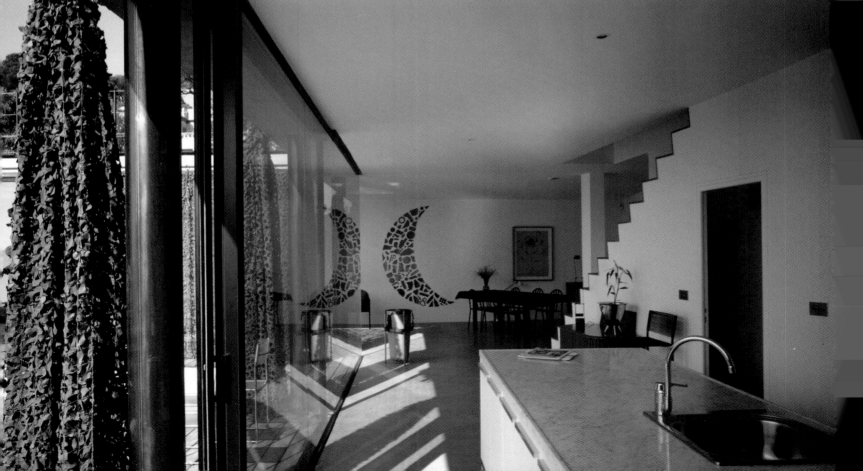

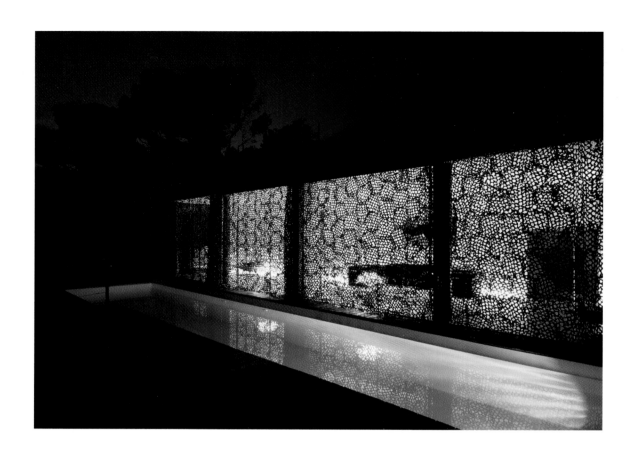

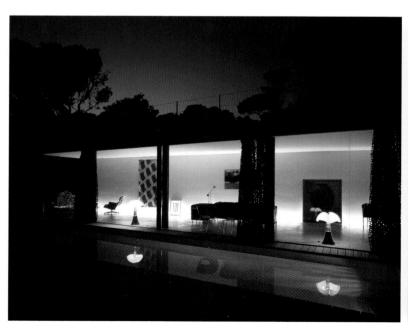

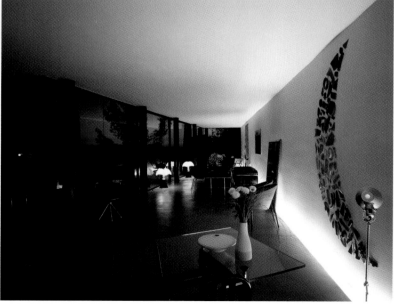

Site plan

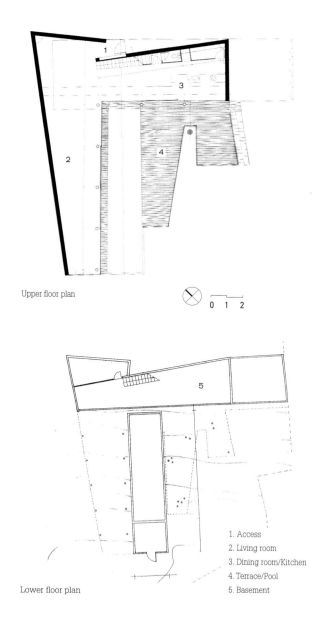

Upper floor plan

⊗ $\overline{\quad 0 \quad 1 \quad 2 \quad}$

Lower floor plan

1. Access
2. Living room
3. Dining room/Kitchen
4. Terrace/Pool
5. Basement

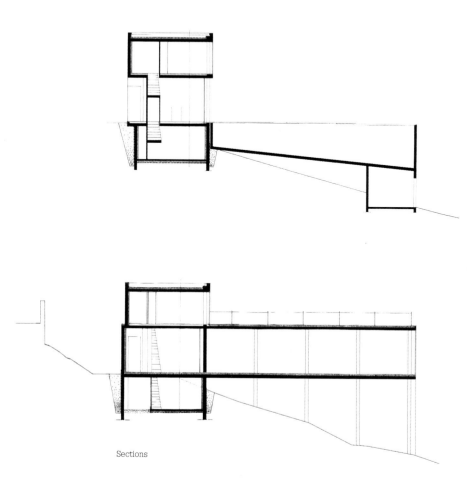

Sections

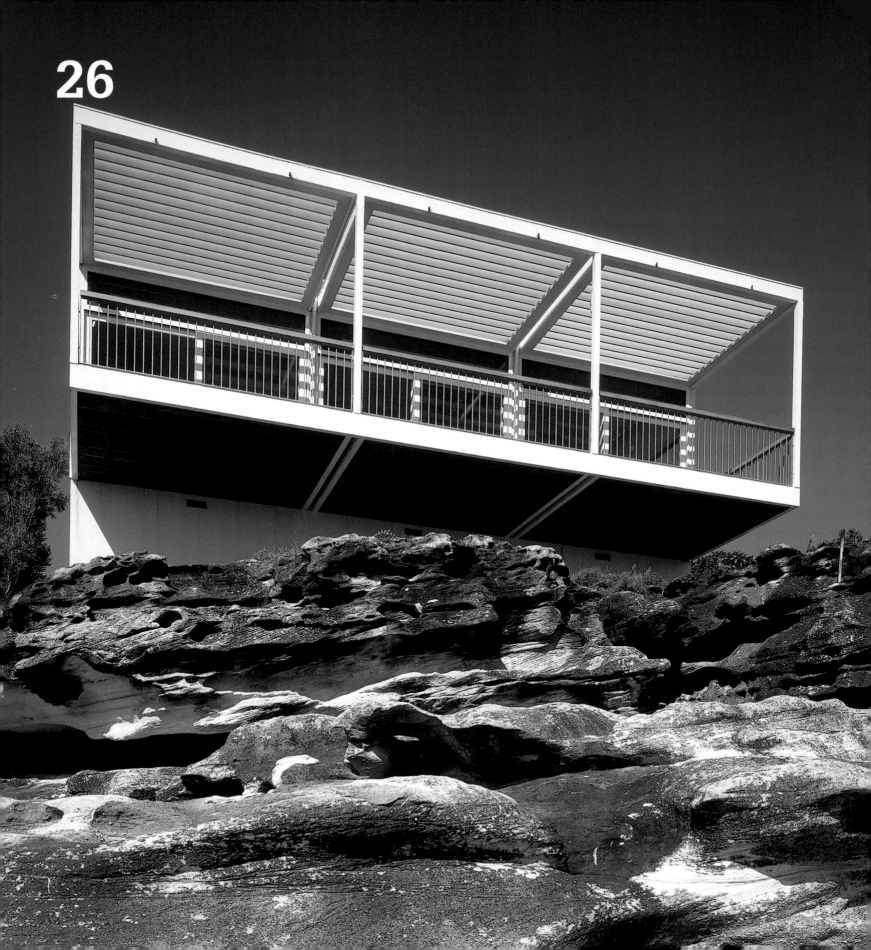

Architect: **Clark Pearse Architects** Collaborators: **Robert Zimmermann, Michelangelo Zaffignani, Konrad Klostermann**

Location: **Sydney, Australia** Area: **2,669 square feet** Date: **2001** Photography: **Richard Glover / VIEW**

Bundeena House

A s Palm Beach and the top of its peninsula mark the extreme north of the suburbs of Sydney, Australia, Bundeena and the Royal National Park mark the southern limit of the developed part of the city. The architects wanted to create a house that would respond clearly to this site in both its structure and form. The plot is almost ideal and has such defining features: it is situated atop a sandstone reef, just at the shoreline, with panoramic views of Jibbon Beach (the boundary of the Royal National Park) and fig trees, in perfect harmony with the natural environment.

The home was conceived as two units joined by a single roof. Designed to make the most of its surroundings, each unit relates directly to the two natural elements that dominate the plot. The upper unit includes the entrance, two bedrooms, a bathroom, and the laundry room, joined by a corridor that runs the length of the unit and looks out over the ocean. Sliding windows fully integrate this corridor with the exterior. Kitchen, dining room, and living room all occupy a large, bright space in the lower unit, with the master bedroom, an office, and a bathroom somewhat isolated behind the fireplace.

The construction, as well as the materials and details that define the building, has its origins in the traditional beach house, typical to the region but disappearing over time as large structures spring up in the coastal areas. Solid slabs of concrete contrasting with large glass openings, latticework that filters the light, and exterior spaces that link the surroundings with the interior, blend together to create a unique and magical setting.

Page 30:
The lower unit, just at the edge of the reef, sits on a concrete foundation and looks as if it is floating on the rocks. A palette of grays blends with the different shades of the stone as the light changes throughout the day.

Page 32:
An exterior section between the two units becomes a patio of sorts, extending the spaces and serving as a transition area between the two parts of the house and as a close link with the natural setting.

Page 34:
The unit that contains the fireplace and shelving serves as a dividing wall between the living room and the master bedroom. Its dark color contrasts with the lightness of the rest of the space and accentuates its function as furniture for both rooms.

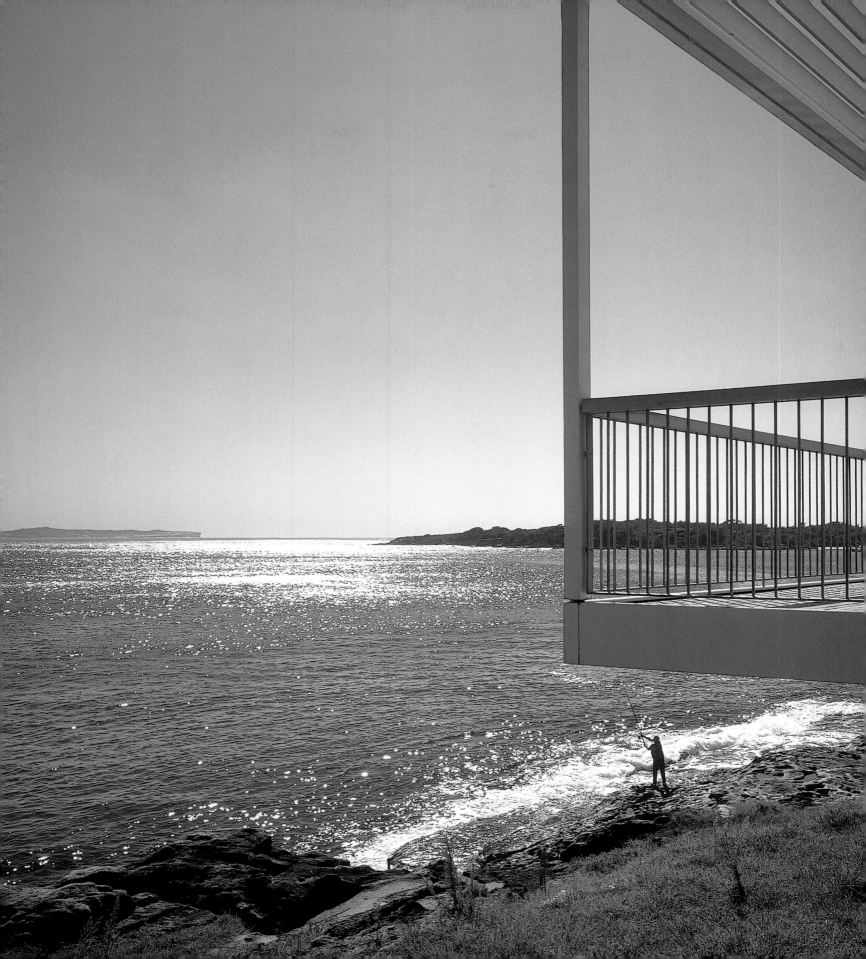

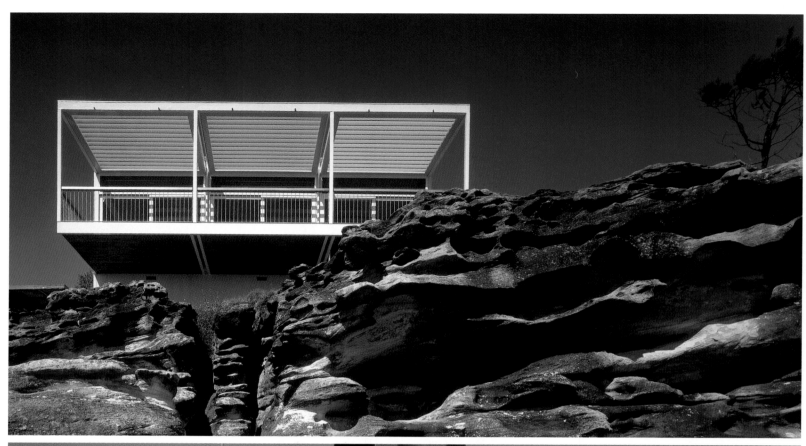

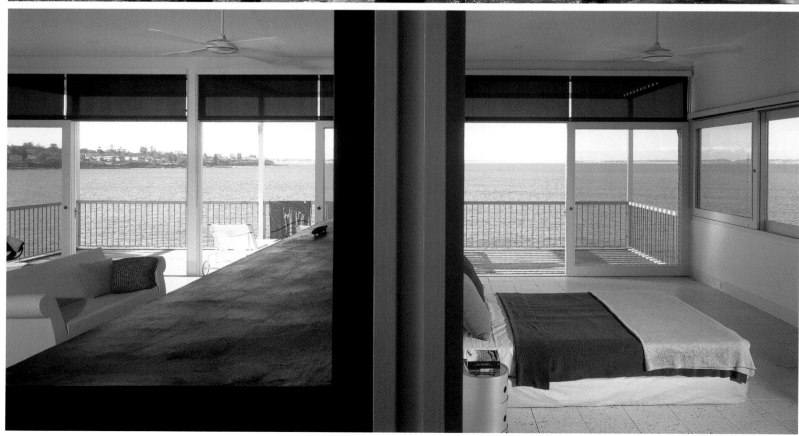

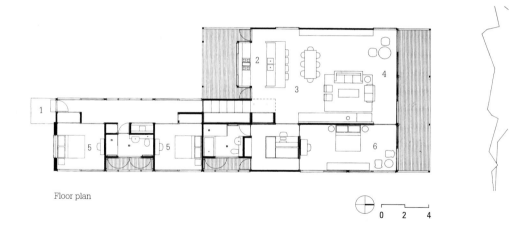

Floor plan

1. Access
2. Kitchen
3. Dining room
4. Living room
5. Bedroom
6. Master bedroom

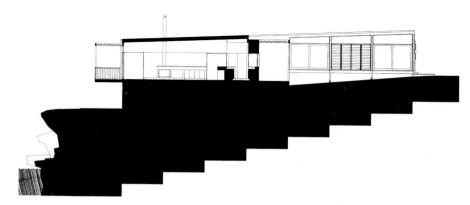

Longitudinal section

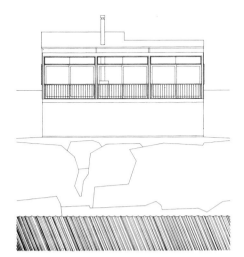

Rear elevation

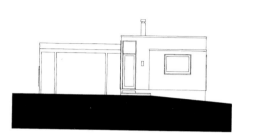

Front elevation

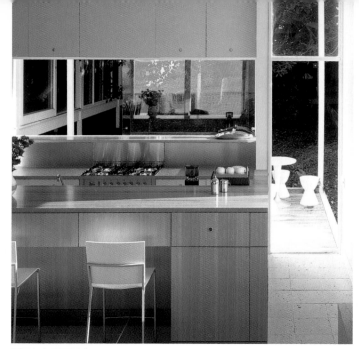

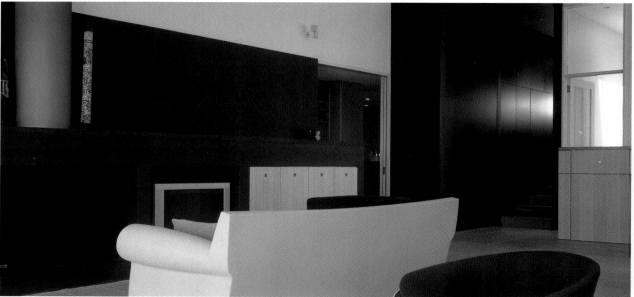

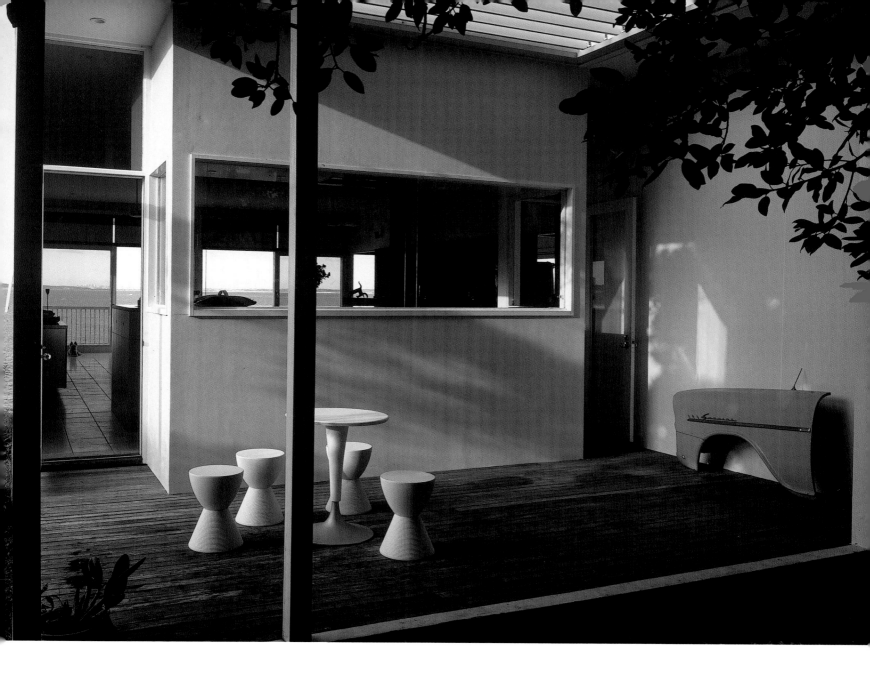

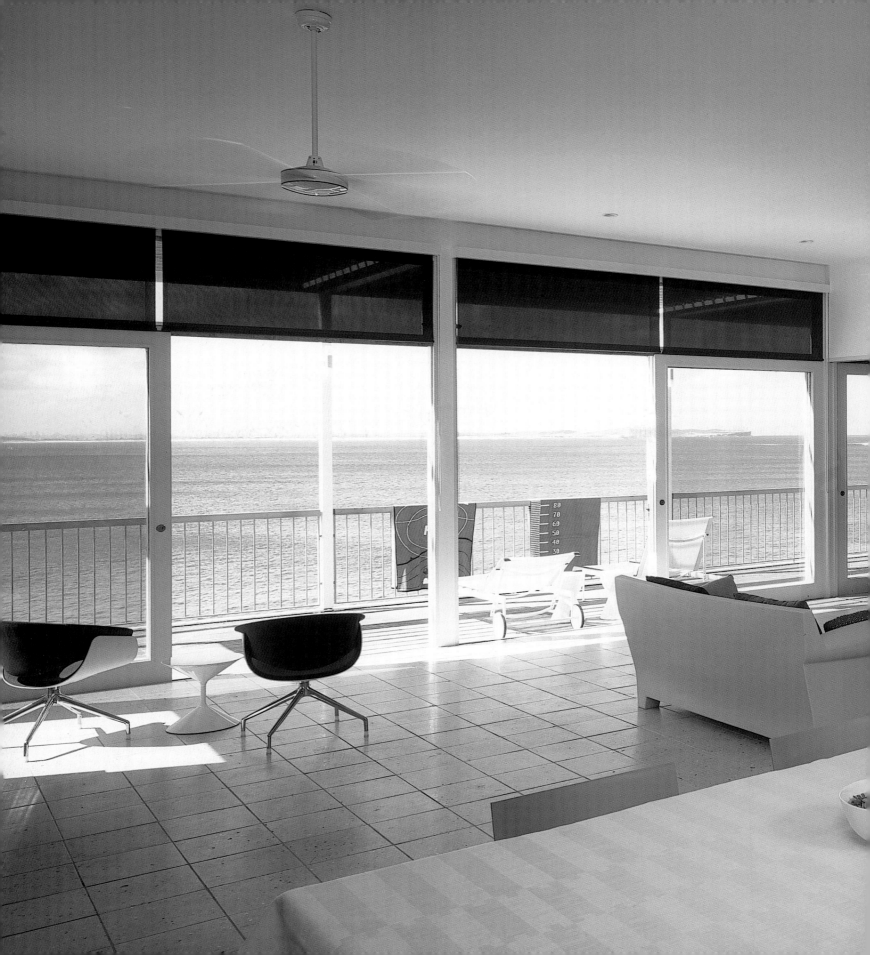

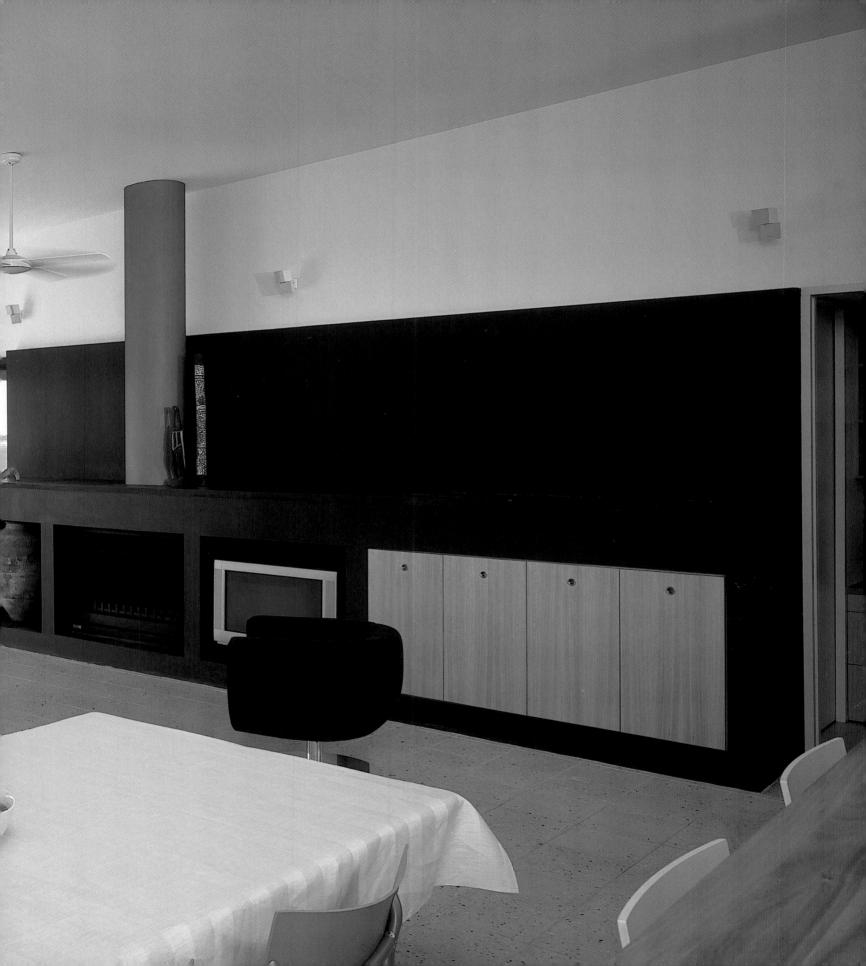

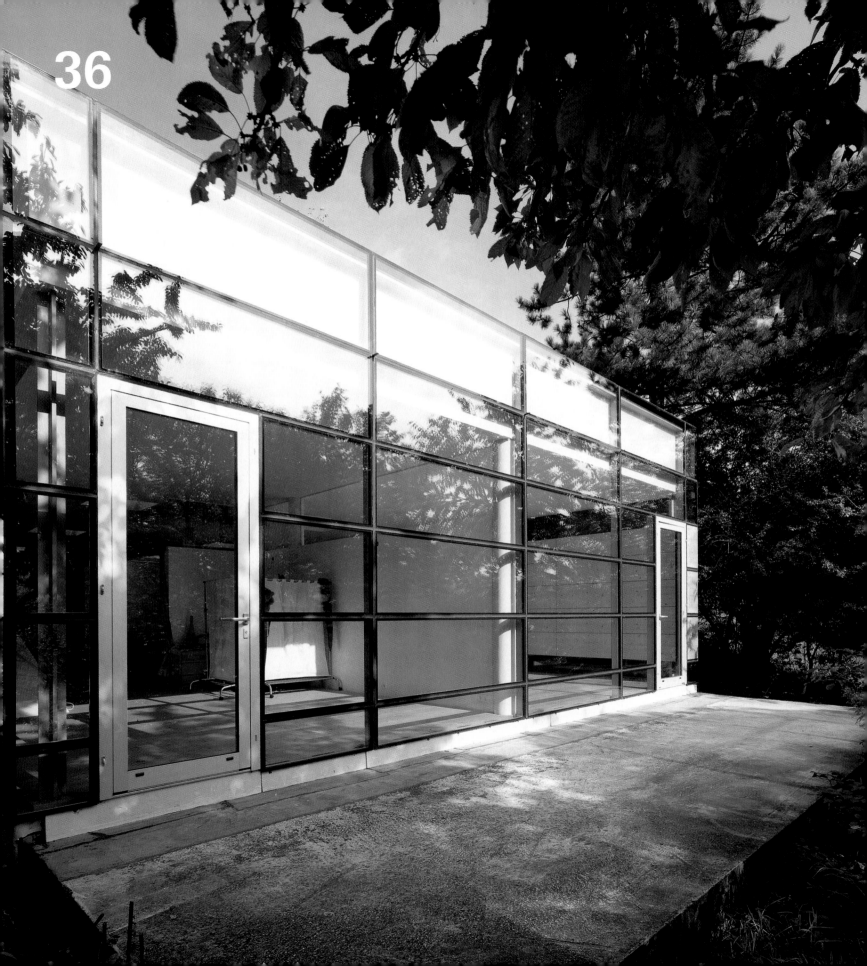

Architect: **lichtblau . wagner architekten**

Location: **Hintersdorf, Austria** Area: **2,800 square feet** Date: **2002** Photography: **Bruno Klomfar**

slope . house hintersdorf

Page 40:
The overhead lighting, the narrow lateral openings, and the large glass plates of the facade afford a variety of relationships with the exterior and a rich interior space marked by accents of light and shadow.

Page 42:
Since the house has no basement, it was important to provide for as much storage space as possible on the lower level. Cabinets built into the interior dividers and the side wall of the house fulfill this need.

The challenge of this project was to create a home and office in a protected area with minimal visual impact while making the most of the setting's physical features. Using the natural slope of the land, the project was conceived as an underground structure with few exterior surfaces and maximum heat retention. The roof becomes an extension of the high part of the land, almost completely camouflaging the building and providing a highly efficient means of thermal isolation. Part of this green roof slopes to create an interior patio and a better connection between the exterior and interior.

The plan is based on a rectangular unit divided into two symmetrical sections by the interior patio—sections that could, in the future, function as small, independent homes. Each section, in turn, is subdivided into two spaces, one facing the view and the other buried in the mountain, with the services in the center. The bedrooms sit below ground and are illuminated by inclined conduits that capture the sunlight from different angles. Since the service areas are in the middle, the bedrooms and living areas can be divided as required; modifying the original plan would not be difficult.

All the interior finishes are wood, and many components made of prefabricated pieces were set up by the owners themselves. The structure of the only facade consists of a system of three layers of tempered glass in a light metal frame, a marriage of the latest industrial technology and the tradition of local artisanship. This strategy achieved maximum efficiency and reduced construction costs by as much as 60 percent.

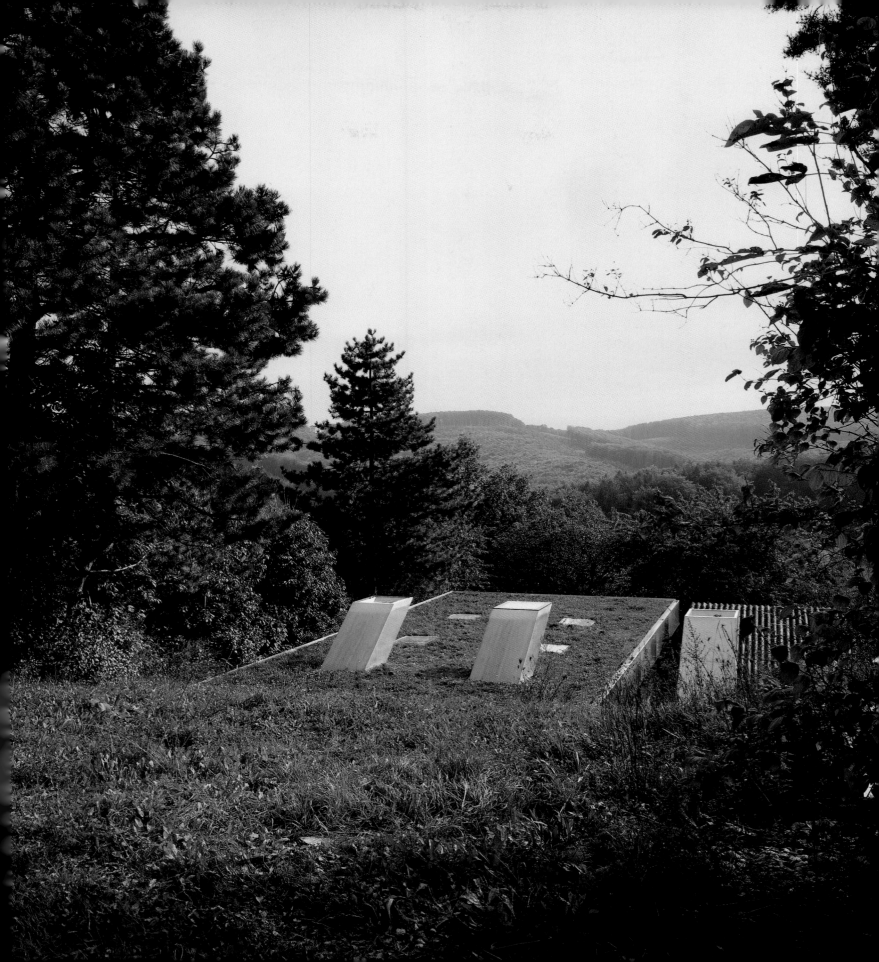

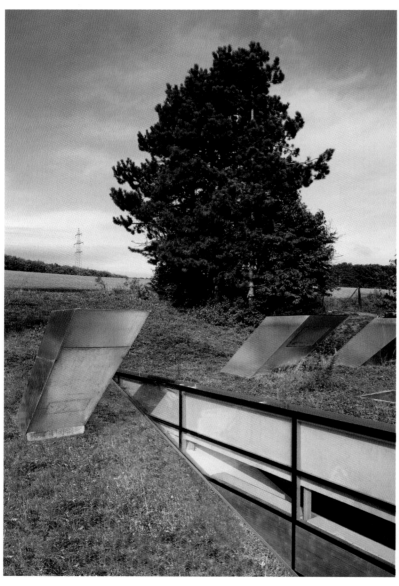
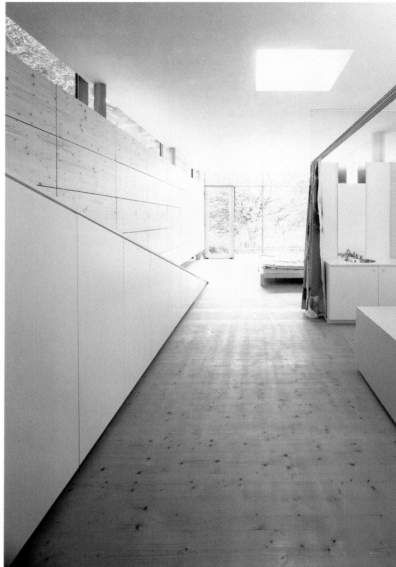

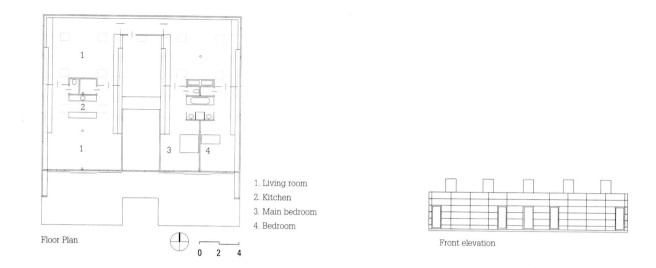

1. Living room
2. Kitchen
3. Main bedroom
4. Bedroom

Floor Plan

0 2 4

Front elevation

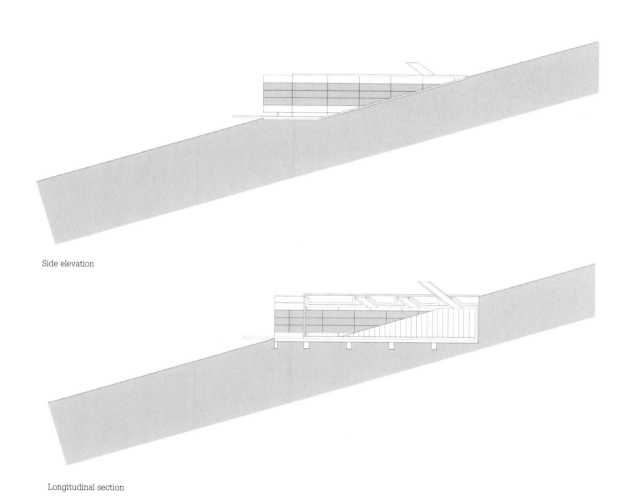

Side elevation

Longitudinal section

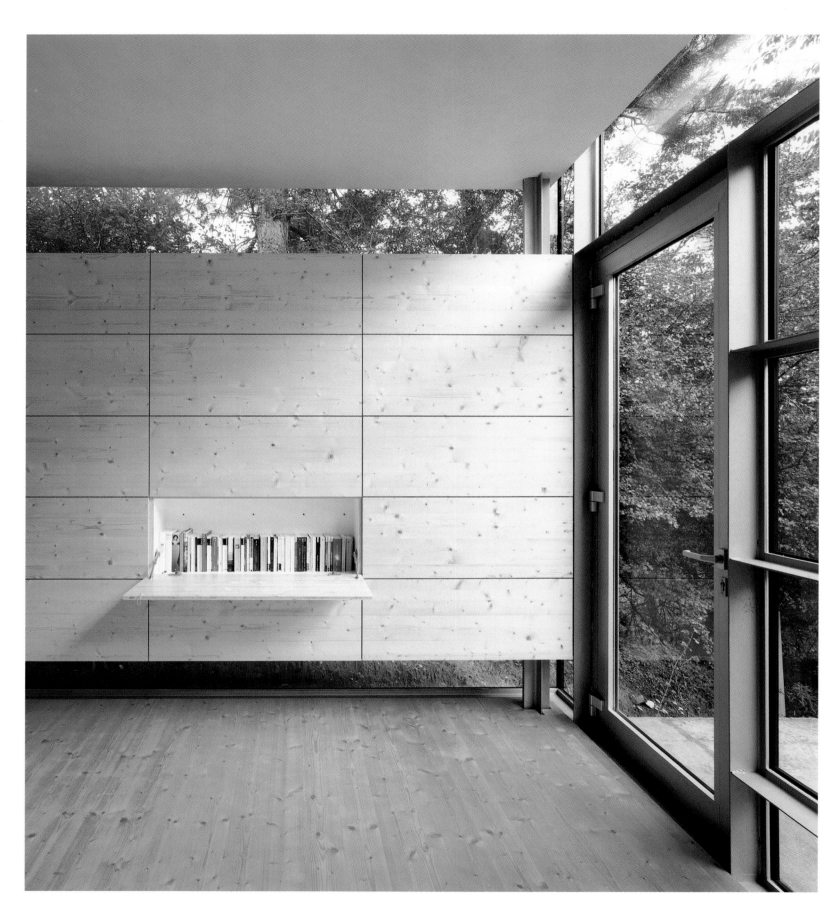

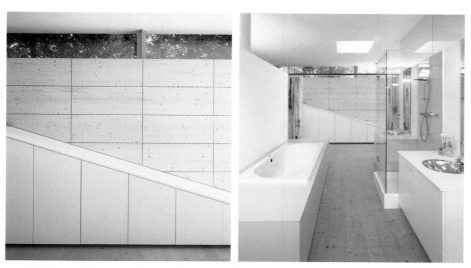

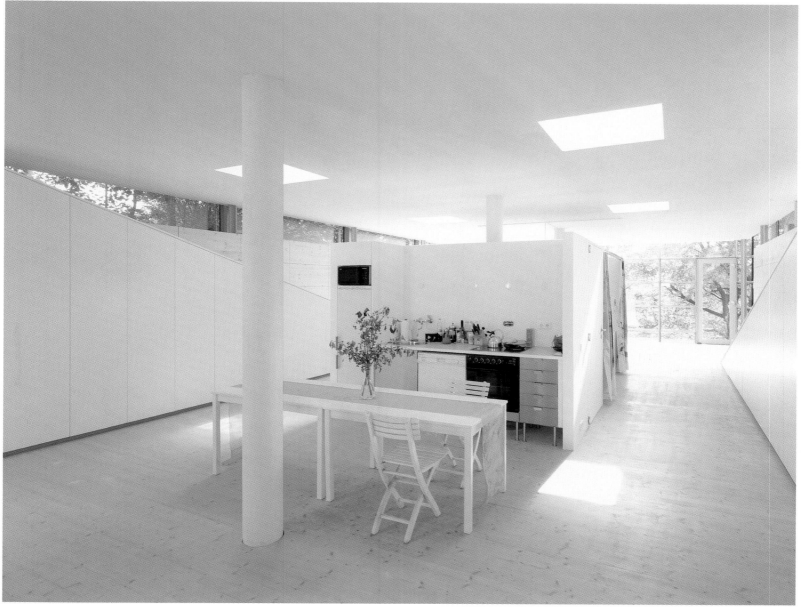

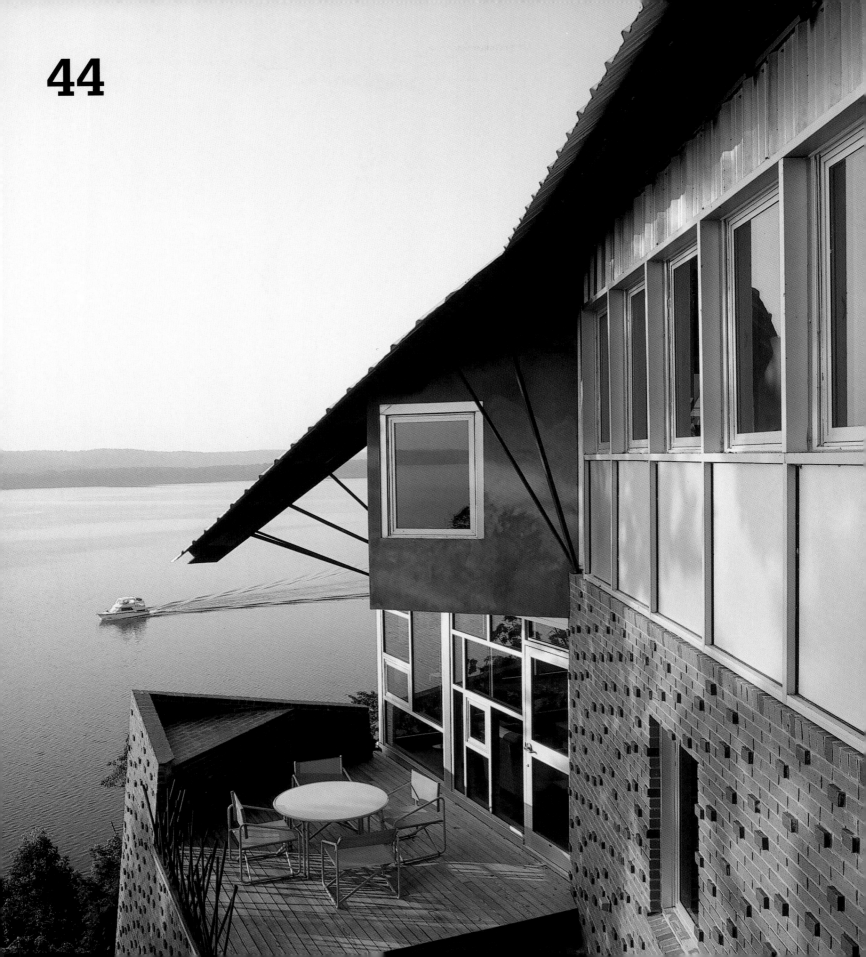

Architect: **buildingstudio** Design team: **Samuel Mockbee, Coleman Coker, Agrippa Spence Kellum, Patrick Johnson**

Location: **Tennessee, United States** Area: **3,200 square feet** Date: **1997** Photography: **Undine Pröhl**

Tennessee River Residence

Page 48:
The composition consists of a small
number of elements that, due to
their placement and large size,
achieve a highly dramatic effect.

This house is suspended on a steep slope above the Tennessee River, just east of Shiloh National Park, where Tennessee, Mississippi, and Alabama meet. It is here that the river widens due to the proximity of a lake, and this has sparked the construction of vacation houses for visitors from Nashville and Memphis. The site is about 120 feet above the water on the western face of the cliff, making for a spectacular view of the surrounding woods.

The house was built for a married couple and had to provide space for their collections of modern photographs and pre-Colombian art. The building follows the natural slope of the land, jutting out from the highest point of the plot, and is divided into three distinct levels. A hall extends the length of the building, ending at the living room, just at the edge of the ravine. It functions as a long gallery whose ceiling increases in height from the entrance to the far end, in which one can enjoy the owners' art collection. As a finishing touch to the composition and in contrast to the linear arrangement, the living and dining areas are two stories high and enclosed in glass.

Formally, the house takes a radical approach, but at the same time, it retains traditional elements of regional construction. The bedrooms are on a lower level from which a view closer to the trees can be enjoyed in an intimate, secluded setting. The building materials help reinforce the general plan: brick at the base, which blends with the terrain; large windows; and a galvanized aluminum roof that extends horizontally and unifies the composition.

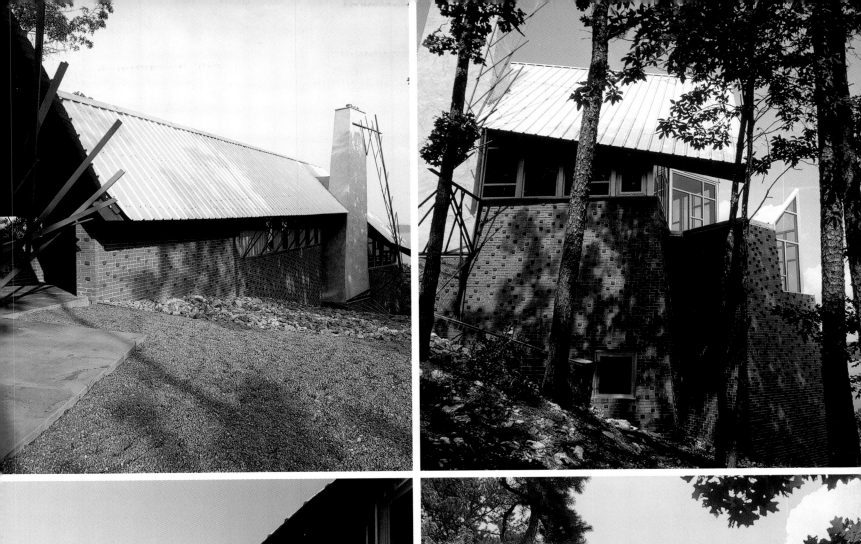
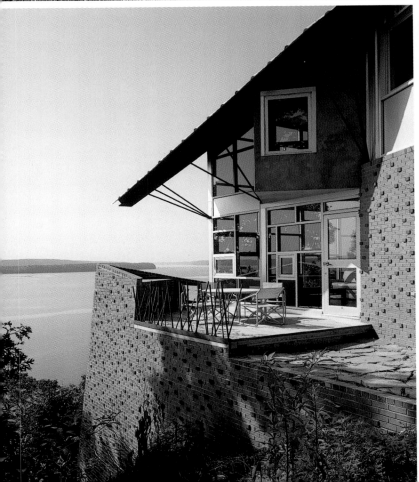
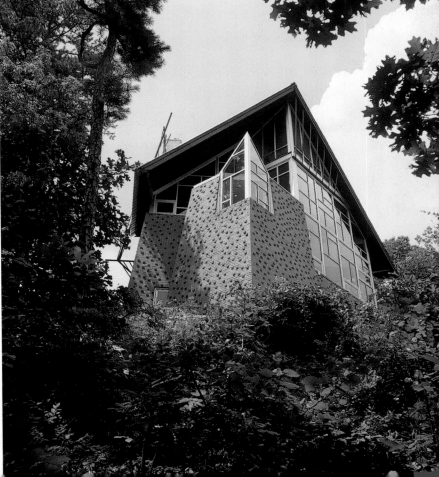

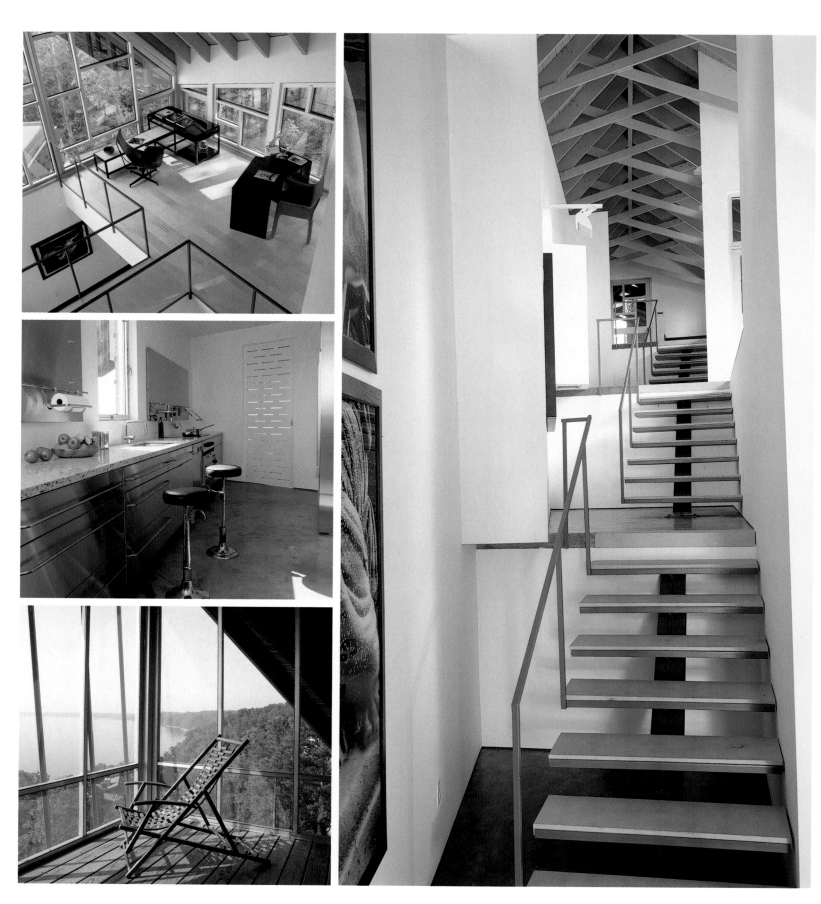

Site plan

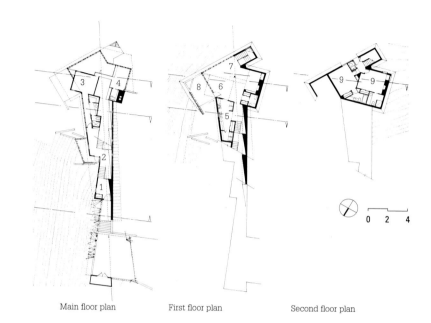

Main floor plan First floor plan Second floor plan

0 2 4

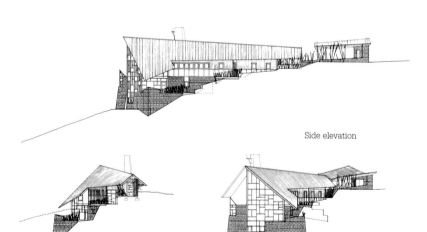

Side elevation

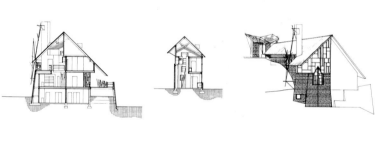

Front elevations

Longitudinal section

1. Access
2. Gallery
3. Bedroom
4. Reading room
5. Kitchen
6. Dining room
7. Living room
8. Terrace
9. Bedroom

Architect: **Patkau Architects**

Location: **San Juan Island, Washington, United States** Area: **2,775 square feet** Date: **2000** Photography: **James Dow / Patkau Architects**

Agosta House

This project involved creating a home for a Manhattan couple that wanted to relocate to the heavenly enclave of San Juan, a small rural island on the Pacific Coast in Washington State. In addition to the conventional features of a home, the project had to include an office in which the couple would continue their professional work and a small garden, enclosed and protected from the local deer that run wild.

The site is a large, 42-acre parcel, mostly covered by a dense forest of Douglas firs, a little more than a quarter of which is a preserve. The house sits on a meadow atop a hill, flanked on three sides by the trees, but open on the northwest side to a panoramic view of the valleys and fields below, Haro Strait, and the islands of British Columbia in the distance.

Extending across the ridge of the meadow, the house is almost like a spatial barrier, dividing the site into an enclosed forecourt facing the preserve, with a sweeping panorama of the sea off in the distance. Its section looks like a distorted object, playing with inclined walls and roofs, responding to the subtle but continuous slope of the land. The spatial arrangement of the house is the result of the close link between the interior/exterior and a series of interior partitions that define some of the spaces.

Structurally, the dwelling consists of strong frames of unfinished wood covered with conventional panels of painted plaster on a concrete foundation. Hot-water pipes in the foundation provide heat. The exterior is finished mainly with sheets of galvanized steel, which protect the structure not only from the elements but also from the danger of forest fires.

Page 54:
Galvanized steel sheets, the framework of unfinished wood, and the glass wall produce different layers that provide glimpses of the panorama on the opposite side of the house and create a feeling of lightness.

Page 56:
The dialogue between the interior and exterior is constant and reflected in many ways: the roof overhangs; the large openings; the placement of the elements, which creates small patios; and the exterior latticework, which protects the garden.

Page 57:
The elements left open to view and the materials used, predominantly wood, create an interior setting that is contemporary yet reminiscent of traditional structures throughout the United States.

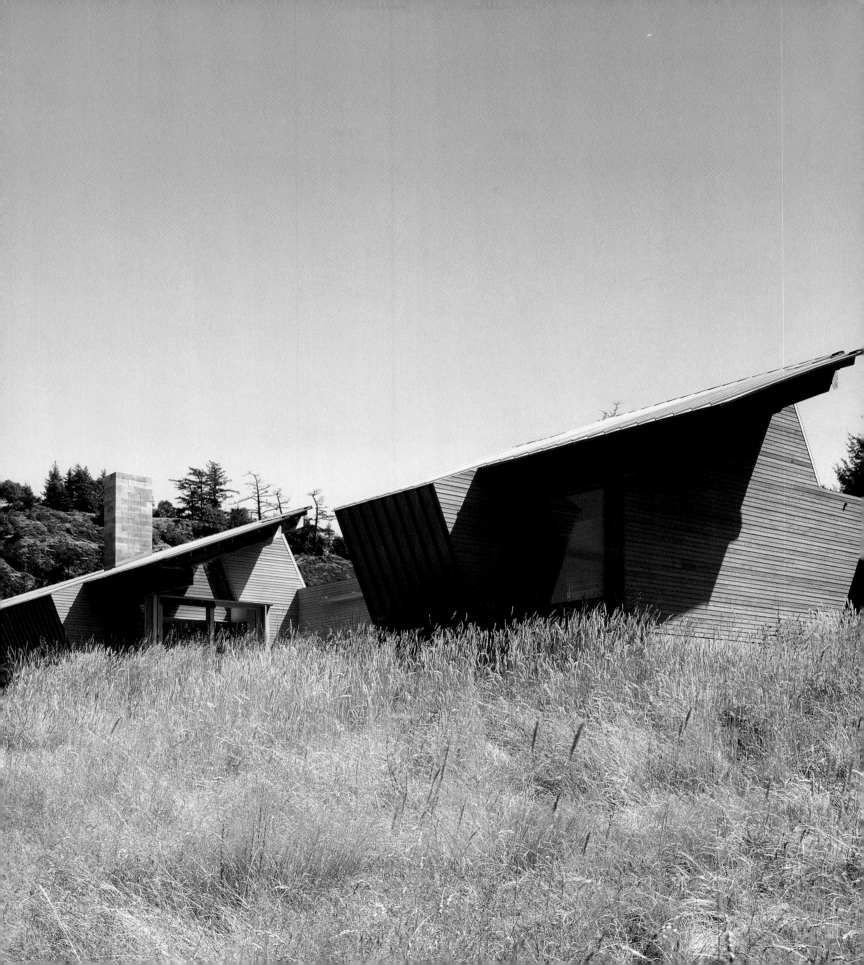

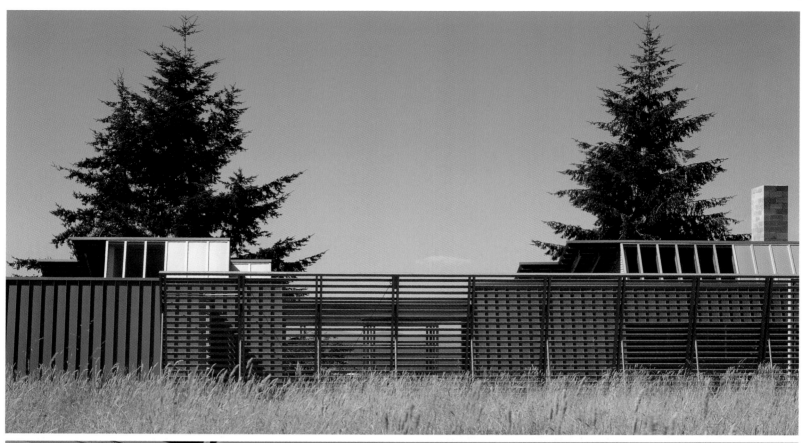

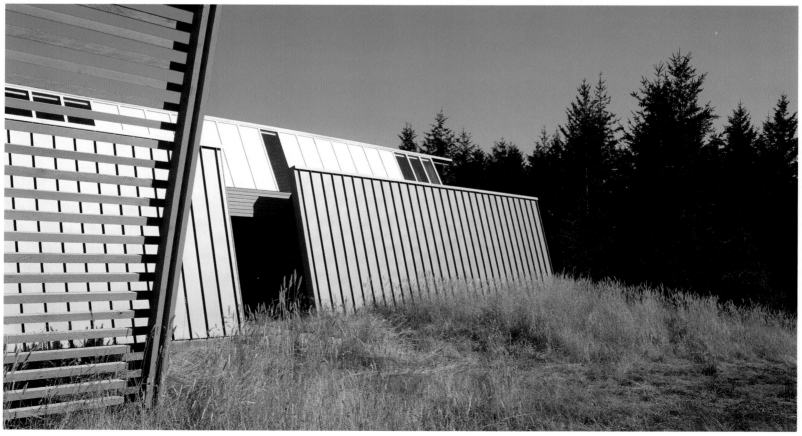

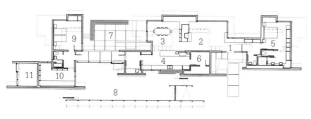

Floor plan

0 4 8

1. Access
2. Living room
3. Dining room
4. Kitchen
5. Master bedroom
6. Storage
7. Terrace
8. Enclosed garden
9. Guest bedroom
10. Study
11. Garden

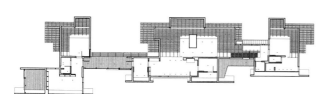

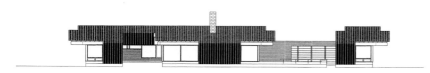

Projected roof plan

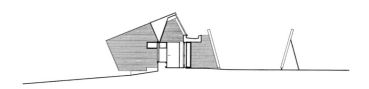

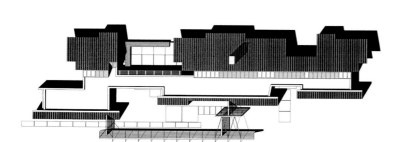

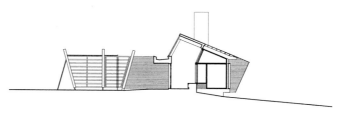

Roof plan

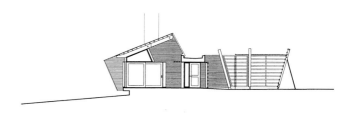

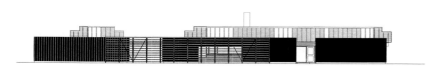

Elevations

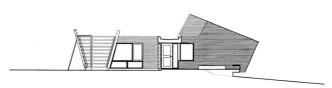

Transversal sections

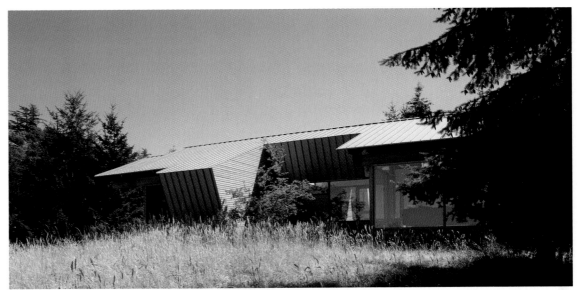

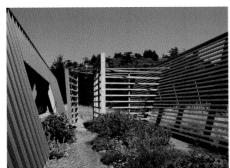

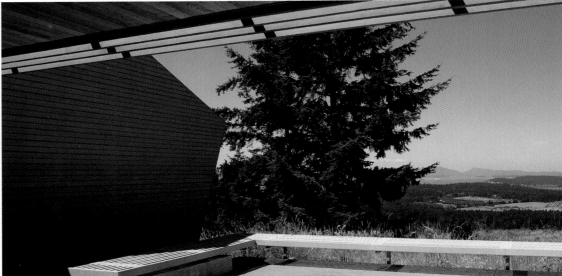

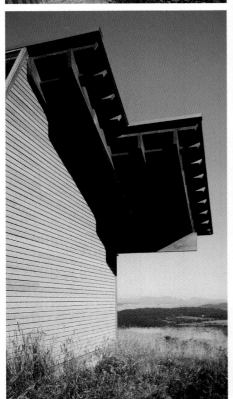

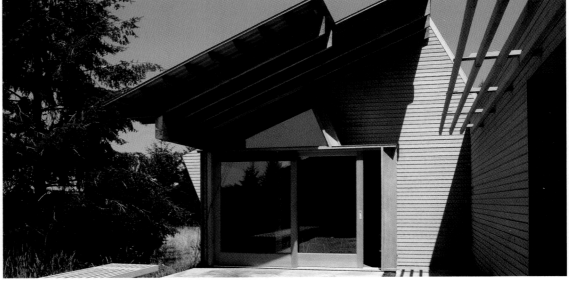

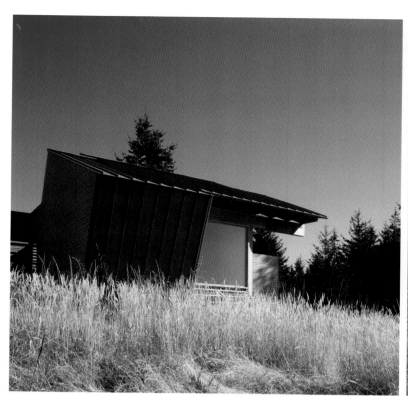
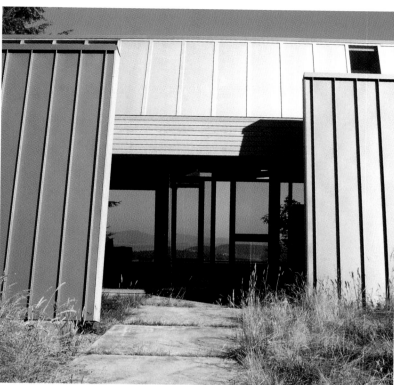
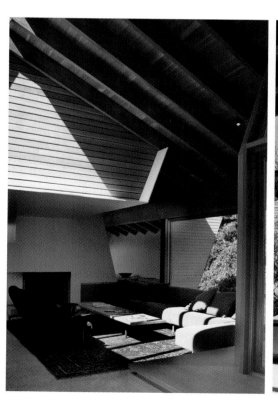
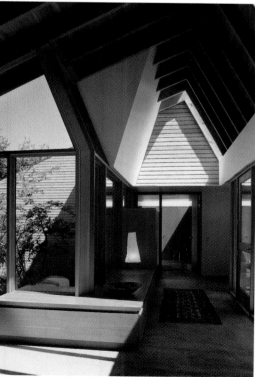
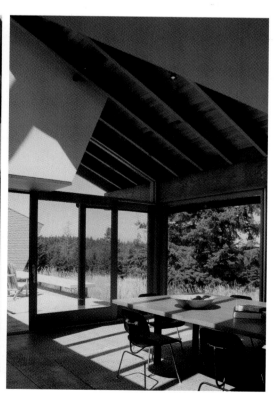

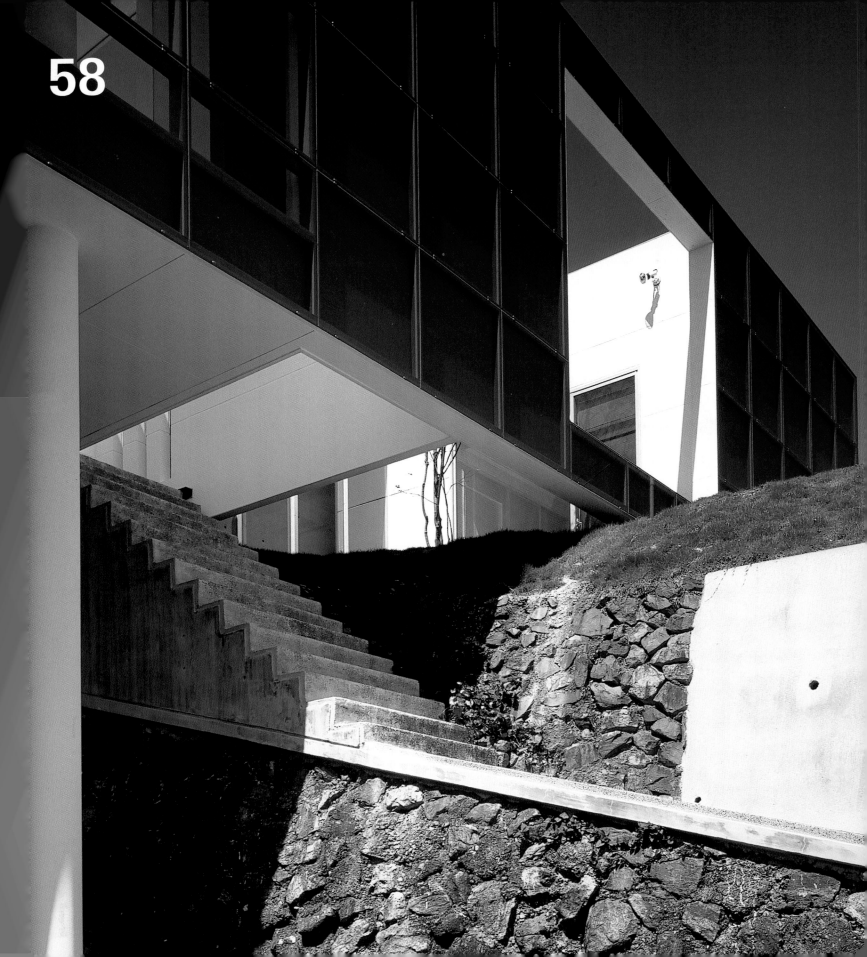

Architect: **Katsufumi Kubota / Kubota Architect Atelier**

Location: **Obatake, Yamaguchi, Japan** Area: **1,500 square feet** Date: **1993** Photography: **S. Otake**

Crystal Unit

Page 62:
A simple plan with a single patio creates an interesting segue between the natural environment, the exterior architecture, and the interior of the home.

Page 64:
Many structural elements of the building were used as interior finishes. In the rear, the reinforced concrete wall displays a fine texture in the corridor leading to the bedrooms.

This home was built in a residential complex near the city of Iwakuni, Japan. The slope of the land at the edge of the plot at one end of the housing development prompted the client to build his residence here, where the topography ensured privacy. In addition, the site has a splendid panorama of the surrounding landscape, combining views of the sea, the islands, and the bridges in just the right balance. From the beginning, a fundamental goal of the design was linking this landscape, which unfolds in front of the house, with the modern lifestyle inside.

The spaces are all enclosed by the same continuous glass skin, which acts like a large mirror. The placement on the site, the clean shapes, and the minimum amount of detail makes the structure unique. Reflections of the sea, the sky, and the islands on the glass surface make the building seem ethereal and hardly subject to the laws of gravity.

A unique formation was the obvious choice for placement. A shifting of earth created a green platform, above the natural level of the terrain, one side of which provides support for the house. The formation's size and shape guided the decisions regarding the structure's proportions. Four slender columns brace the side of the building opposite the natural support and produce a dramatic effect in the area of the living room. The entrance, in the middle of the structure, is marked by stone stairs where the green platform meets the undisturbed land. A patio, which separates the social area from the bedrooms, is the only opening that breaks the continuity of the glass facade. The patio also defines the entrance and traffic patterns, while offering a close-up view that contrasts with the far-off panorama.

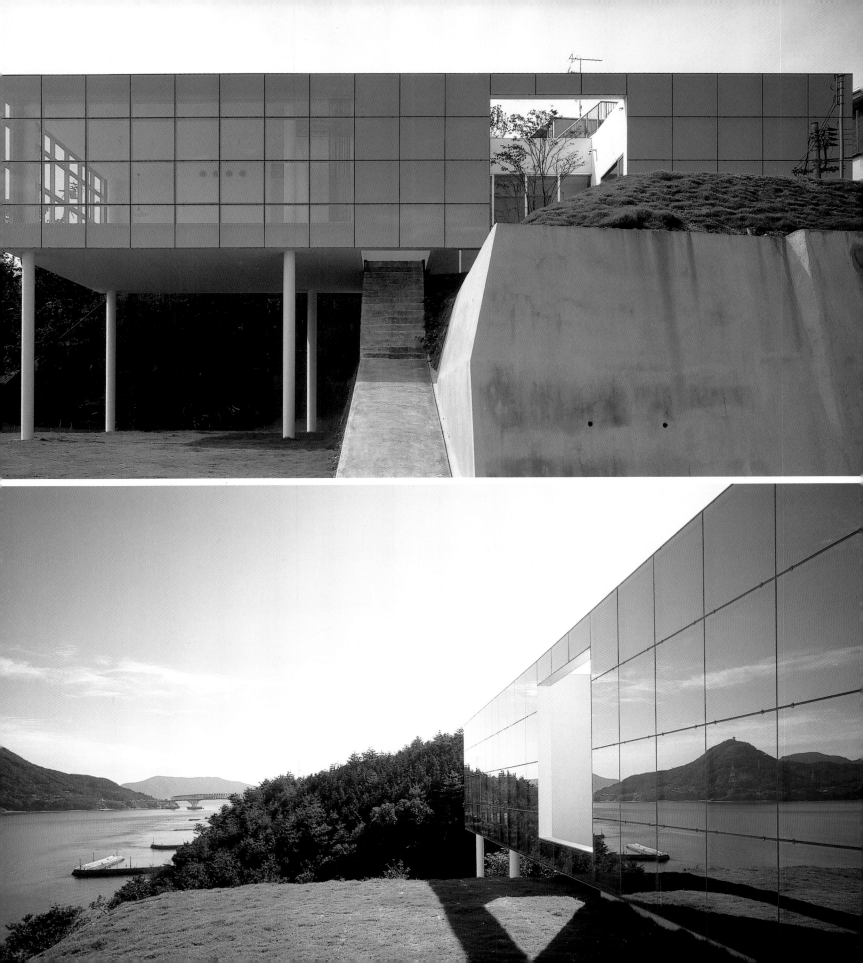

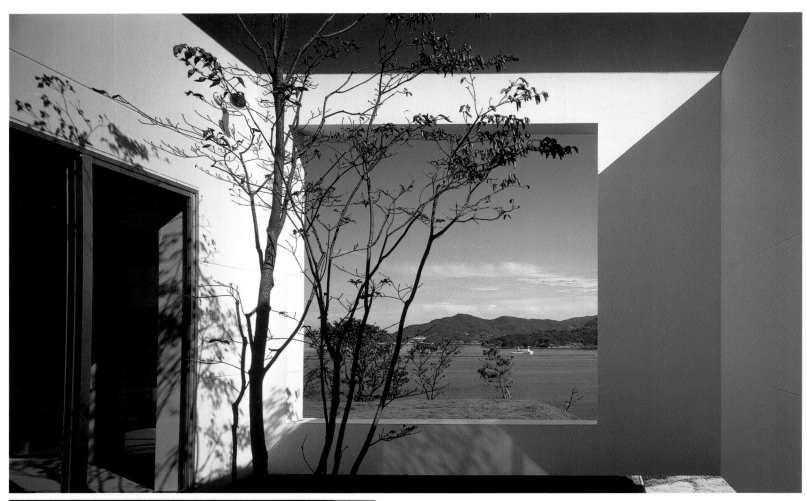

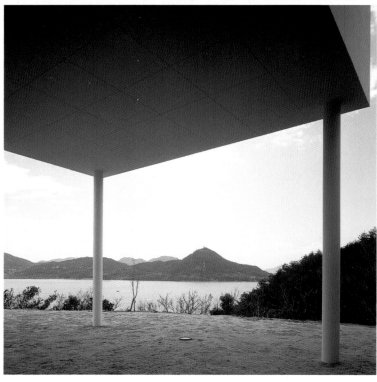

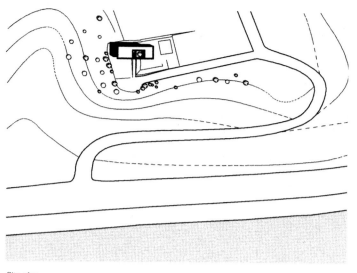

Site plan

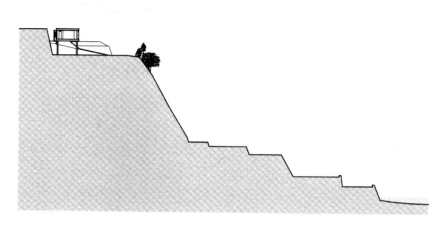

Section

1. Access 5. Kitchen
2. Terrace 6. Patio
3. Living room 7. Bedroom
4. Dining room

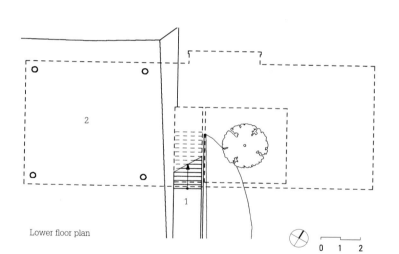

Lower floor plan

0 1 2

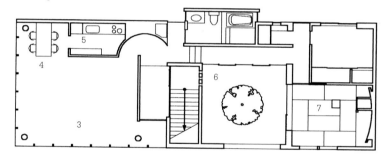

Upper floor plan

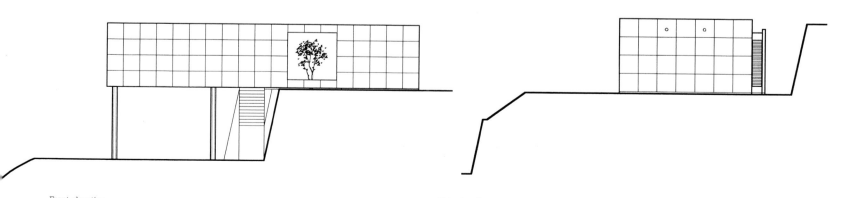

Front elevation

Side elevation

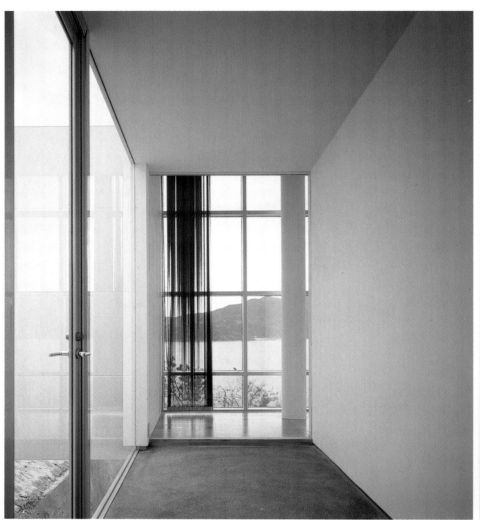

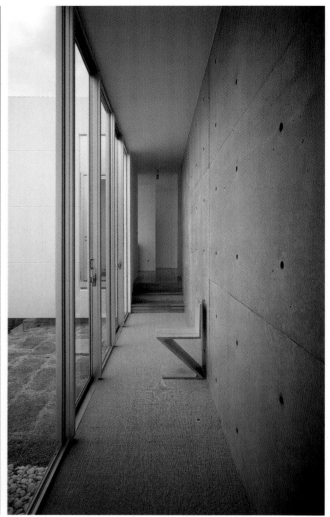

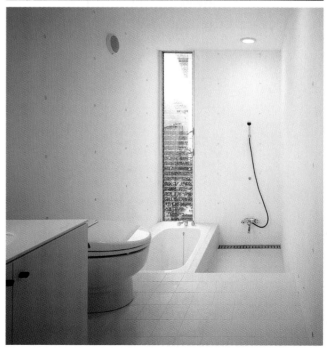

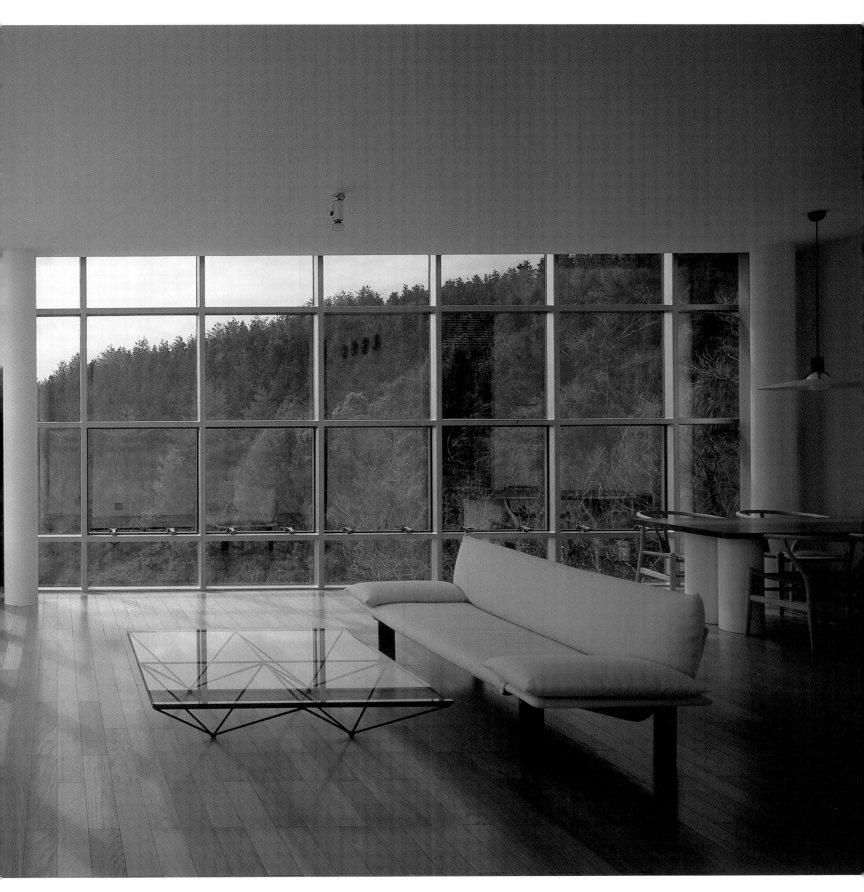

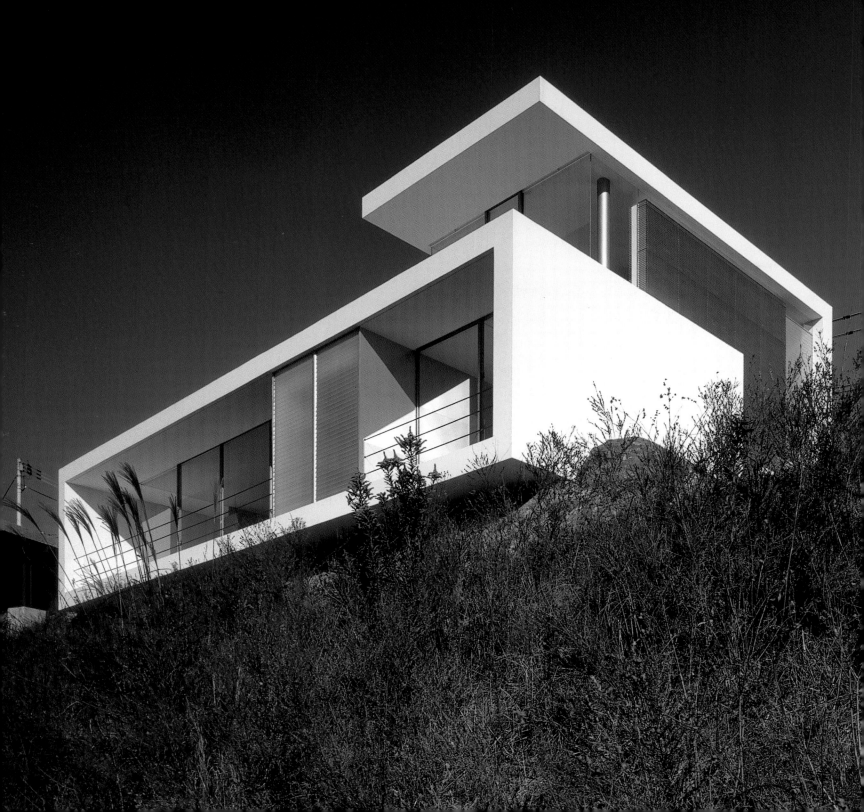

Architect: **Katsufumi Kubota / Kubota Architect Atelier**

Location: **Obatake, Yamaguchi, Japan** Area: **1,215 square feet** Date: **1997** Photography: **N. Nakagawa**

Y House

Page 70:
The wall facing the neighboring houses is closed for privacy, but it has great formal expressiveness.

Page 72:
The occupants of the neighboring houses cannot see into the high windows of the lower floor, which protect privacy and enrich the interior while allowing air to circulate.

This house is located in a suburb of Iwakuni, Japan, in a district that has developed rapidly and is now becoming a bedroom community. The location of the site is special, not only because of its natural slope or the views but also because of the freedom permitted by the regulations governing areas on the fringes of developments. Since the area in question constitutes one of the last pieces of land in the complex, it was not restricted like the others. Its end position offered the possibility of interesting views to the south, while the northern side faced the neighboring dwellings. The challenge was to take maximum advantage of this freedom and the physical conditions of the site while designing a bright building with clean, crisp lines.

The structure consists of two white boxes joined together, totally open to view, one horizontal and the other vertical. This creates a simple layout. The lower floor is used as an entrance and social area, while the upper floor accommodates the bedroom, an office, and the exit to a spacious terrace on the roof of the lower section. Sweeping overhangs, produced by recessing the glass wall, protect the interior from direct sunlight while opening up the view.

The synthesis achieved in the plan, which resolves not only the layout but also the conditions of the surrounding area, is also reflected in the materials and finishes used in construction. The exterior openings are marked by thin metal strips, latticework in the service area, and glass on the large surfaces. Inside, certain carefully thought out elements, such as the unfinished concrete wall and the wooden floor and furnishings, create a warm, welcoming atmosphere.

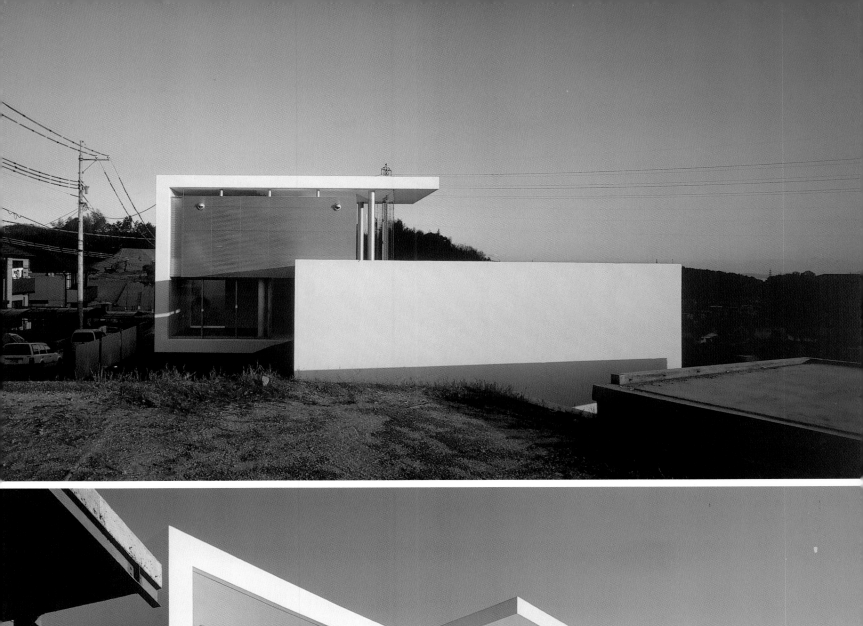
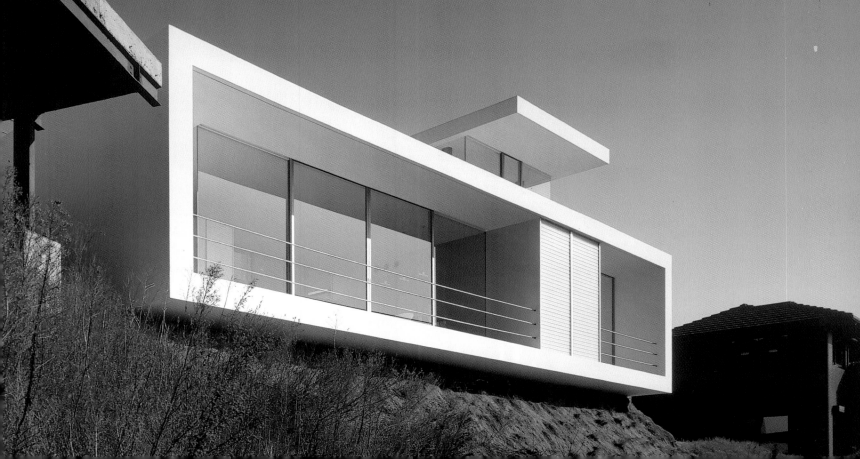

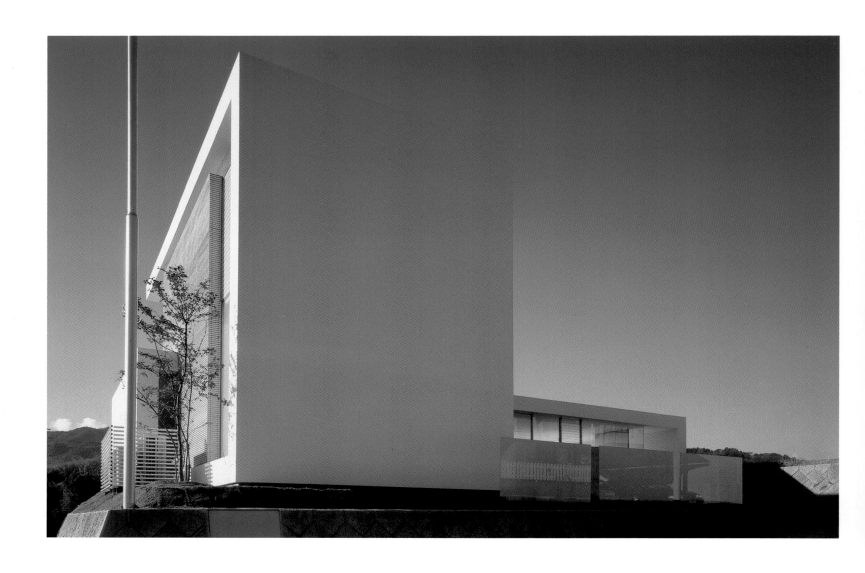

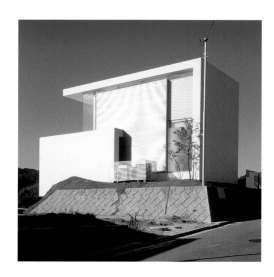

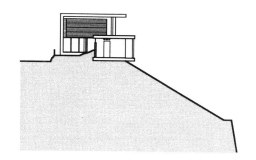

Site plan

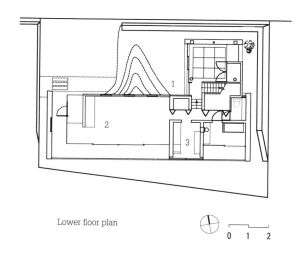

Lower floor plan

1. Access
2. Living room
3. Kitchen
4. Study
5. Bedroom

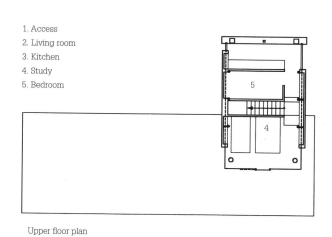

Upper floor plan

0 1 2

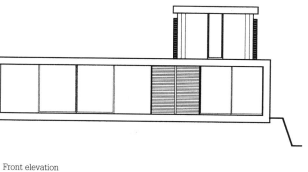

Front elevation

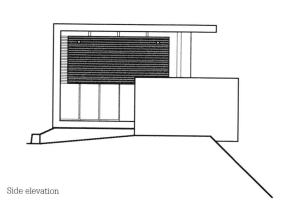

Side elevation

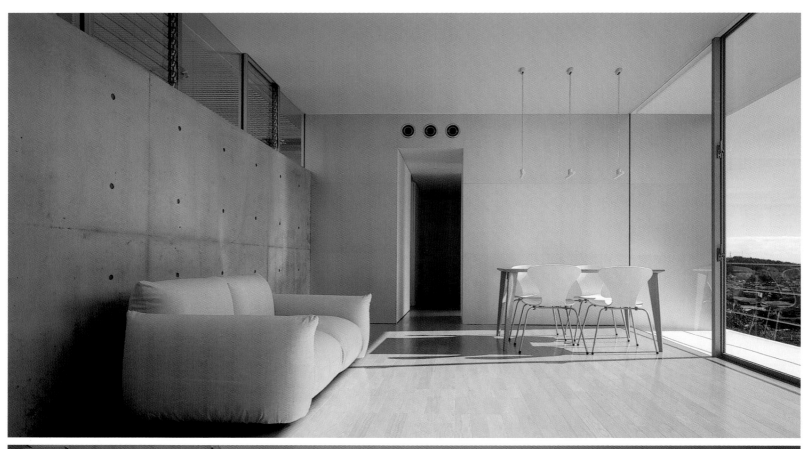

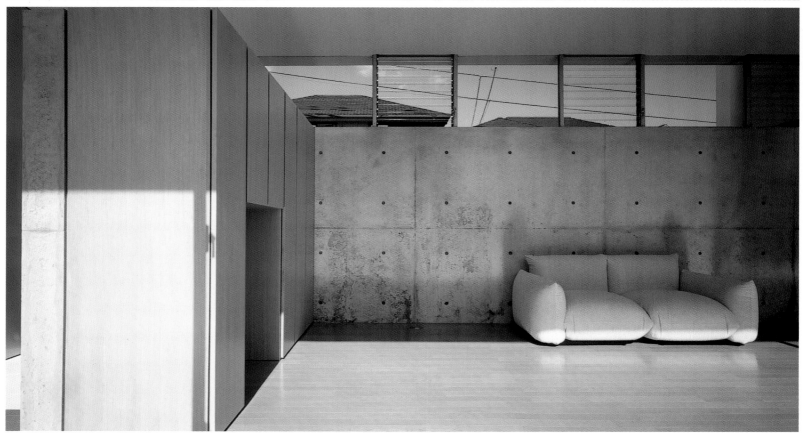

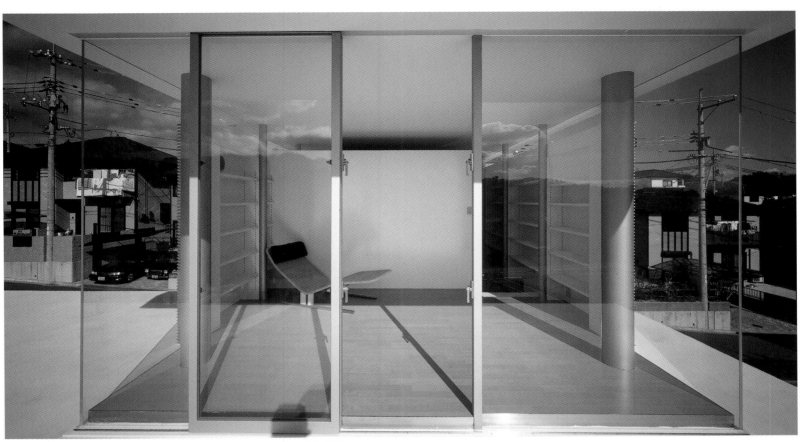

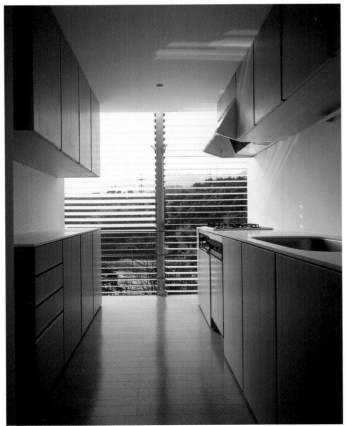

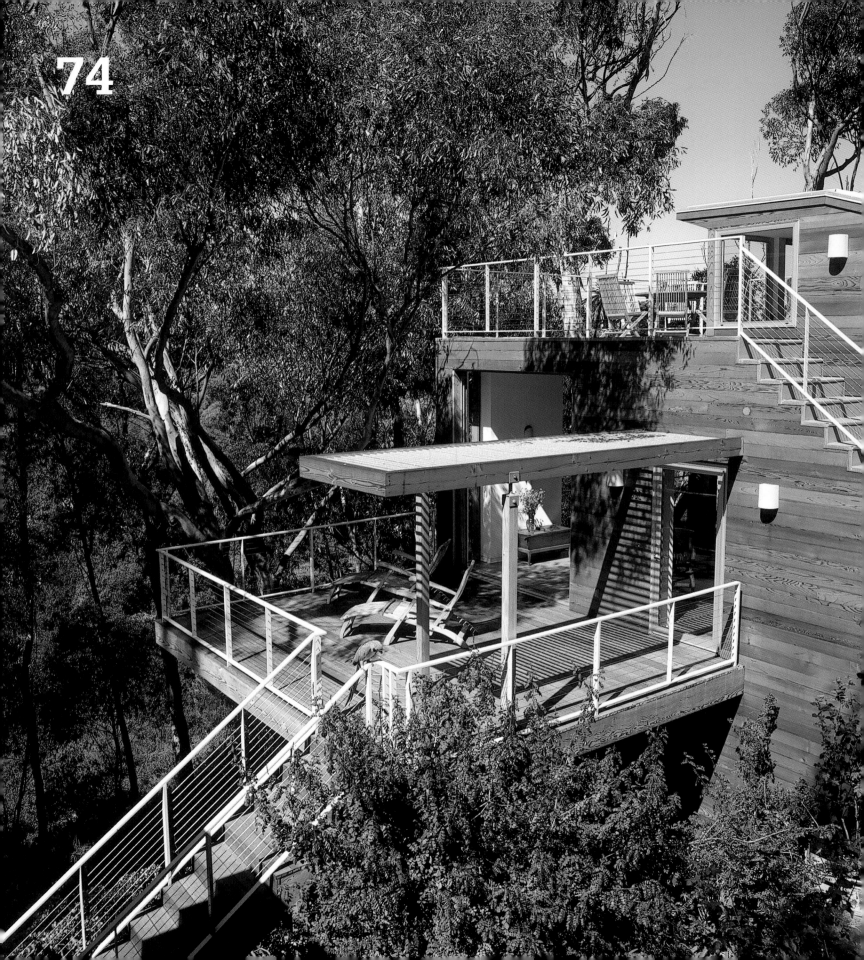

Architect: **Safdie Rabines Architects**

Location: **Mission Hills, California, United States** Area: **1,400 square feet** Date: **2000** Photography: **Undine Pröhl**

Lomac Residence

Page 78:
The framework of posts raises the
house enough to take advantage of
the panoramic view of the canyon
and minimizes the impact on the
vegetation that covers the site.

Page 80:
The use of wood in the interior is
striking. The floor, shelves, and
kitchen furnishings are made of a
wood typical of the region, which
has an interesting texture with
horizontal streaks.

This house, which is completely surrounded by a eucalyptus forest, rests on a light framework of posts that allows the occupants to enjoy the exuberant vegetation and the view of California's Mission Hills Canyon. The building materials, such as cedar, glass, and aluminum, make it seem unsubstantial, although it is a married couple's permanent residence. Access to the house is via a metal staircase that leads to an extensive mahogany porch. A long, narrow pergola, made of aluminum slats in a wooden frame, marks the main entrance. The challenge for the designers was to achieve a composition that appears bright and spacious despite its small size.

A very simple design minimizes corridors and residual spaces by placing vertical traffic on one side. The interior and exterior spaces are divided among four levels. This achieves interesting spatial relationships in the interior and creates a permanent connection with the exterior from every room in the home. Large, sliding-glass doors emphasize this idea by opening onto terraces that have outstanding views.

The arrangement of the spaces and the use of materials and finishes all contribute to the theme of making the best use of the house's natural setting. Outside, wood dominates the walls and terraces, while metal rails create an illusion of transparency. The interior is enriched by the play of windows and levels that provide opportunities to enjoy the landscape from multiple vantage points. Tall windows in the living room offer a view of the treetops, while the low openings in the kitchen integrate it with the garden in the rear.

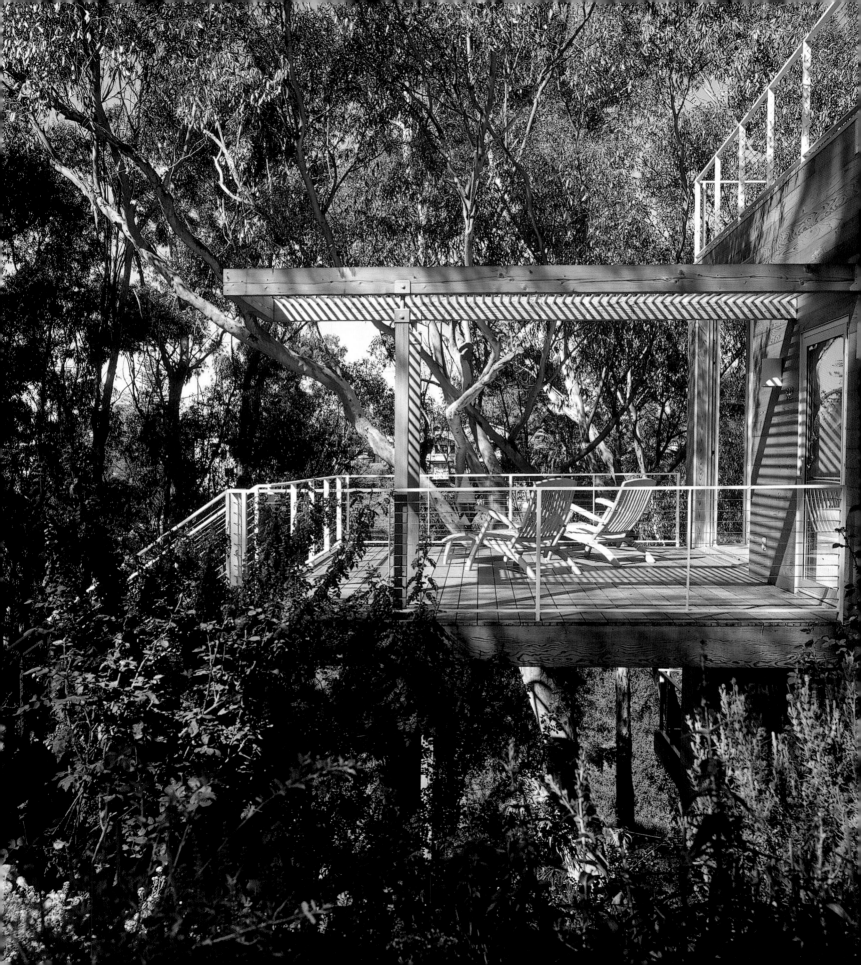

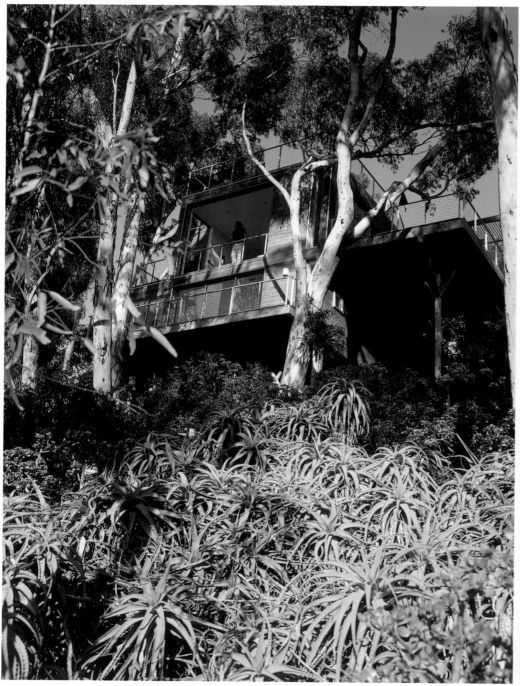
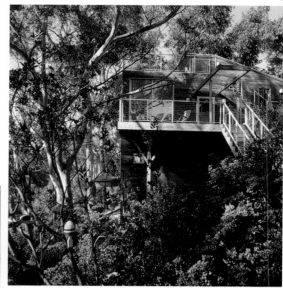
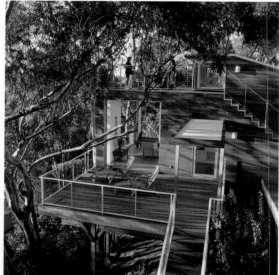
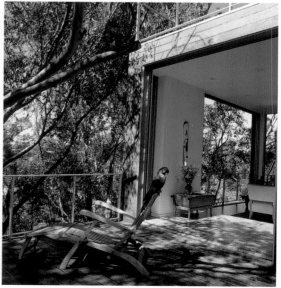

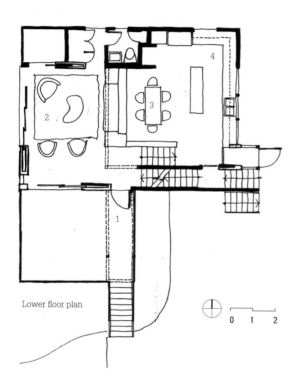

Lower floor plan

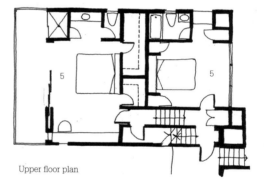

1. Access
2. Living room
3. Dining room
4. Kitchen
5. Bedroom

Upper floor plan

0 1 2

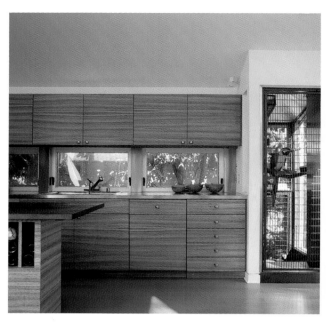
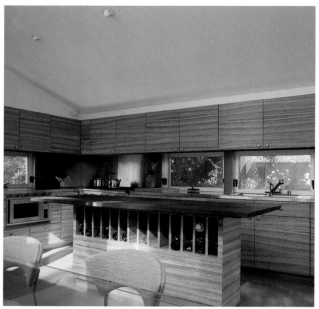

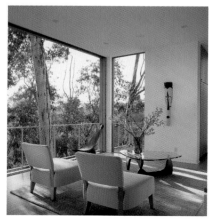
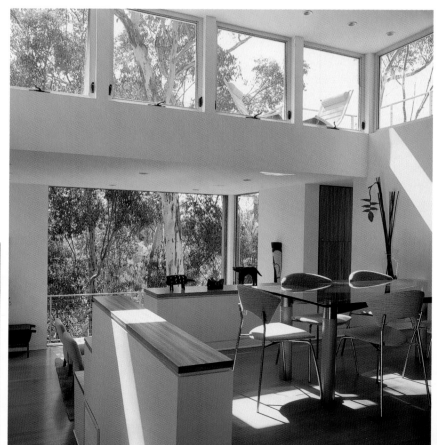

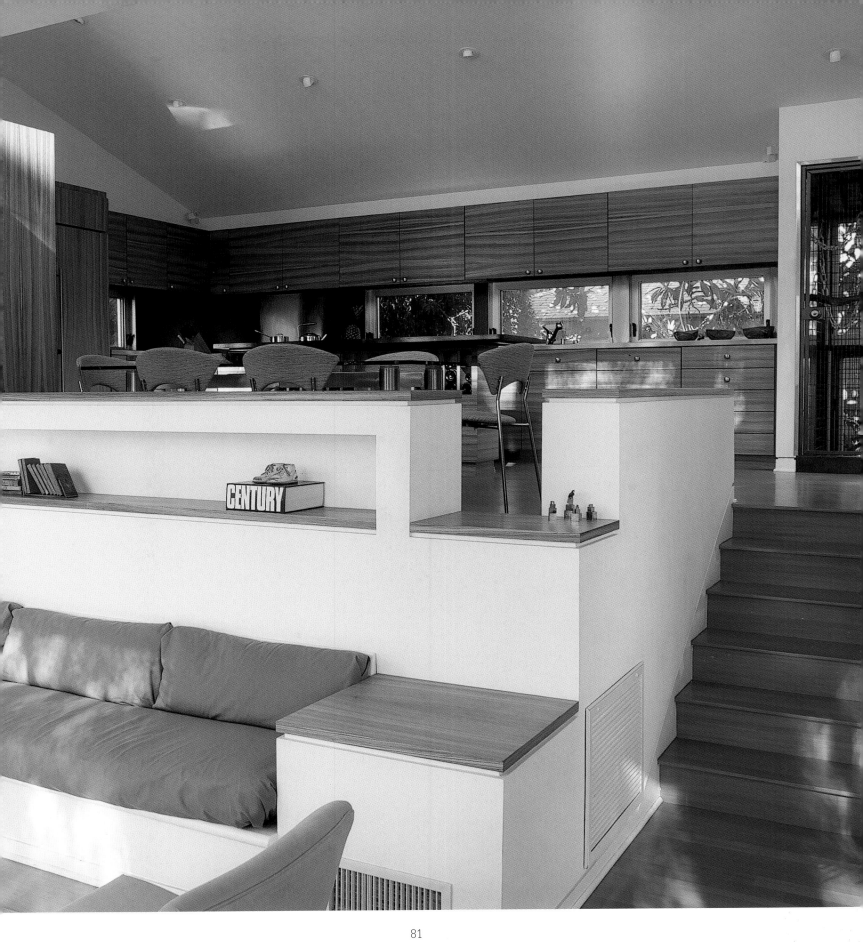

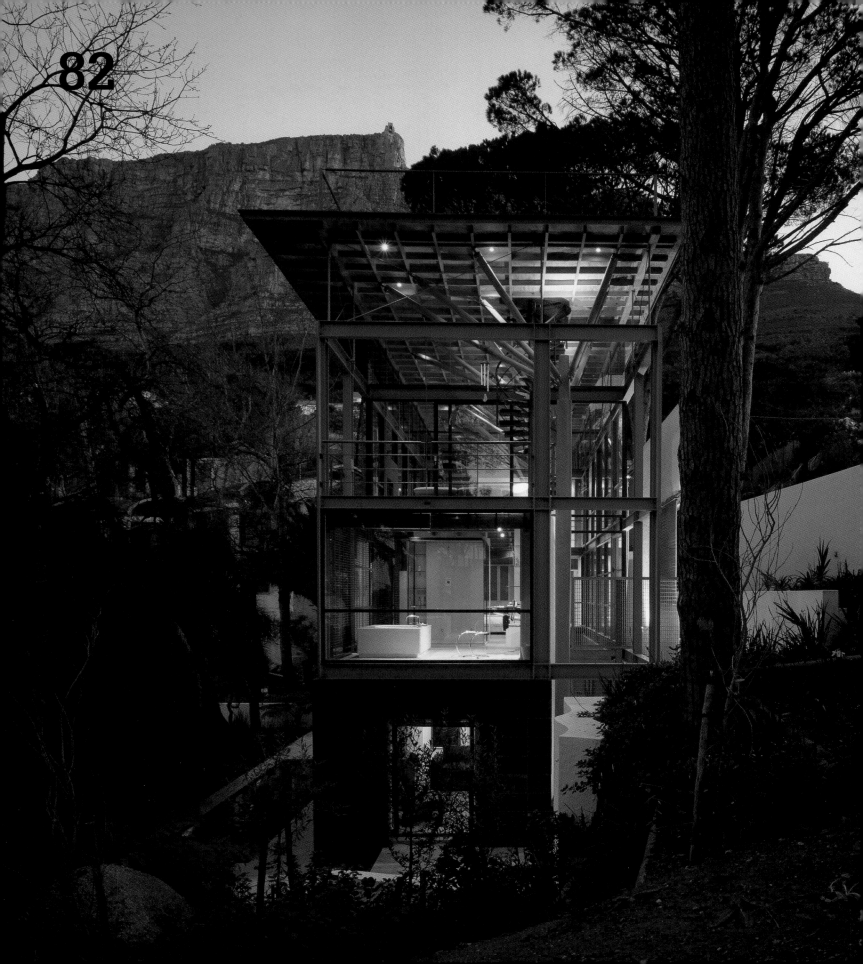

Architect: **Van der Merwe Miszewski Architects**

Location: **Cape Town, South Africa** Area: **2,475 square feet** Date: **1999** Photography: **Van der Merwe Miszewski Architects**

Tree House

Page 86:
These wooden posts branch out in an imitation of the way trees open up to support their leafy tops. The use of wood in the framework, as well as for many finishes, the floor, and the blinds, further integrates the structure with its surroundings.

In South Africa, trees can have social implications, not just as elements of nature but as refuges or everyday meeting places for children and adults. This was the source of inspiration and a point of departure in the design of this project. Building a home in the area of Table Mountain, a distinctive feature of this city's landscape, became a great challenge to the architects as they responded to a context of such natural richness.

Adjacent to a valley and a small stream, this site has a natural baldachin that is formed by the tops of the umbrella pines. These trees, majestic and statuesque, become the principal conceptual reference that translates into the shape and structure of the house. Five treelike supports brace the roof, under which all household activities are carried out. A continuous skin of steel and glass, resting on a solid, closed stone base, surrounds the structure, achieving total transparency. This eliminates the barriers between the natural surroundings and the interior, making the house seem like part of the woods around it.

A series of levels—perceived as bridges, spiral staircases, and double heights—offers varied perspectives, and the appearance of the interior is in constant flux, as the light entering through two openings in the roof changes throughout the day. The house's three levels accommodate different functions, according to their location. In the upper part, which includes the entrance, are the social area, the dining room, and the kitchen. The middle area contains the bedrooms, and the service areas are on the most closed-off, lowest level.

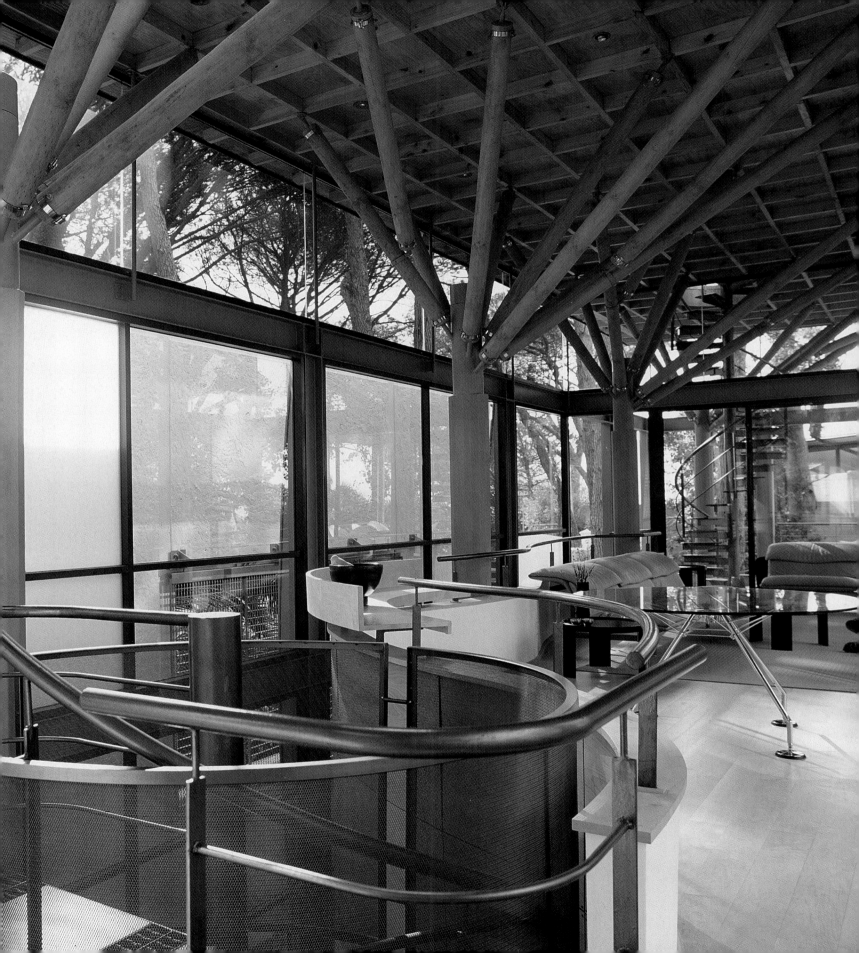

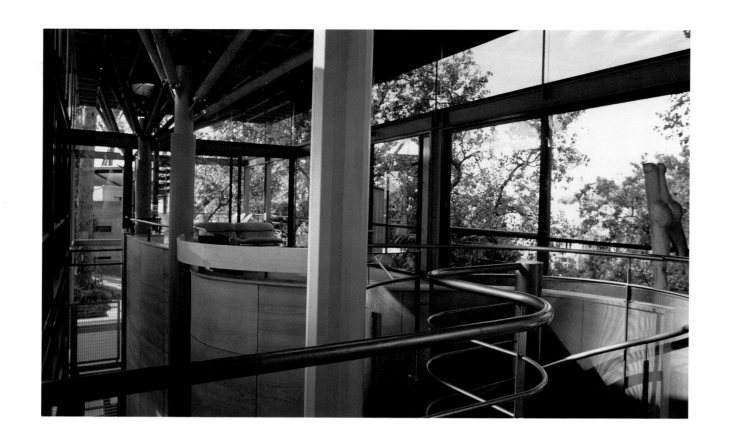

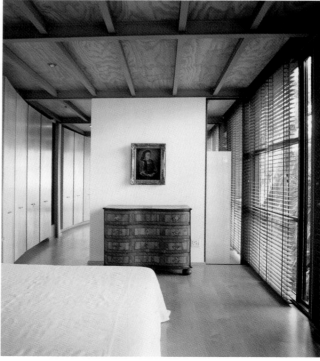

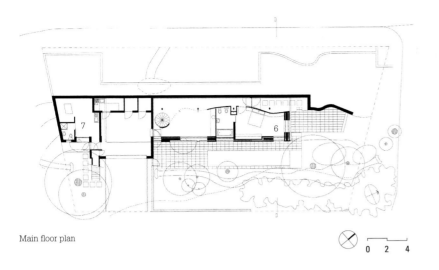

Main floor plan

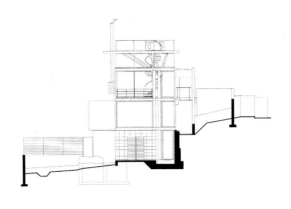

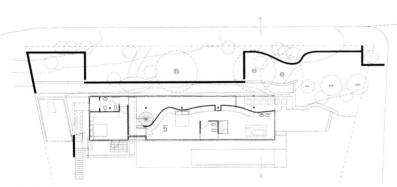

First floor plan

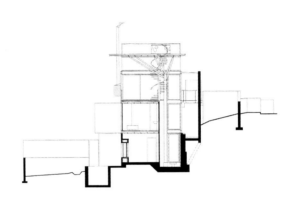

Transversal sections

Second floor plan

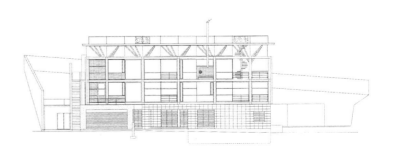

Side elevation

1. Access
2. Dining room / Living room
3. Kitchen
4. Terrace
5. Main bedroom
6. Bedroom
7. Machine

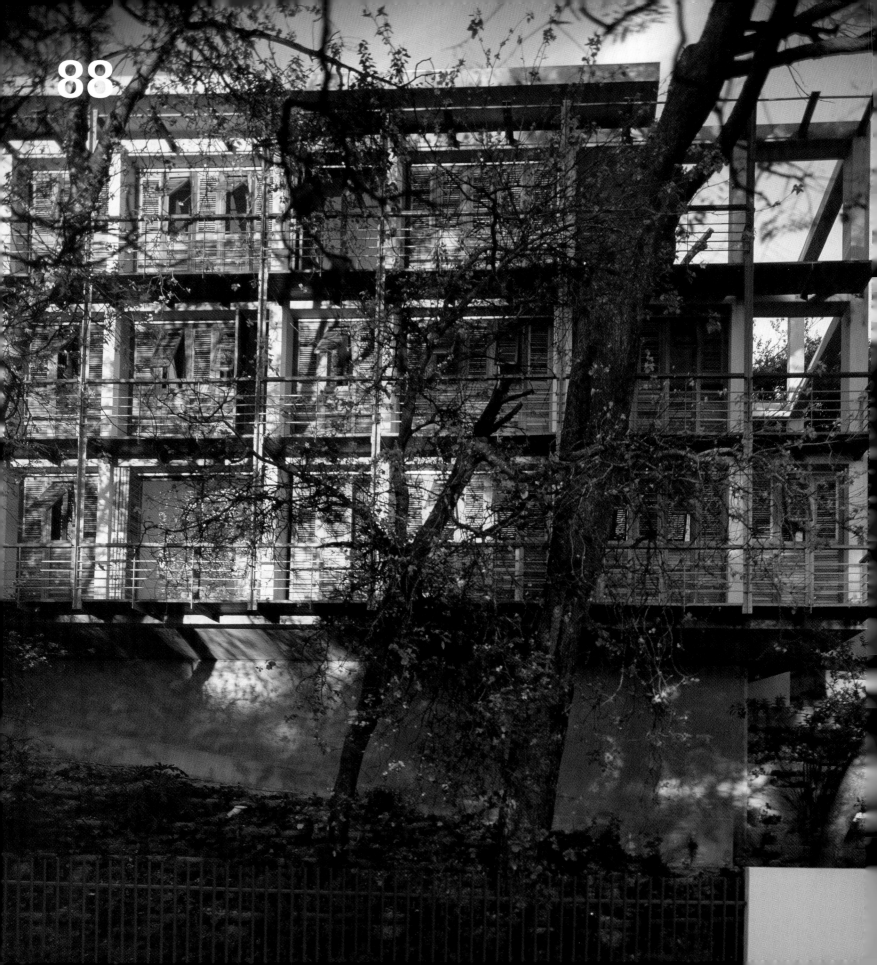

Architect: **Van der Merwe Miszewski Architects**

Location: **Cape Town, South Africa**　　　Area: **5,165 square feet**　　　Date: **2000**　　　Photography: **Van der Merwe Miszewski Architects**

Cliff House

Page 92:
The rectangular unit is broken up
and enriched with various elements
that succeed each other down the
length of the interior. The fireplace,
the stairs, and the double height of
the upper level introduce a variety of
spatial experiences.

This house sits on a 45-degree slope on a long and very narrow plot in Oranjezicht, a residential area of Cape Town, South Africa. The site is surrounded by housing complexes and a dense forest of pine trees, which are typical of the region, and enjoys spectacular panoramic views of the city and the sea in the distance. In addition to meeting a family's basic needs, the plan had to preserve the existing vegetation to ensure privacy and make the most of the scenery.

Due to the physical features of the site, the house is narrow and arranged on a structural orthogonal reticle that follows the contours, thus minimizing the amount of excavation required. The shape, the use of glass, and the repetitive modular structure were determined in response to the effect of the sun, wind, and views. The solid base on which this Cartesian, transparent composition rests is set back from the glass-enclosed section.

The entrance is at the middle level of the home, which contains the living room that is dominated by the central fireplace, the kitchen, and the dining room, extending to an outdoor terrace. A staircase adjacent to the entrance leads to the lower level, where the bedrooms are found, or the upper floor, with a study and balconies that boast magnificent panoramic views of the city and mountains. The exterior wall that faces the access road is solid, with few openings, and maintains a dialogue with the language of the nearby housing complexes. The rear facade is a succession of translucent layers formed by the metal framework, the wooden partitions, and the glass windows, generating a rich texture that opens up to the forest and the views.

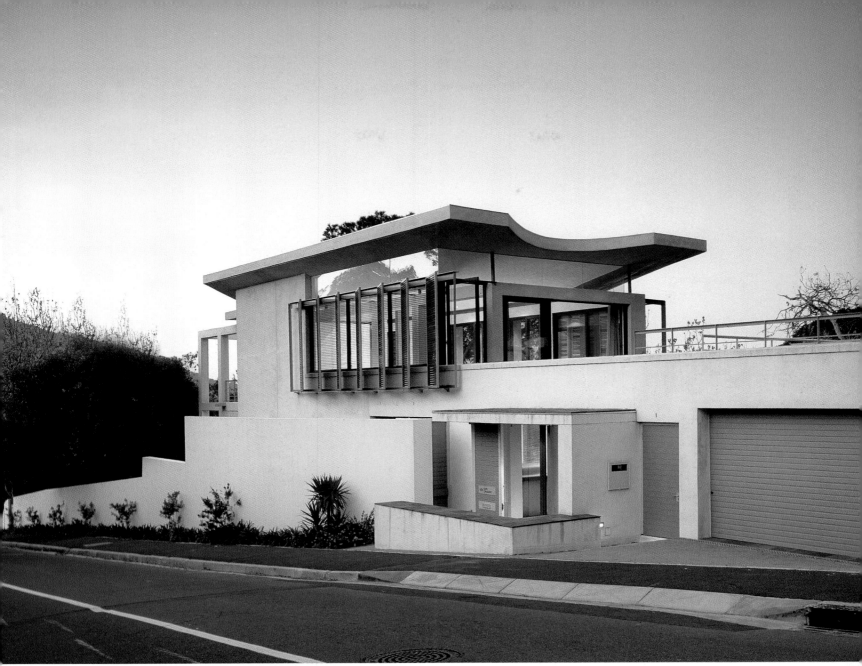

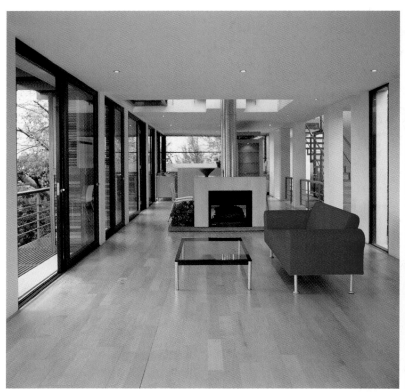

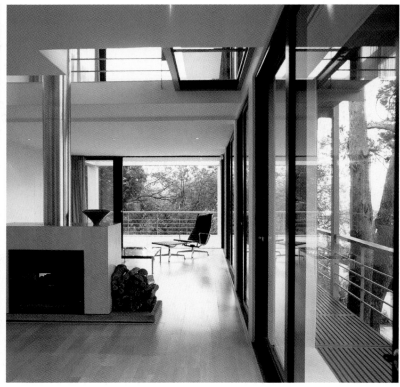

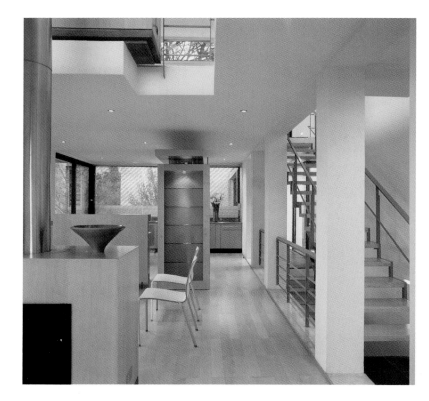

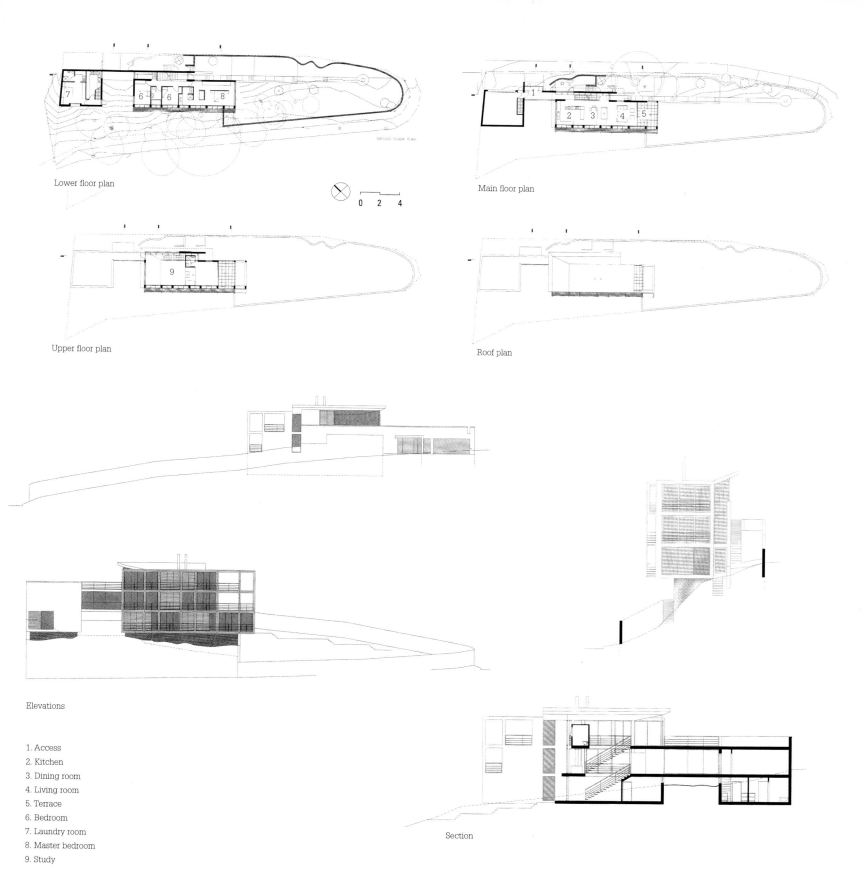

Lower floor plan

Main floor plan

0 2 4

Upper floor plan

Roof plan

Elevations

1. Access
2. Kitchen
3. Dining room
4. Living room
5. Terrace
6. Bedroom
7. Laundry room
8. Master bedroom
9. Study

Section

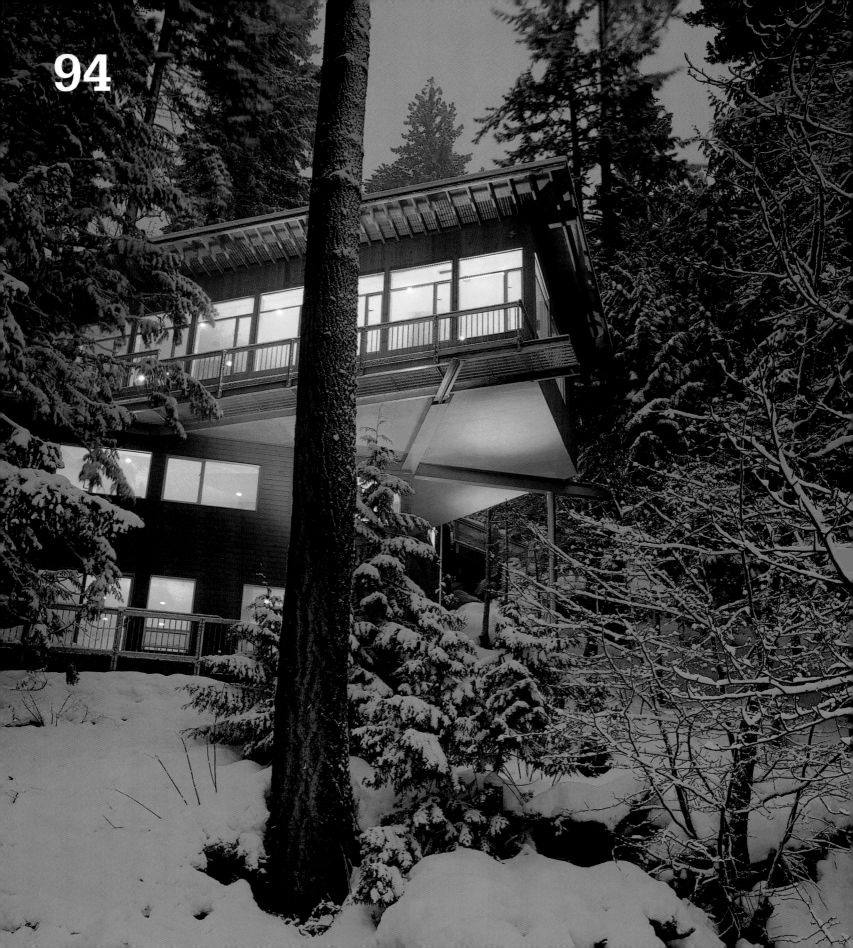

Architect: **Eric Cobb Architects** Collaborators: **Ian Butcher, Kirsten Mercer-Cobb, and Randal Larsen**
Location: **Cascade Mountains, Washington, United States** Area: **4,198 square feet** Date: **2000** Photography: **Steve Keating, Eric Cobb**

Cascades Lake House

Page 98:
The exterior balcony functions as a catwalk, emphasizing the projection of the upper unit, and also as a vantage point for gazing out onto the lake and enjoying the natural setting.

Page 100:
The juxtaposition of textures and materials, such as glass, slate, light wood, and stone, creates a playful setting with a warm, inviting interior.

This site was chosen for a vacation home because of its unique character, year-round livability, and proximity to Seattle, Washington. The terrain slopes steeply and continuously from the access road to the site of the house and down to the water. Most of the adjacent plots on this lake are crowded with tall firs and cedars. The trees were seen as a spatial asset and not as an obstruction to the view, and the house was situated on the cleared-out space from which the lake is visible.

The house consists of three parts: a box-shaped upper unit; a narrow, two-story section below it; and an inclined, cantilevered shelf that joins them. Entry and circulation are routed around, over, and among the different parts of the composition. The small box-shaped unit, which is linked to the main entrance by exterior stairs, is used as a garage. In the lower, two-story base, several bedrooms are placed one after the other to afford each an excellent view of the lake. Finally, the living areas are located in the upper unit and are marked by the inclined shelf and rotated vis-à-vis the other unit. In this open space, the kitchen separates the living and dining areas.

The design includes various strategies to ensure a high degree of flexibility in the interior. A rock-climbing wall was installed inside the two-story unit, vertically linking two bedrooms. Some custom-made furnishings double as extra beds for guests, and more are hidden in built-in cabins.

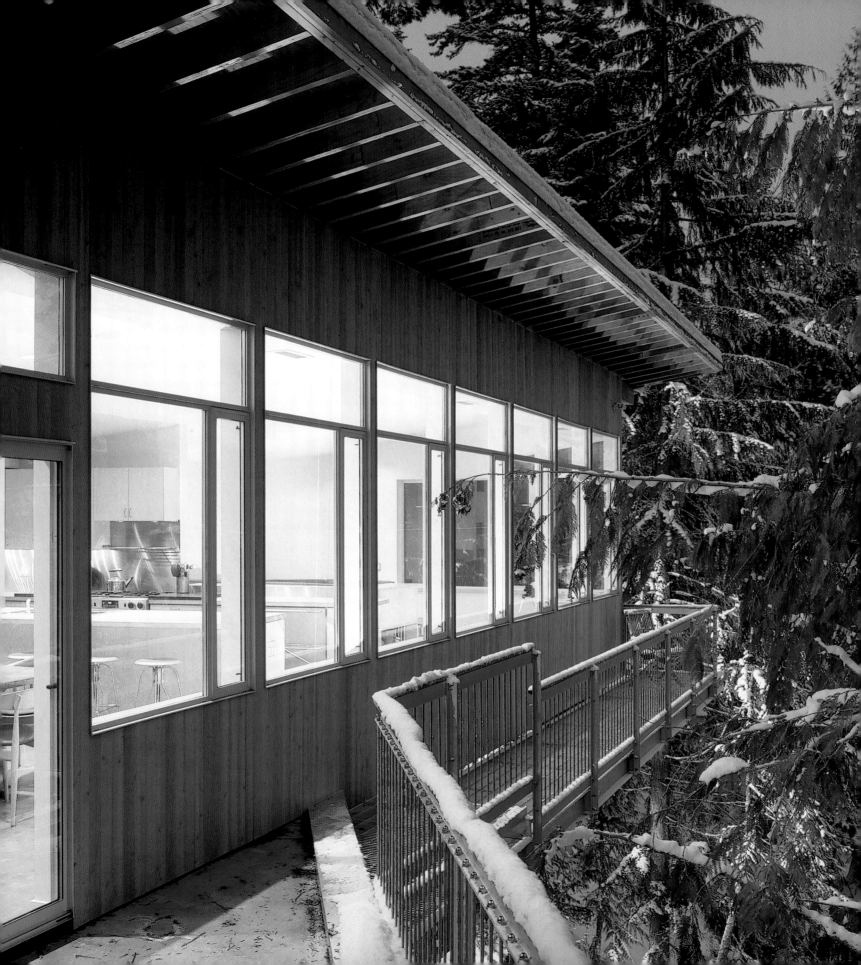

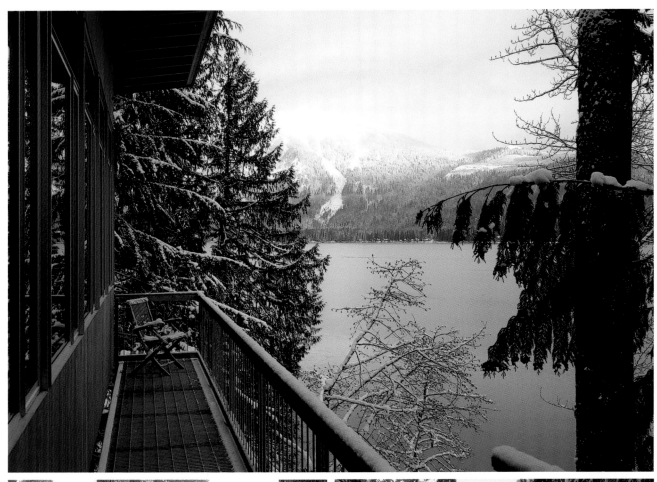

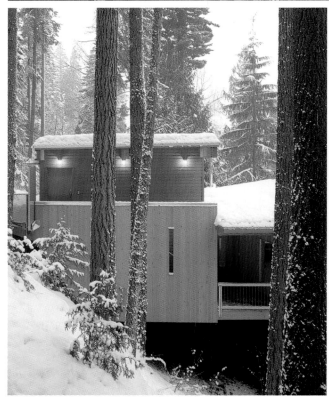

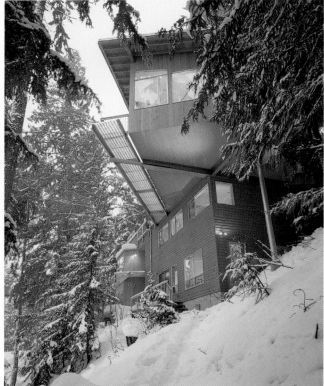

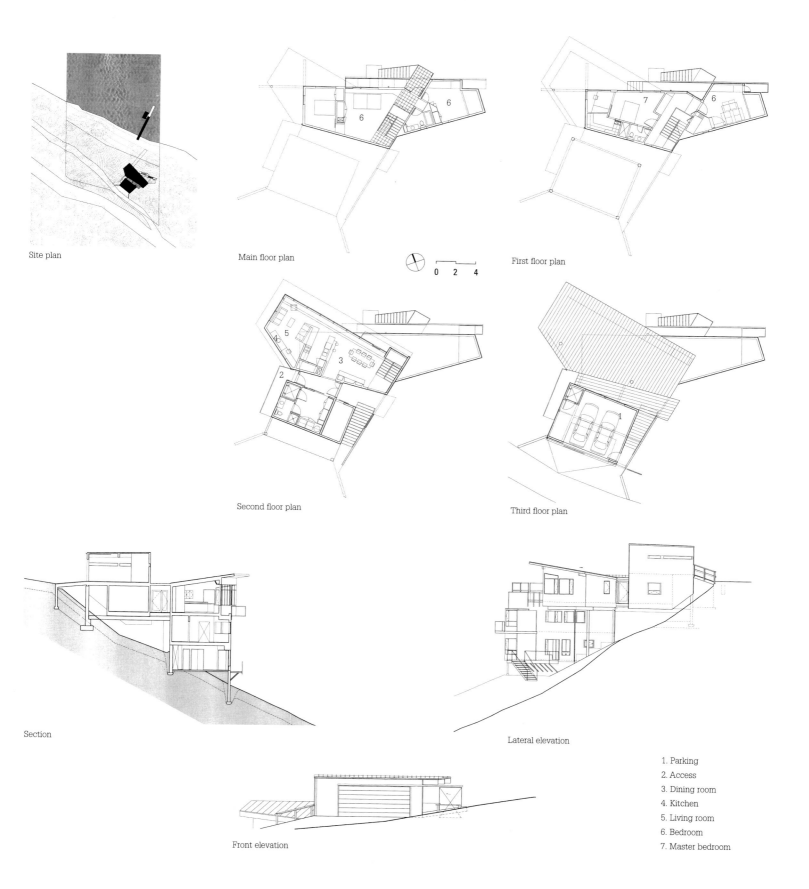

Site plan

Main floor plan

First floor plan

0 2 4

Second floor plan

Third floor plan

Section

Lateral elevation

Front elevation

1. Parking
2. Access
3. Dining room
4. Kitchen
5. Living room
6. Bedroom
7. Master bedroom

99

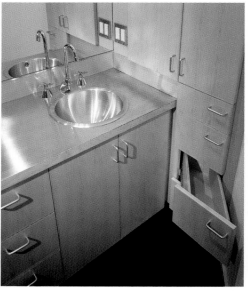
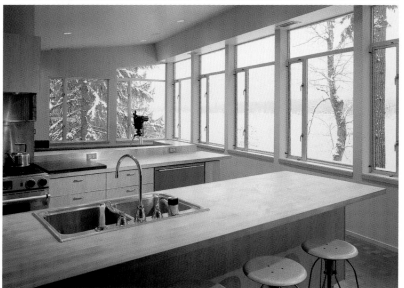

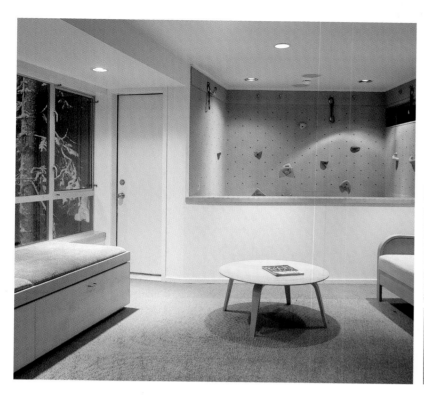

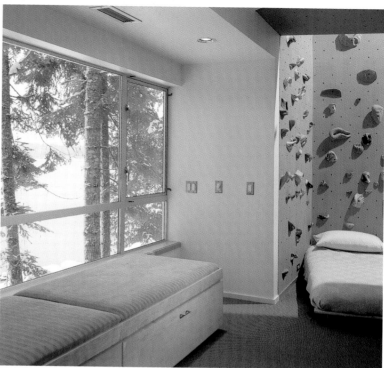

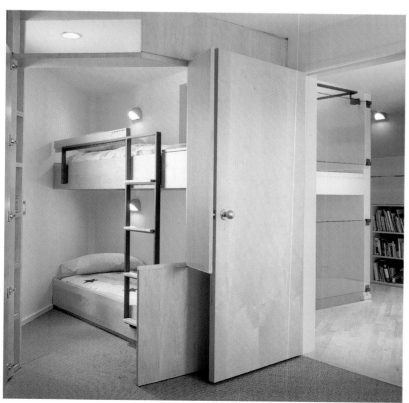

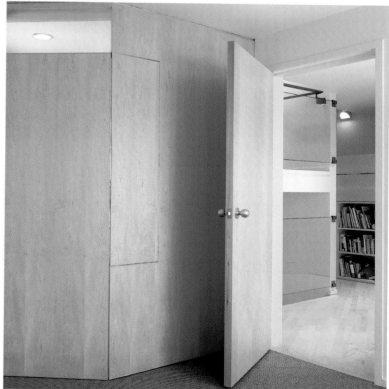

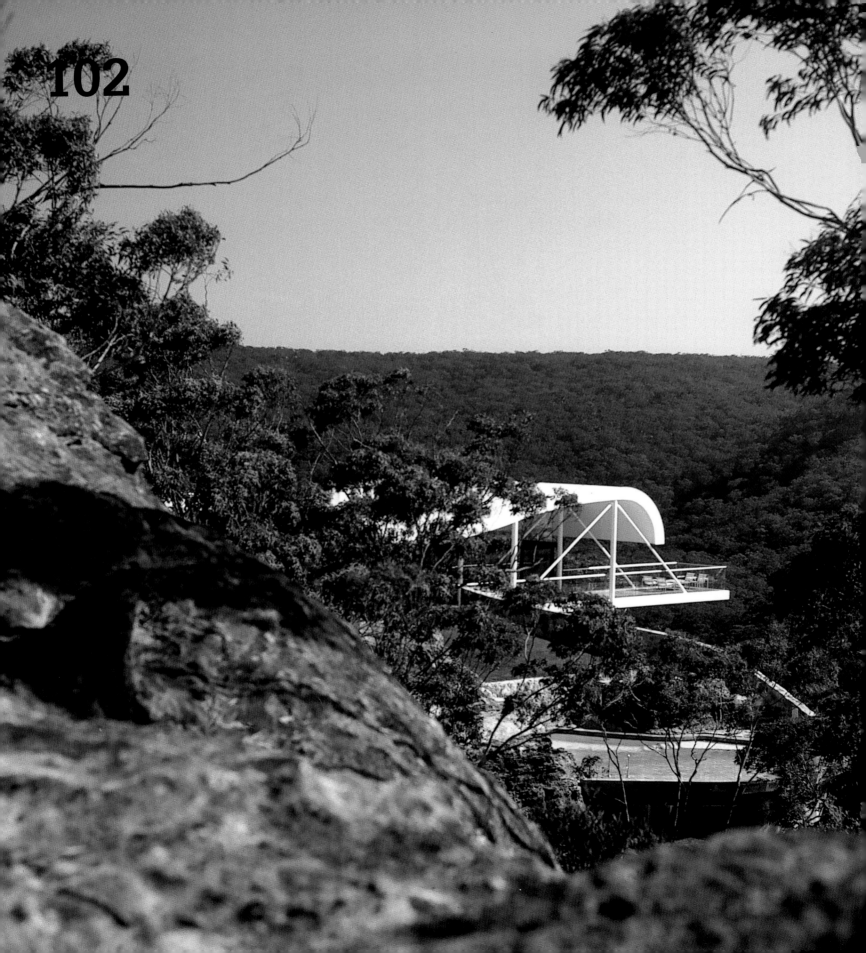

Architect: **Harry Seidler & Associates**

Location: **Joadja, Australia** Area: **3,875 square feet** Date: **1999** Photography: **Eric Sierins**

Berman House

Page 105:
The projecting terrace is an extension of the living room and a spectacular vantage point that looks out over the deep precipice below. The thinness of the structural elements emphasizes the way the parts are suspended.

Page 106:
Meticulous stonework creates a transition from the natural stone to the finished walls that divide the principal interior spaces. This use of materials creates a genuine link between the natural setting and the most private areas of the house.

This house sits atop a rocky, steep precipice and looks out over the canyon formed by a river far below. It is surrounded by a vast expanse of vegetation, huge trees, and rich fauna. The spectacular location and the fragility of the natural setting were determining factors in the construction of a building that appears solid, yet is light as it minimizes its impact on the surroundings.

A continuation of the rocky platform on which it sits, the house is arranged horizontally on two levels: The one below, at the edge of the precipice, is very transparent and contains the living areas, and the other, a little higher, is closed and private, and houses the bedrooms. The framework is concrete, and the roof covering the social area, bedrooms, and garage achieves an undulating effect through the use of curved metal beams of varying thicknesses. These curves were made possible by new technologies being applied in the metallurgical industry. The projecting terrace, visible from the ravine, is attached to the metal structure by diagonal arms, which further emphasize the weightless appearance of the composition.

Walls of natural stone, quarried on the site, contrast with the lightness of the rest of the structure. Essentially, a succession of platforms connects the garage, the access road, and the swimming pool on an axis perpendicular to the home and crossing through it at the center. In addition to the use of stone as a raw building material, the difficult access to the site suggested the construction of a tank to collect the rainwater that falls from the undulating roof.

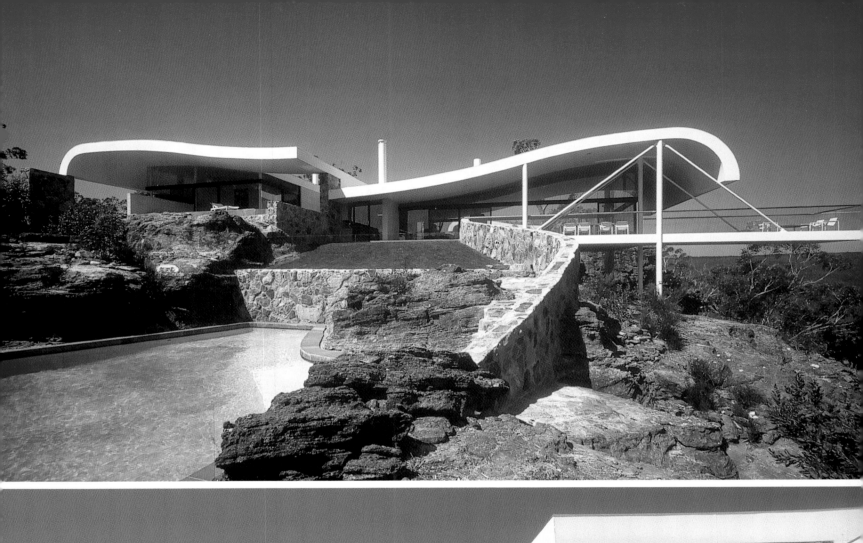

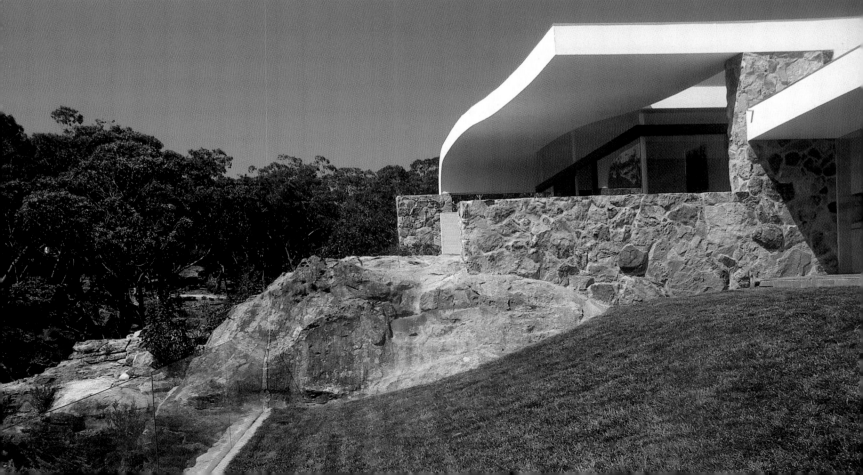

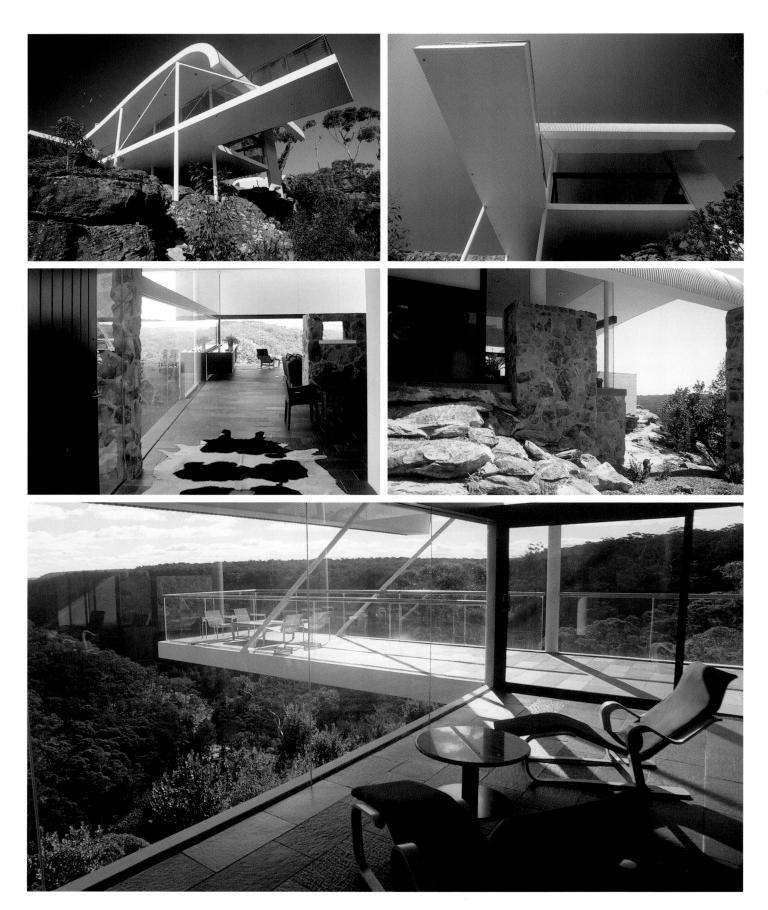

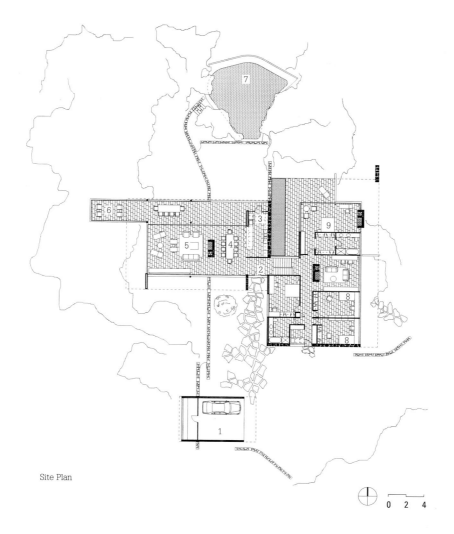

Site Plan

1. Parking
2. Access
3. Kitchen
4. Dining room
5. Living room
6. Balcony
7. Pool
8. Bedroom
9. Master bedroom

0 2 4

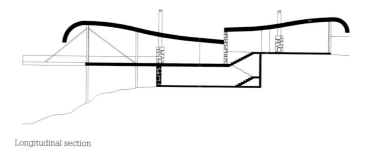

Longitudinal section

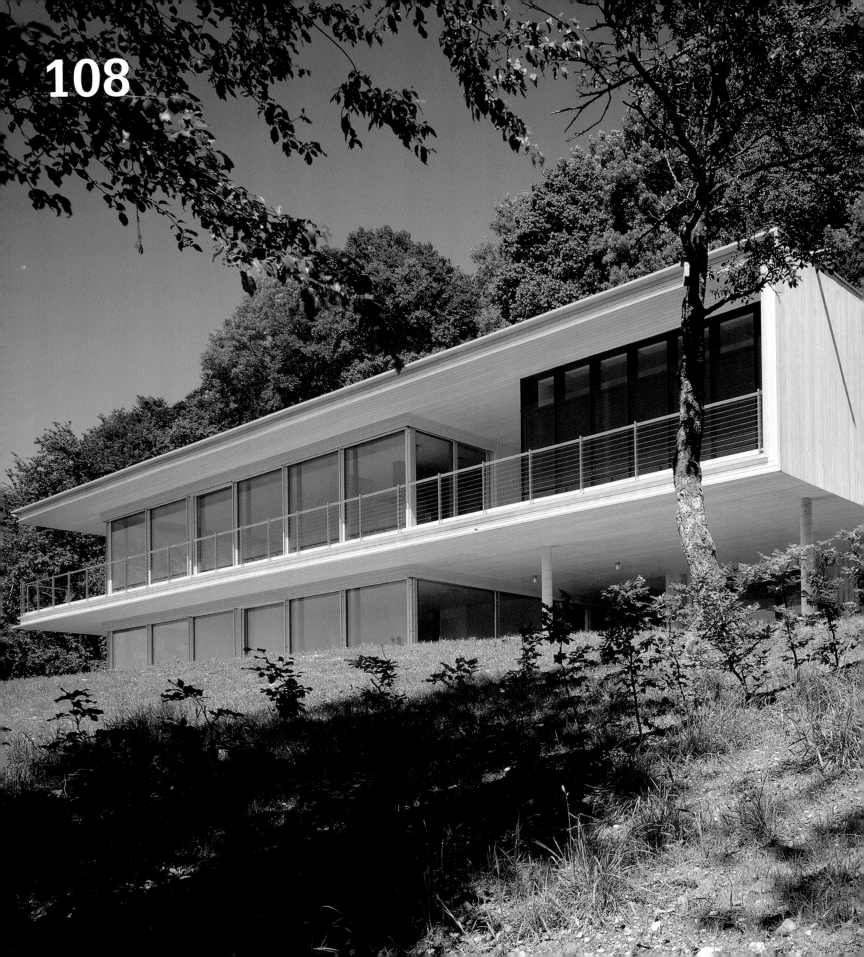

Architect: **Herman Kaufmann** Collaborator: **Martin Rümmele**

Location: **Langen, Vorarlberg, Austria** Area: **5,060 square feet** Date: **2001** Photography: **Ignacio Martínez**

House in Fuchs

Page 112:
The C-shaped upper box looks like a single-folded element that emphasizes the direction of the most important panoramic views.

Page 114:
The interior treatments and the use of wood to cover the floor continue the idea of bright, open, peaceful spaces. Sliding windows emphasize the flexibility of the spaces and their relationship with the exterior.

With its exceptional location and vegetation, this piece of land was once the site of a small country home in an advanced state of disrepair. The property was bought with the intention of demolishing the old building and erecting a new one that would make the most of the location. While the plan is fairly extensive and the built-on area is much larger than it was before, the project strove to have minimal impact on the environment and to find an architectural language that respected the setting.

The two-story structure has a rectangular unit that is closed on one side and is supported by a second lower unit, which is very light and transparent. This basic composition set out to achieve several purposes: a tranquil language, an emphasis on horizontality, and a low building. The part of the basement that faces the mountain is reinforced concrete, while the rest of the structure consists of prefabricated wooden modules that comprise the framework and roof. These elements have pronounced overhangs that emphasize the relationship between the interior of the house and the exterior space. This structure is also the support for all the walls and windows.

Local pine wood links the building to the traditional architecture of the region, while the large windows bring inside a splendid panoramic view of the Bregenz forest. The layout of transparent spaces covered by overhangs provides a variety of protected exterior areas. One of these spaces serves as the entrance on the upper floor of the house. Branching off from it is a hall that leads to all the rooms.

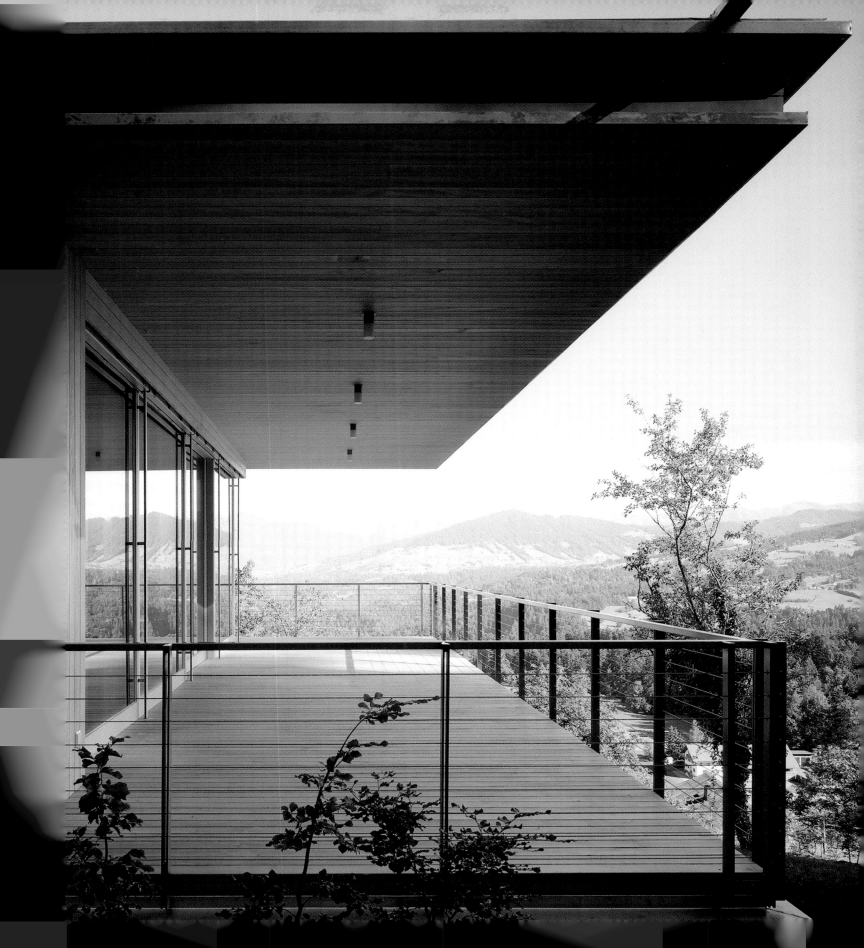

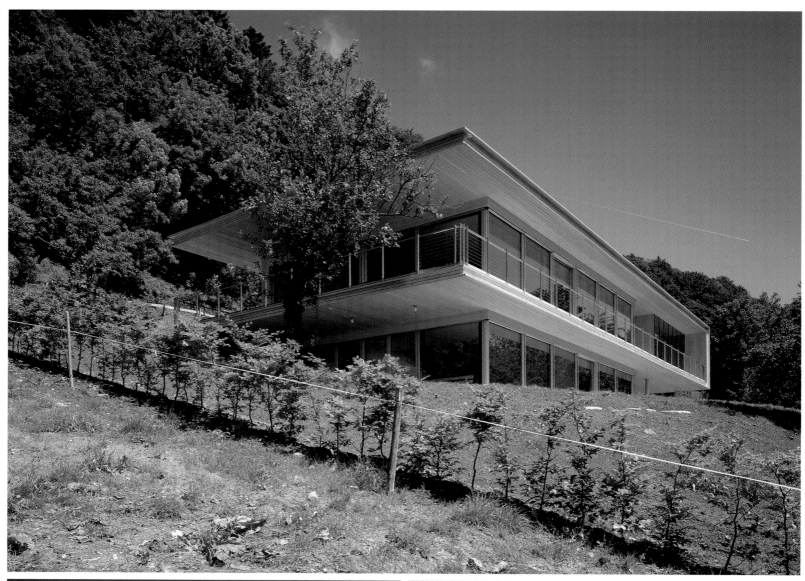

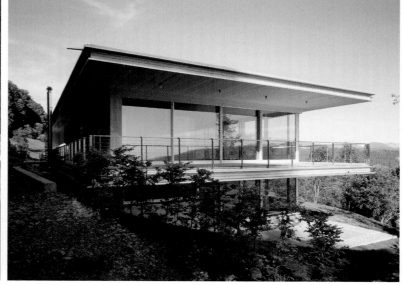

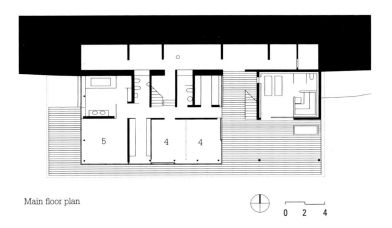

Main floor plan

Transversal section

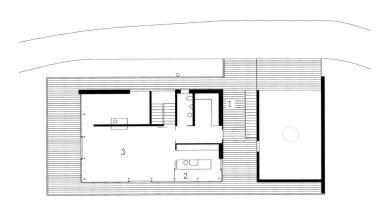

First floor plan

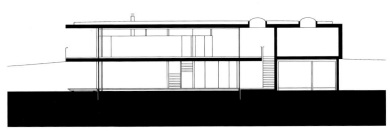

Longitudinal section

1. Access
2. Kitchen
3. Living room/Dining room
4. Bedroom
5. Master bedroom

113

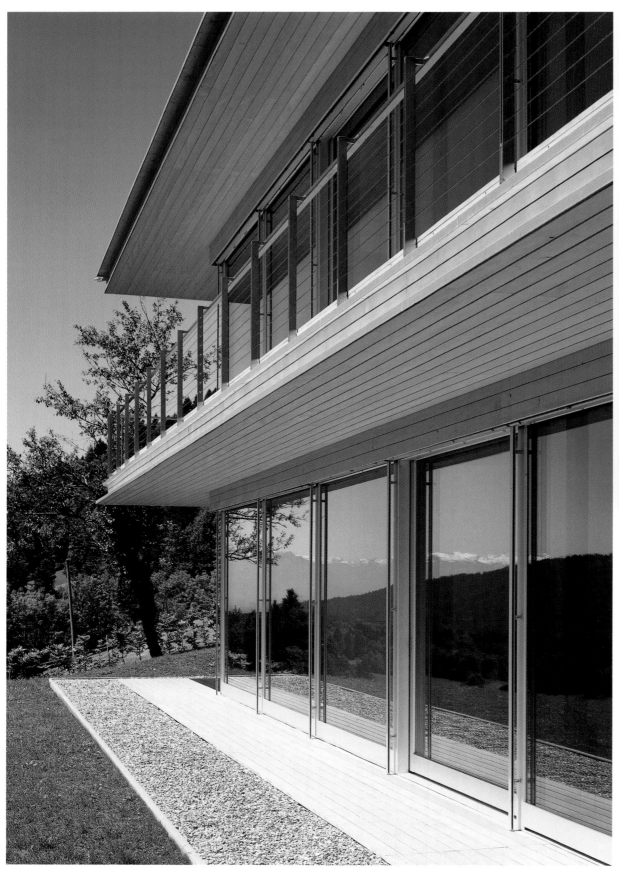

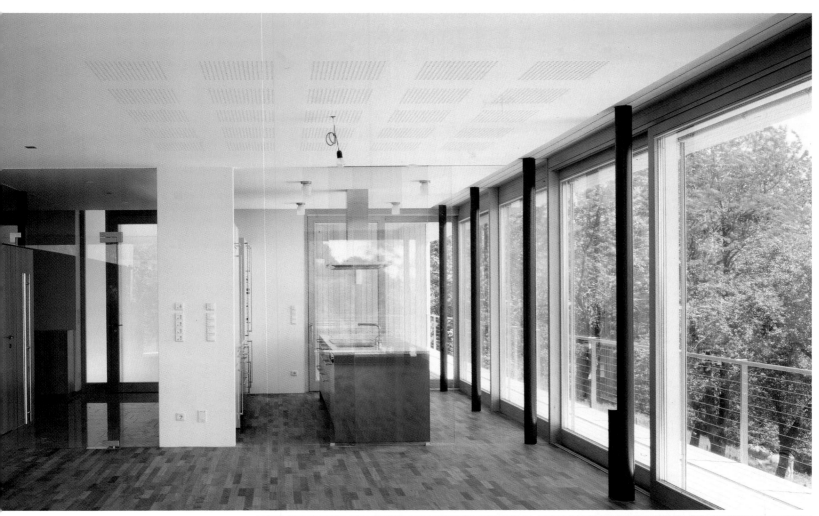

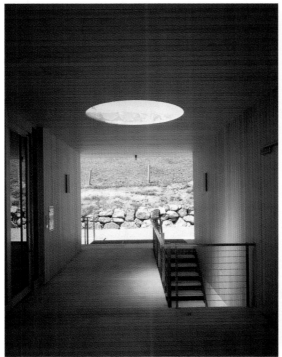

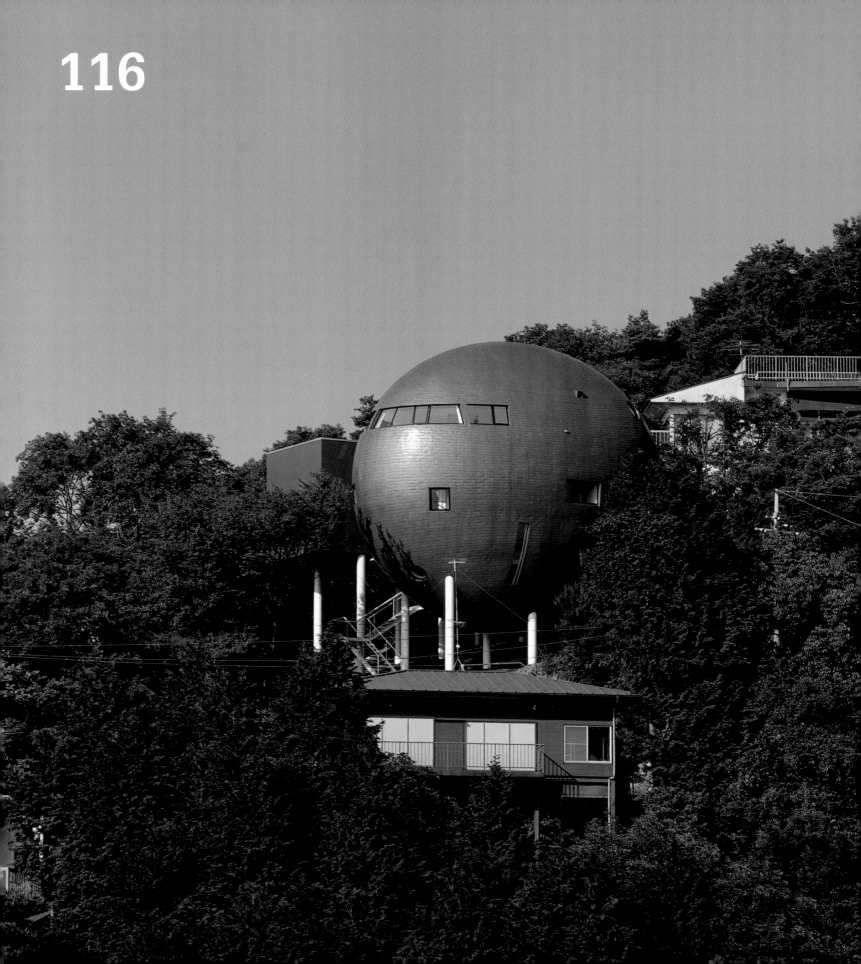

Architect: **Satoshi Okada Architects** Collaborator: **Lisa Tomiyama**

Location: **Atami, Shizuoka, Japan** Area: **1,634 square feet** Date: **1997** Photography: **Hiroyuki Hirai**

villa man-bow

Page 120:
The home is accessed via a metal staircase that rests lightly on the ground. The system of pillars has minimal impact on the vegetation and thus helps prevent erosion.

Page 122:
The joining of the laminated wood in the ellipse's frame was achieved by using cutting-edge computer systems and programs. The interior finish was also possible due to new materials, such as the flexible plasterboard veneer.

This unique building is located in the mountainous region of Atami, about 60 miles west of Tokyo. The site has a 70-degree slope and faces north, with a splendid view of the sea across the valley. In addition to the pronounced slope, the land is characterized by complex physical and climactic conditions that would make any construction project difficult: a position 30 feet above the access road, frequent strong wind, high humidity, corrosive salinity from the sea, dense clouds, and a high risk of earthquakes.

The clients, a family working in the movie industry, wanted a house that would also function as a guest cottage for holidays and weekends. They had clear ideas about how to make this place habitable: controlling the dampness as much as possible, taking advantage of the panoramic view above the trees, sheltering the structure from wind, and minimizing the work of gathering up leaves in the fall. This family would be compensated for the difficult conditions of the land by an extraordinary spatial experience that could not be achieved in Tokyo.

The first step was to create a building on pillars to protect it from the dampness and to capture the panoramic view above the trees. The house is comprised of two units: an ellipse, principally for the living areas, and a rectangular parallelepiped for the bedrooms. Both units are supported by six pillars, each 1 foot in diameter on a 12-foot reticule. To protect against the wind, the first unit, with its aerodynamic shape, faces the valley, while the second is hidden in the woods.

Copper sheets cover the exterior of the elliptical unit; over time, they will acquire the green patina characteristic of this material and blend in with the surroundings. The interior was plastered and painted white throughout, creating the effect of continuity that dramatically alters the perception of the space.

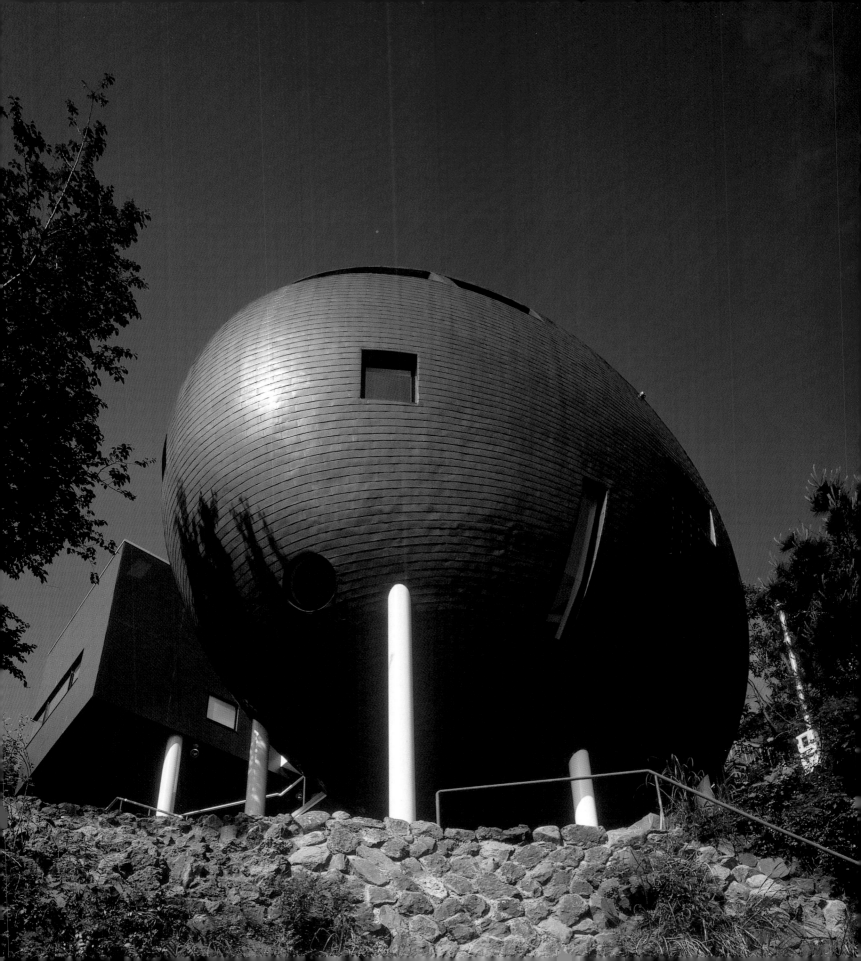

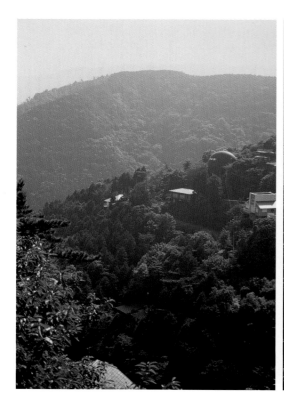

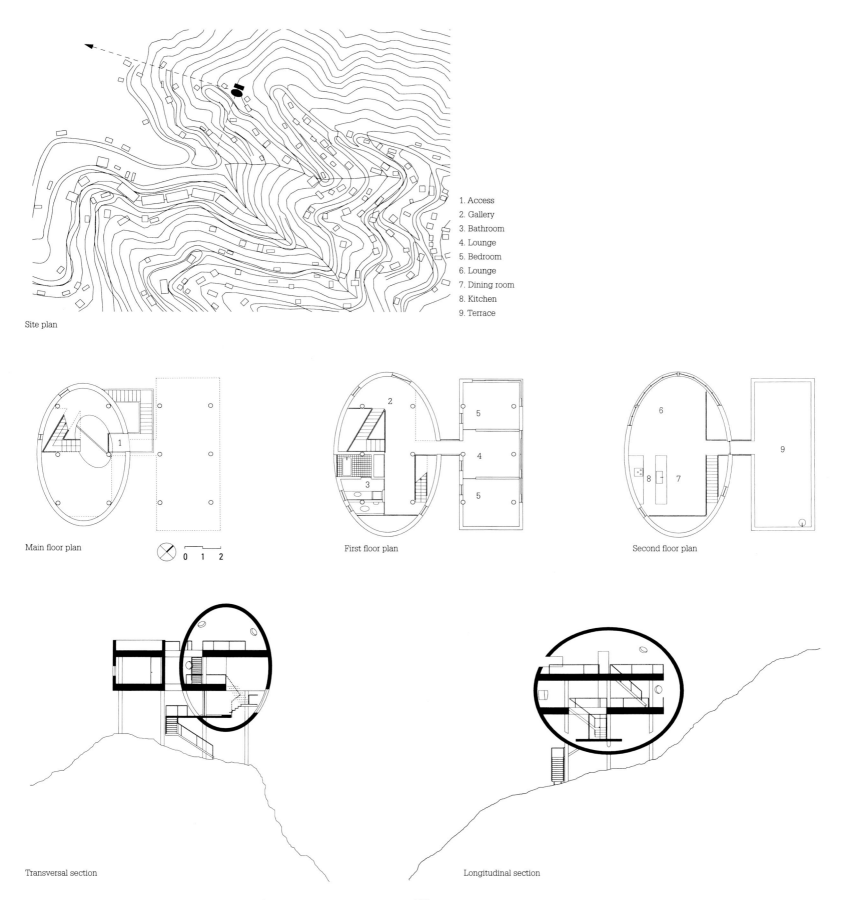

Site plan

1. Access
2. Gallery
3. Bathroom
4. Lounge
5. Bedroom
6. Lounge
7. Dining room
8. Kitchen
9. Terrace

Main floor plan

0 1 2

First floor plan

Second floor plan

Transversal section

Longitudinal section

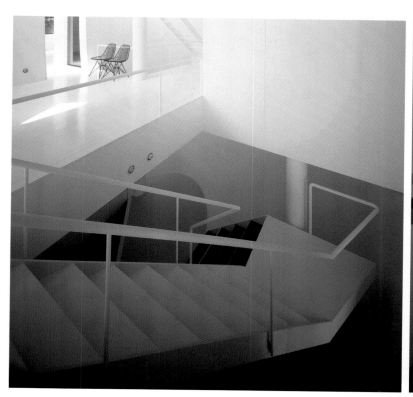
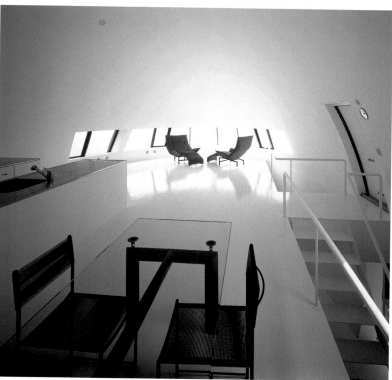
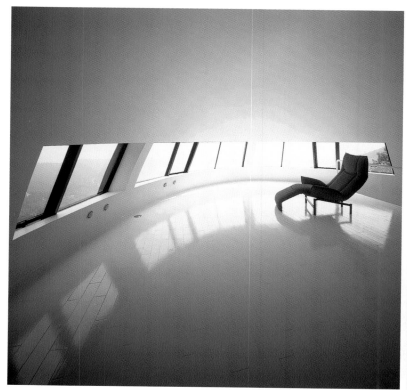

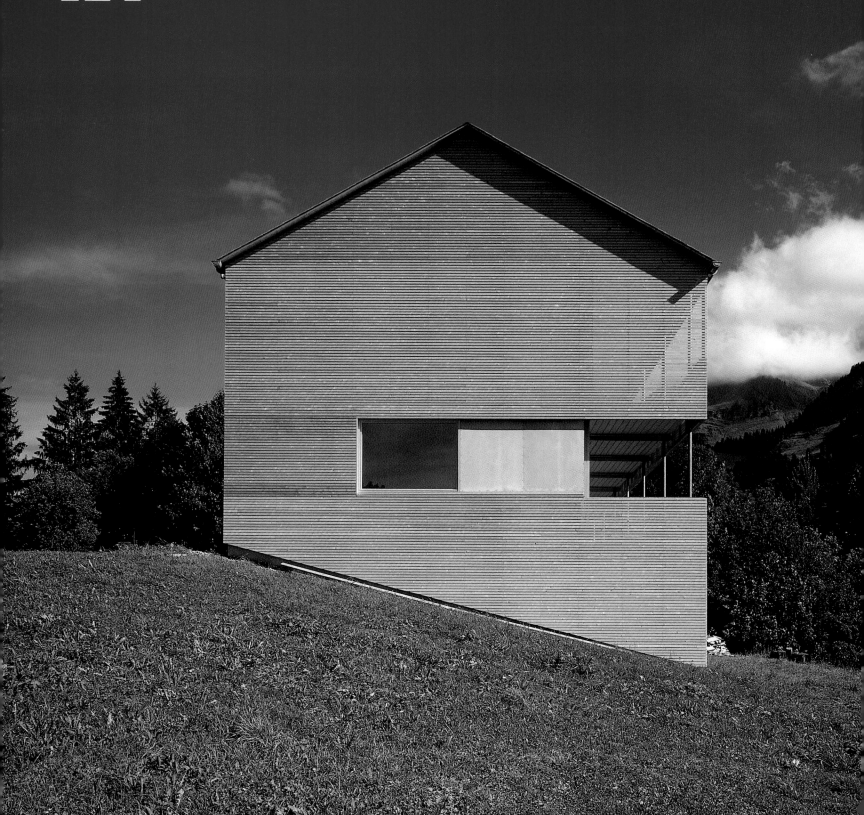

Architect: **Dietrich & Untertrifaller Architekten**

Location: **Egg, Vorarlberg, Austria** Area: **1,960 square feet** Date: **1998** Photography: **Ignacio Martínez**

Sutterlüty House

Page 128:
The huge windows face the southeast and lead to long, spacious terraces that are repeated on every floor. This creates a type of continuous gallery that can be reached from any room in the home.

In a small clearing in the mountains of Vorarlberg, Austria, this light, airy single-family home graces the landscape. The land slopes to the southeast, forming a vast meadow with no tall plant life in the vicinity. These two characteristics blessed the site with a sweeping view of the nearby valleys and guided the design of the structure. The house bears a close resemblance to traditional homes of the region but uses a contemporary language that makes the most of the climactic and geographic conditions.

The building consists of a rectangular unit with three stories and a gabled roof. It sits parallel to the slope of the mountain and the access road. Thus, the natural meadow becomes the house's garden, shielded from view by the home itself. Its length and east-west alignment maximize the scenic views and exposure to the sun in the south. The absence of enclosures, such as garden fences, which are unnecessary this far from an urban setting, enhances the rural feel of the home.

On the northeastern side, the entrance and the storage area provide an insulating buffer zone for the rest of the house. On the southeast side, the house opens up dramatically with large windows, while the rest of the building is covered with a thin skin of wooden slats. This screen creates an effect that distorts distances while protecting the house from the sun's direct rays on the east and west sides and ensuring privacy in the entry area. The lower floor, which leads directly to the exterior, is an open, multipurpose space. The kitchen and dining room are on the middle floor, and the upper floor is reserved for the bedrooms.

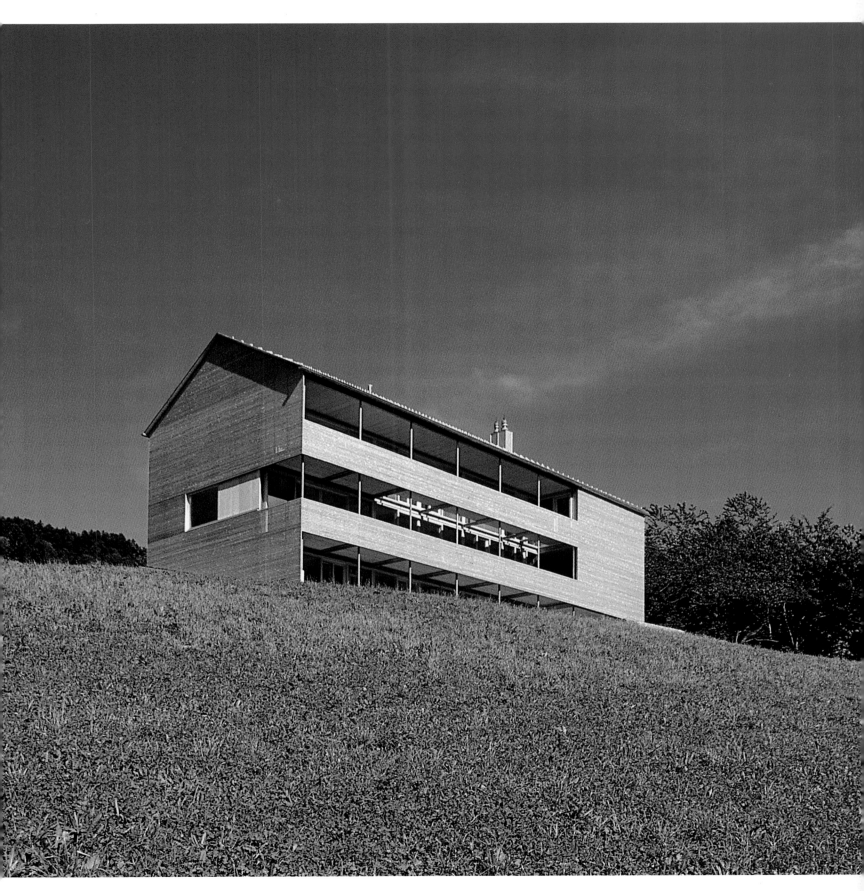

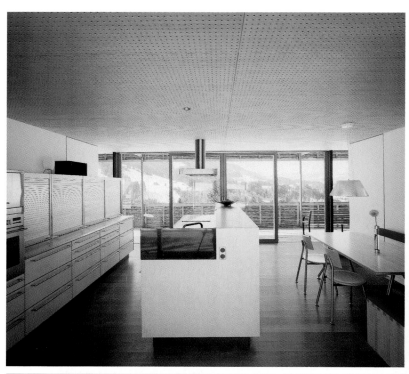

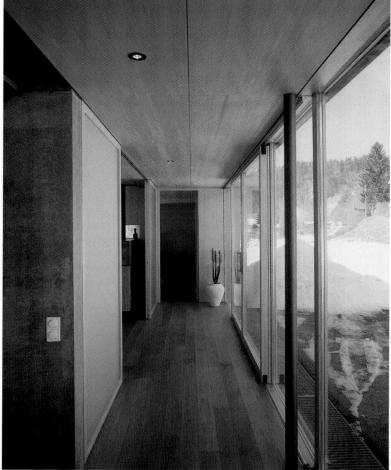

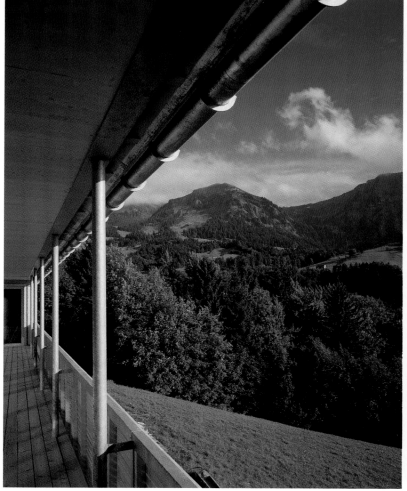

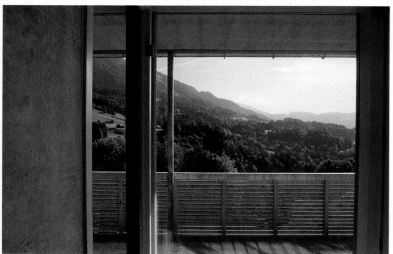

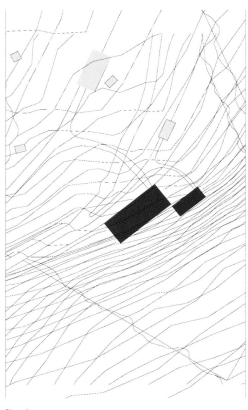

Site plan

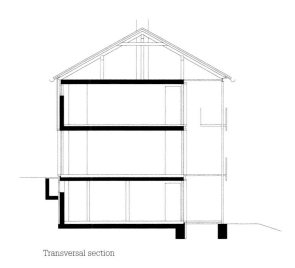

Transversal section

1. Access
2. Kitchen
3. Dining room
4. Bedroom
5. Living room
6. Storage
7. Master bedroom

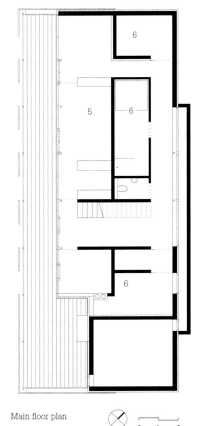

Main floor plan

0 1 2

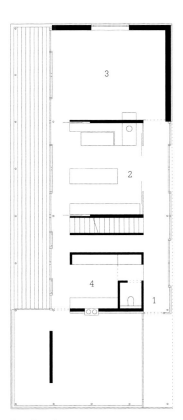

First floor plan

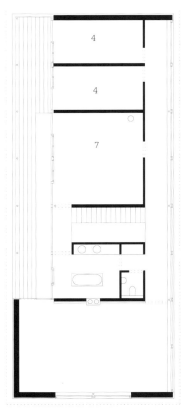

Second floor plan

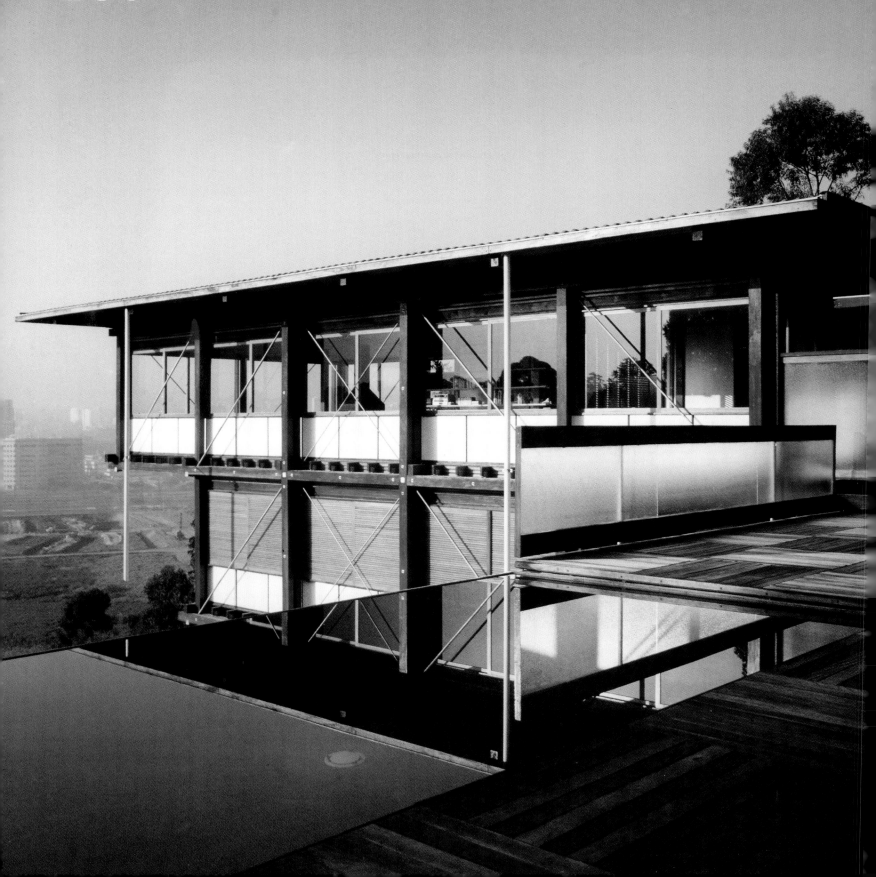

Architect: **Marcos Acayaba**

Location: **São Paulo, Brazil** Area: **2,370 square feet** Date: **1999** Photography: **Nelson Kon**

Helio Olga House

Page 134:
The structural plan and building
techniques allow for the creation of
open, regular interior spaces that
can be used in a variety of ways.
The clean lines are enriched by the
details of the column anchorings
and the wood floor.

This project was conceived as a prototype for an engineer (who did the calculations and produced the house's entire wooden framework in his own workshop) to demonstrate the excellent qualities of wood for construction on very rough terrain. In this case, the extremely steep slope of the land made it impossible to erect any type of traditional structure without dramatically affecting the vegetation. The solution is a building that hangs vertically and is set back from the mountain, supported at just two points: on the top at the access level and three floors below at the base. This prevents erosion of the land while allowing for a striking view of the city in the distance.

Six concrete piles buried 60 feet below the surface were designed so as not to disturb the vegetation. These piles support a reticular system of wooden columns and beams that create a structure of twenty modules, each 11 feet x 11 feet and arranged in four levels. The contact with the land at the upper part, where the garage and swimming pool are located, ensures that the building will be able to withstand the strong south winds.

The main structure was built in forty-five days and without scaffolding, after which a team of three workers assembled the rest using prefabricated sections. This system held down the supervision costs and minimized the loss of materials. Every piece has a specific function in the structural system: the columns counteract compression, the metal beams counteract tension, and the wooden floors brace the system and counteract torsion.

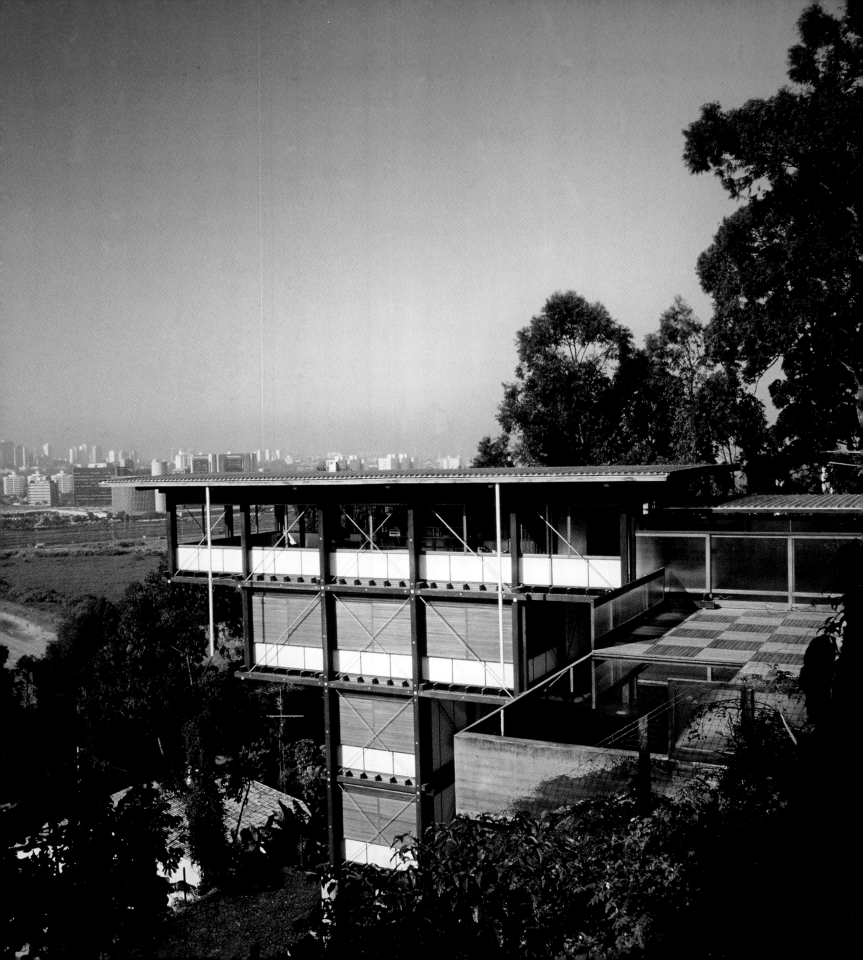

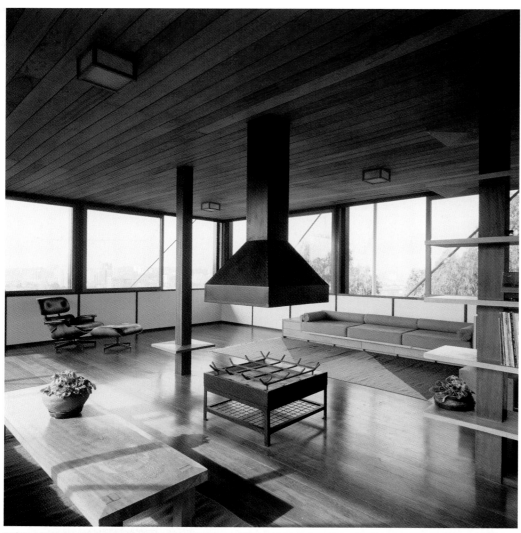

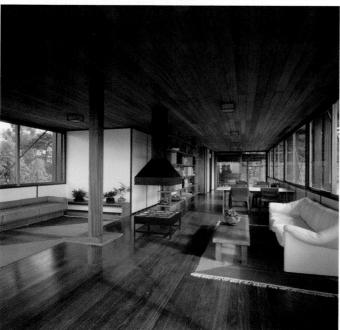

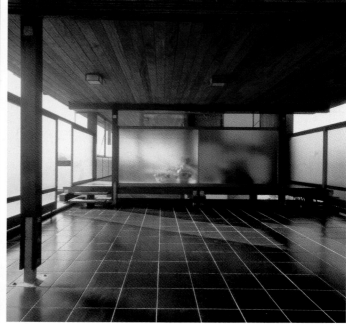

Roof plan

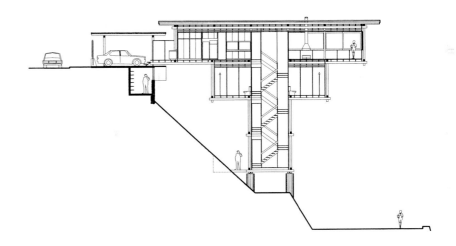

Section

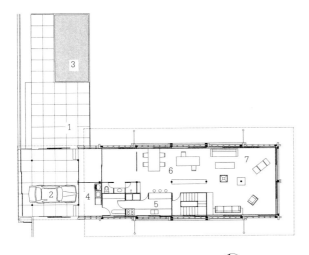

Fourth floor plan

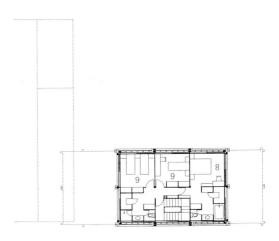

Third floor plan

⊕ 0 2 4

Second floor plan

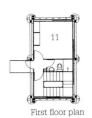

First floor plan

1. Access
2. Parking
3. Pool
4. Laundry room
5. Kitchen
6. Dining room
7. Living room
8. Master bedroom
9. Bedroom
10. Guest bedroom
11. Game room

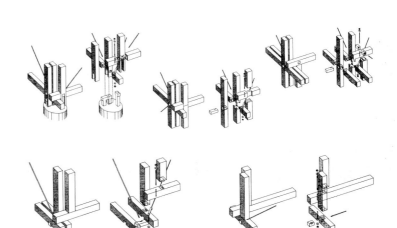

Structure details

135

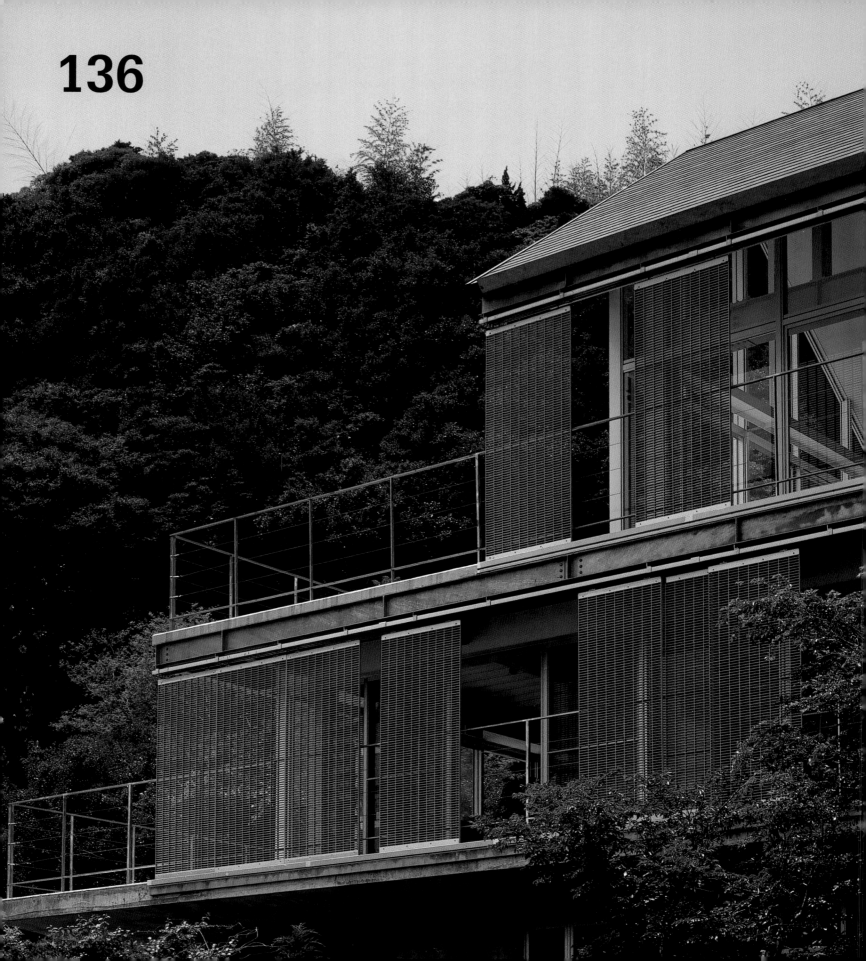

Architect: **Klein Dytham Architecture**

Location: **Shimoda, Shizuoka, Japan** Area: **2,745 square feet** Date: **2001** Photography: **Katsuhisa Kida**

Beach House

Page 140:
The perforated sheets can completely close the house, protecting it from strong winds, or open fully to completely link the interior with the exterior.

Page 142:
The living room is an open, continuous space with spectacular views of Iritahama Beach. The relationship between the living room and the beach is emphasized by the balcony that runs along the main facade.

The varied conditions of this site directly influenced the design and presented a variety of construction challenges. First, the site is part of an area that is protected as a natural park and thus has very strict regulations, especially with regard to the height of a building. Second, the steep slope of the terrain and the sandy consistency of the soil presented enormous obstacles in constructing the foundation. Finally, the area is subject to typhoons, which have seriously damaged the neighboring buildings in the past. But the site also has great advantages, including its exceptional position, higher than the other houses, and the slope, which offers a sweeping view of Iritahama Beach.

The principal design challenge involved making the most of the nearly 270-degree panoramic view by means of practically transparent outer walls while also ensuring protection from typhoons, the sun, and curious eyes. The rectangular building occupies almost the entire site but, due to its slope, major sections are recessed. Reinforced concrete foundation panels provide enough rigidity to support a platform on which the rest of the building sits. The building is also framed by a system of metal posts and beams.

The house is wrapped in a skin of perforated sheets mounted on metal tracks along the length of the facade. This protects against the strong winds and sun, affords privacy, and defines the balcony that runs along the house. The system of tracks is used to move the perforated sheets, thereby controlling the amount of sun and air that enter the building and adjusting the relationship of the interior with the exterior.

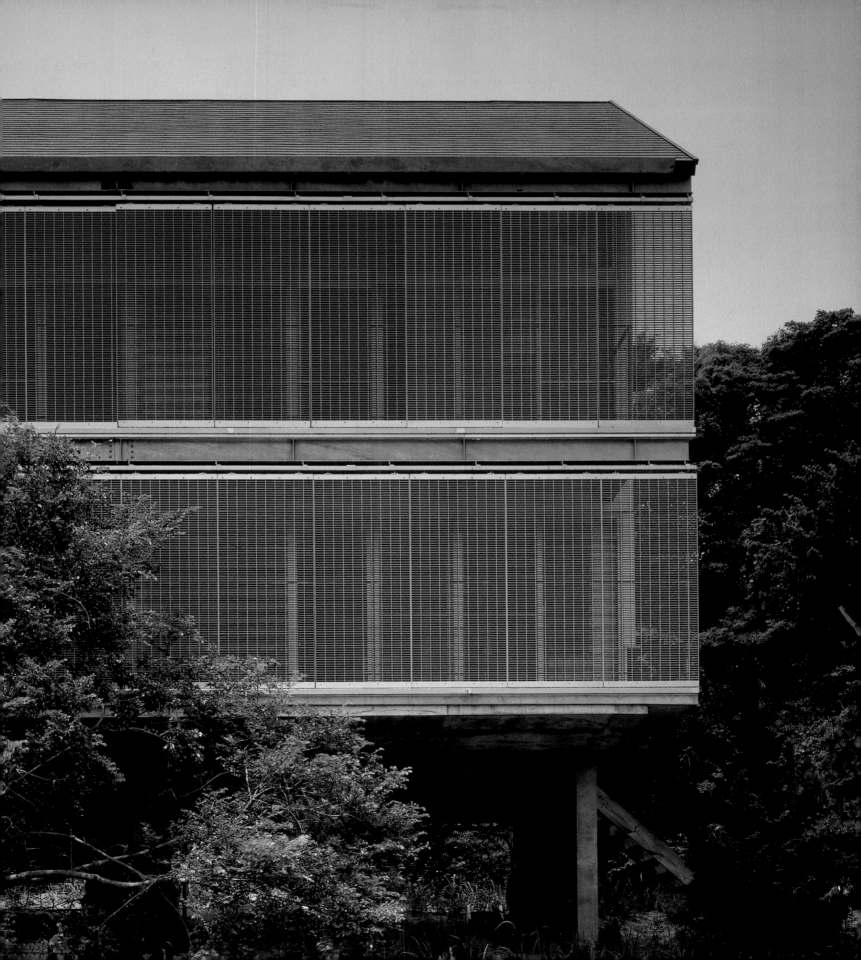

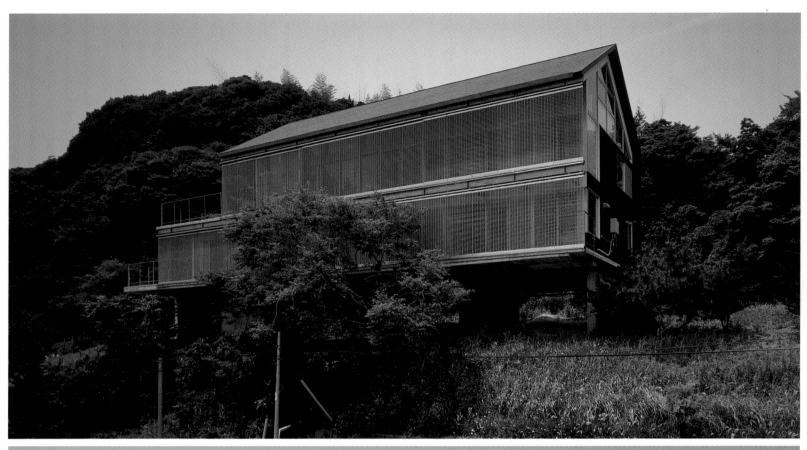

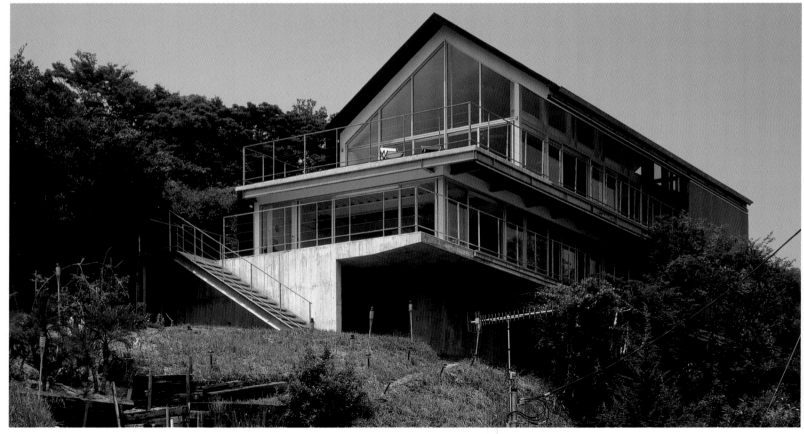

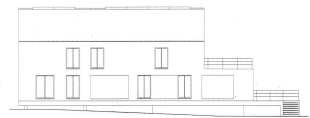

Front elevation

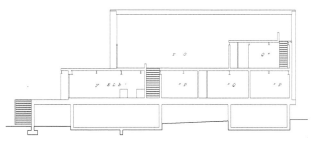

Longitudinal section

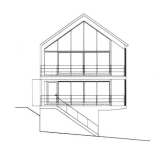

Lateral elevation

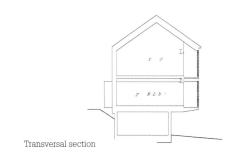

Transversal section

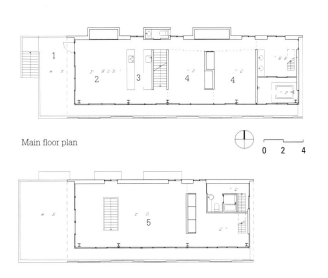

Main floor plan

0 2 4

First floor plan

Second floor plan

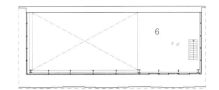

1. Access
2. Dining room
3. Kitchen
4. Bedroom
5. Living room
6. Study

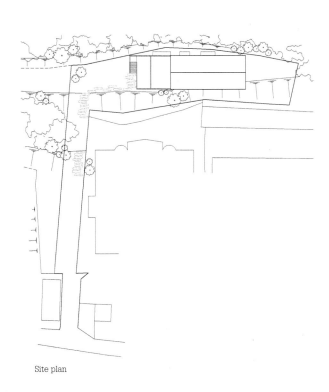

Site plan

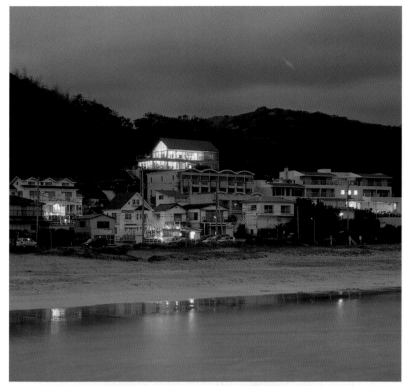

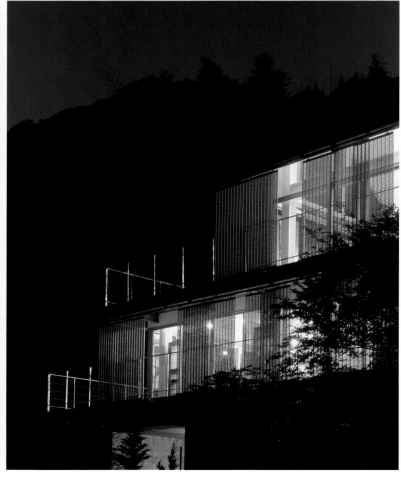

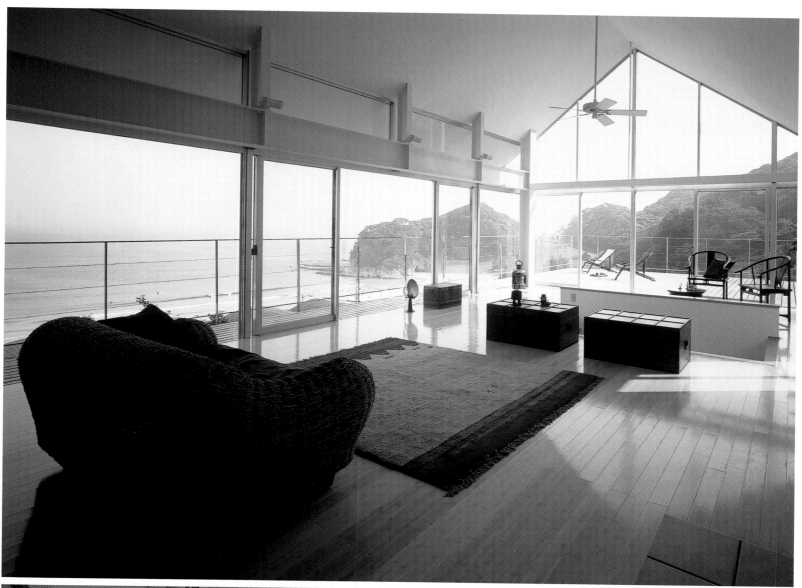

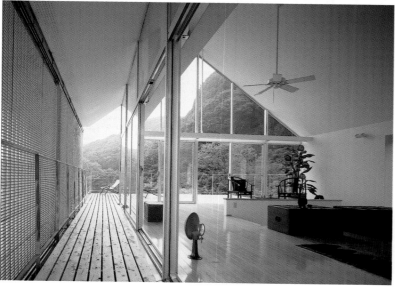

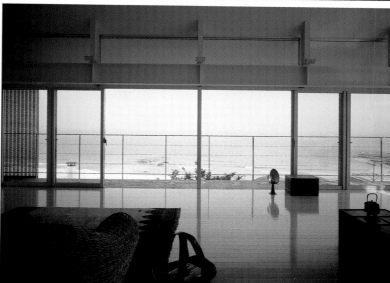

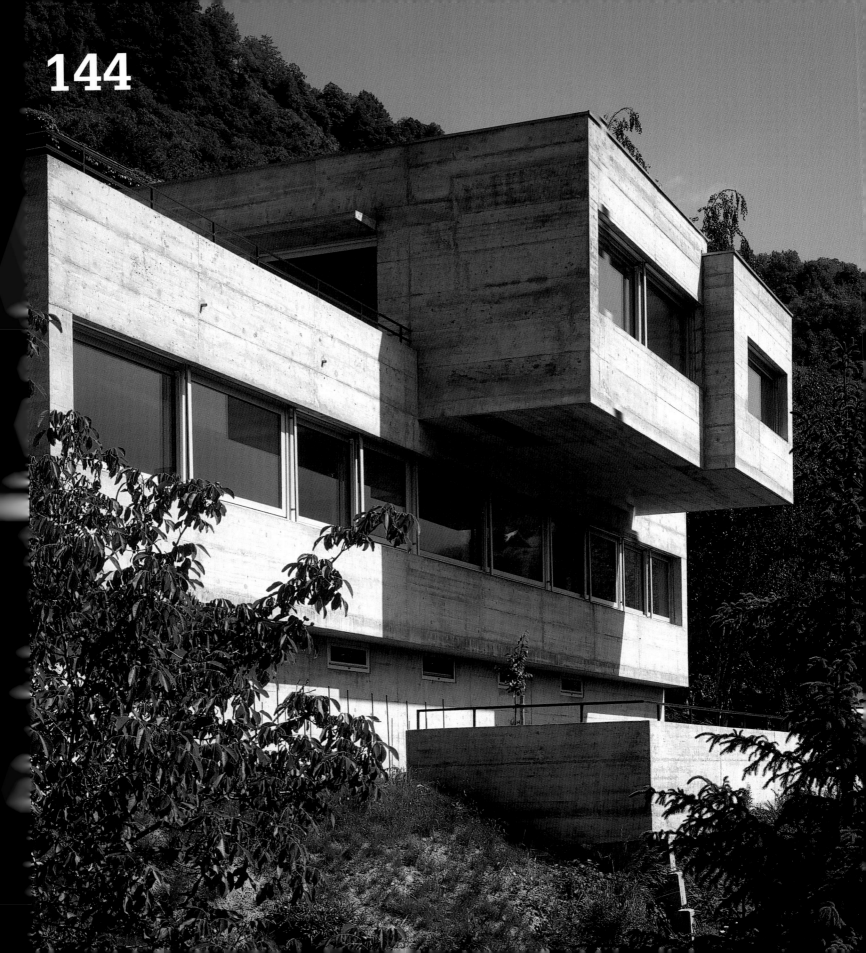

Architect: **Steinmann & Schmid Architekten**

Location: **Naters, Wallis, Switzerland** Area: **2,583 square feet** Date: **1995** Photography: **Thomas Andenmatten**

Hischier House

This sloped site is very rocky, difficult to reach, and surrounded by a dense development of single-family homes. The challenge was to design a building that would make the most of the view of the nearby mountains while also offering privacy. Moreover, this one-family home had to be divided into two floors with a variety of exterior spaces.

The project consists of two units, one on top of the other, following the contours of the land. Both units are positioned to create generous exterior spaces that form an extension of the interior. Four bedrooms, lined up one after the other, and a bathroom all face south and occupy the lower unit. This structure supports the upper unit, which runs east to west and houses the living room, dining room, and kitchen. This placement creates two clearly differentiated terraces, facing east and west, which extend the dining room and living room.

The concrete used in the construction was left open to view as a reference to the rocky terrain on which the house is built. The smooth texture, the color, and the geometry make it look as though the building were made of stone. This is in contrast to the lightness of the large, aluminum-framed sliding windows. Some of the interior walls are also undisguised concrete, but they have been treated with special pigments and a plain finish. The forcefulness of the overall design is reflected in the interior, with light, clean-lined, highly luminous spaces.

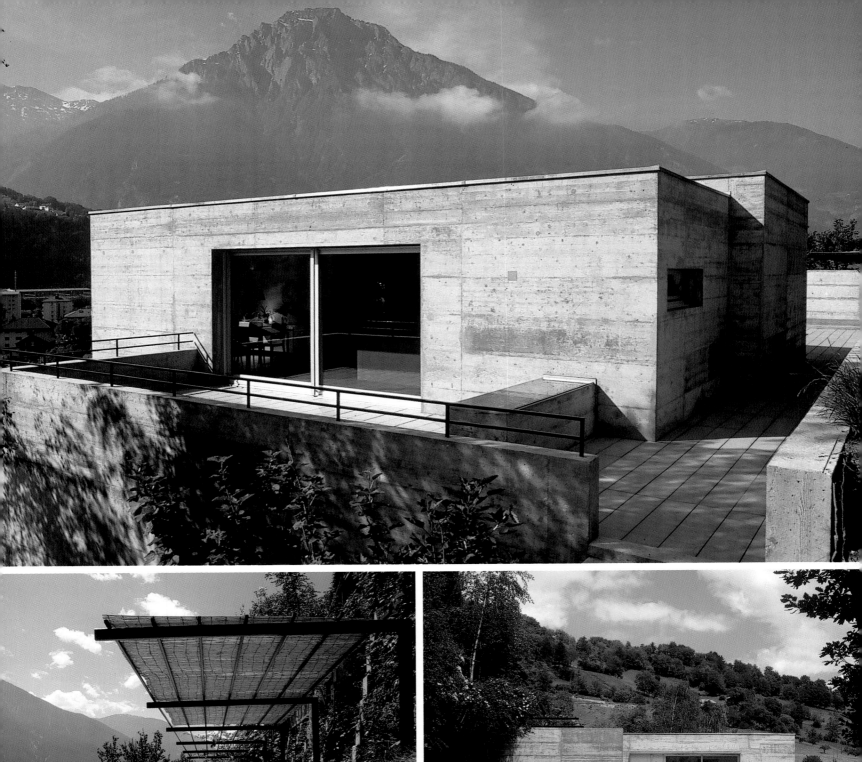
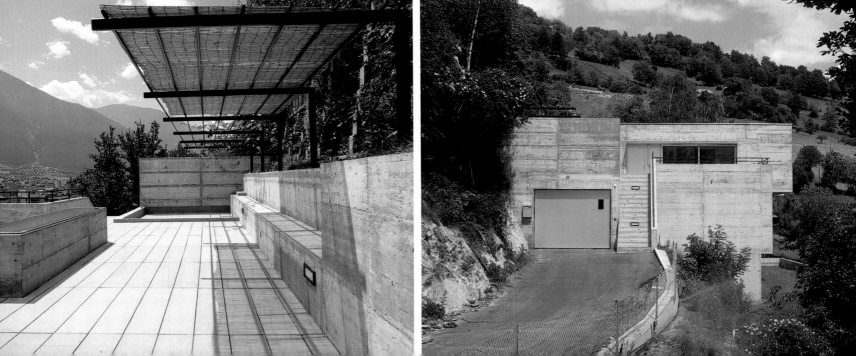

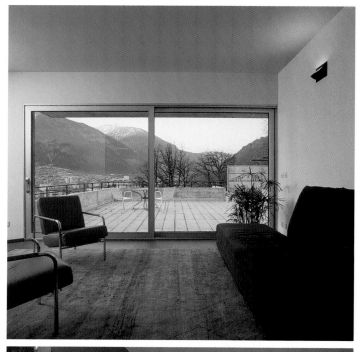
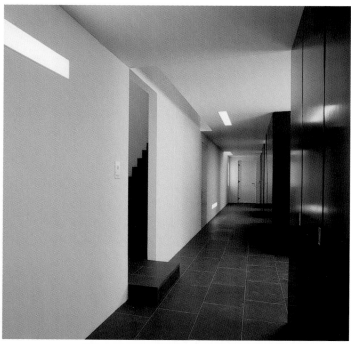
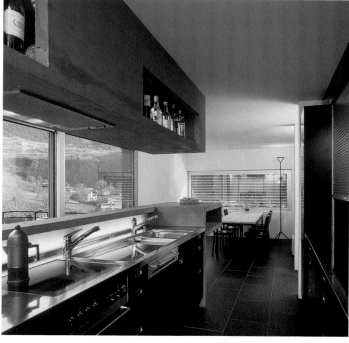
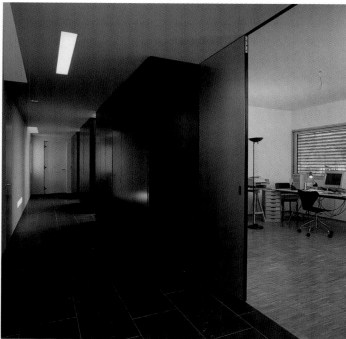

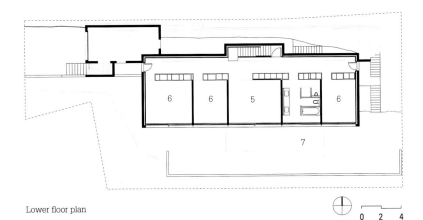

Lower floor plan

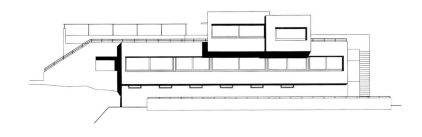

Front elevation

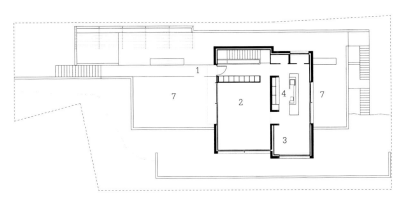

Upper floor plan

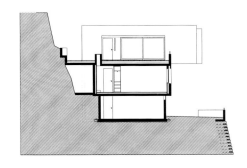

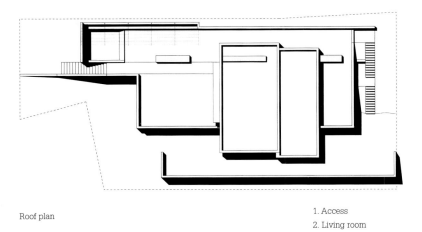

Roof plan

1. Access
2. Living room
3. Dining room
4. Kitchen
5. Master bedroom
6. Bedroom
7. Terrace

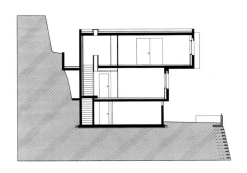

Sections

Architect: **Alexander Tzannes Associates**

Location: **Killcare, Australia** Area: **800 square feet** Date: **1997** Photography: **Richard Glover**

Kronenberg Beach House

Page 154:
The exterior terrace, made of wood, and the garden surrounding the house were designed to blend with the woods and emphasize the relationship between interior and exterior.

Page 156:
The slope of the roof echoes the natural slope of the land, points to the panoramic views (the sea in one direction and the woods in the other), and creates a varied lighting pattern in the interior.

This project in Killcare, Australia, was designed as a vacation home for use during different seasons, but primarily in the summer. The land slopes steeply down to the coast near Sydney. Dense vegetation covers the area, precluding a sweeping panoramic view of the sea but providing a natural refuge from the summer heat. The building's composition, placement, and construction system minimize the environmental impact while allowing glimpses of the sea to filter in through the trees.

The project left undisturbed the rocky formations, some trees, and the site's natural drainage pattern. The house itself is a rectangular structure, conceived as a single space, and modest in size. Its supporting system of metal columns and beams allows for a minimum number of weight-bearing structures to be placed relatively far apart while providing enough rigidity to sustain walls that are mostly glass. The resulting composition is very simple—a glass box with sliding interior doors that makes the best use of the natural conditions of the site.

Materials were selected with a view to create a contrast between the exterior and the interior as well as for their low cost and ease of assembly at the site. The exterior is mainly rusted steel, sheet zinc, glass, and aluminum. The palette of colors, along with the rust that the steel will acquire over time, will blend with the tones of the surrounding flora. Inside, wood predominates, specifically in the paneling that covers the walls, the floor, the sliding doors, and the kitchen furnishings. As a result, the space is warm, comfortable, and highly flexible.

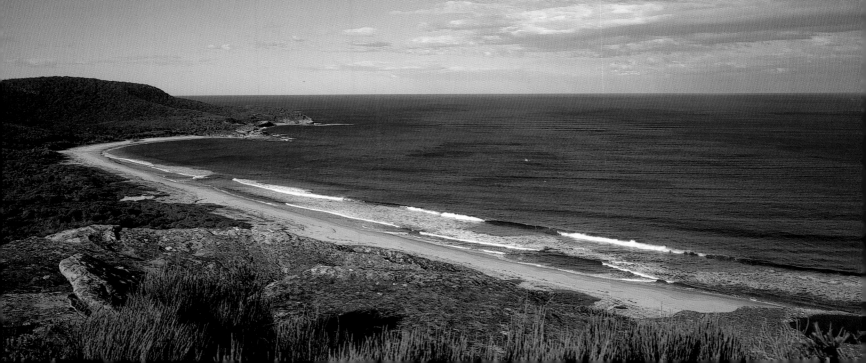

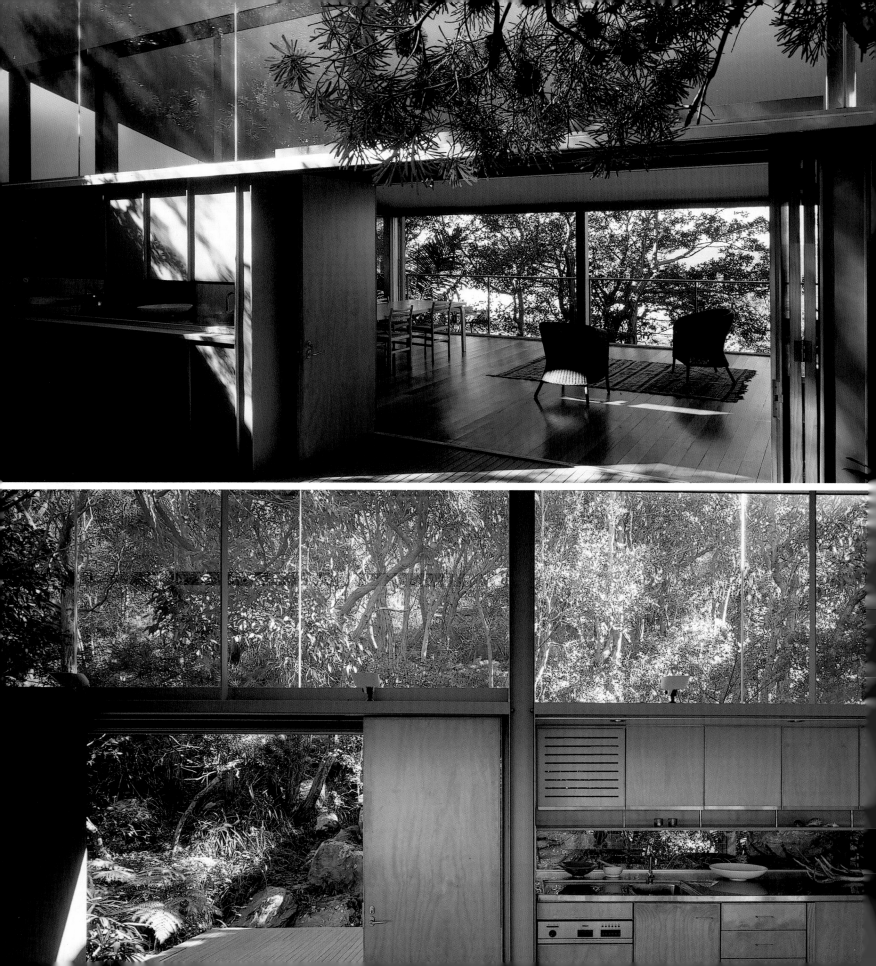

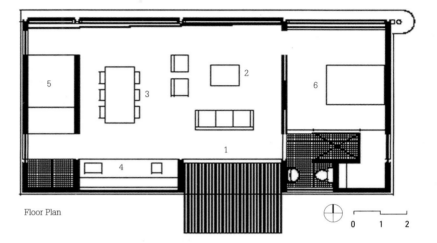

Floor Plan

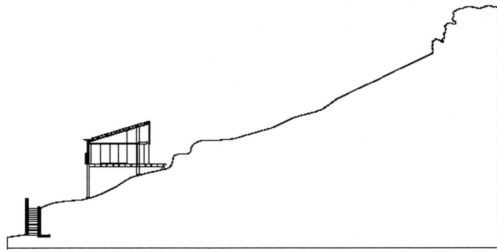

0 1 2

Section

1. Access
2. Living room
3. Dining room
4. Kitchen
5. Study
6. Bedroom

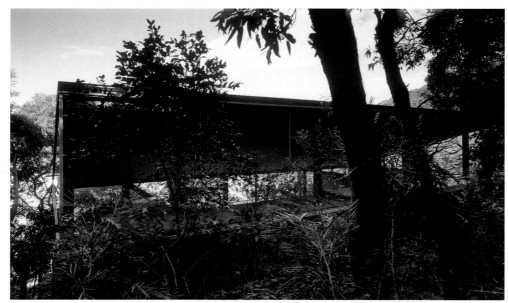

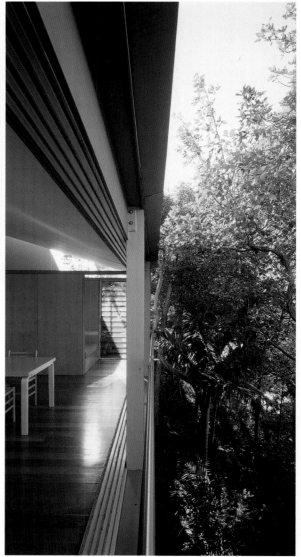

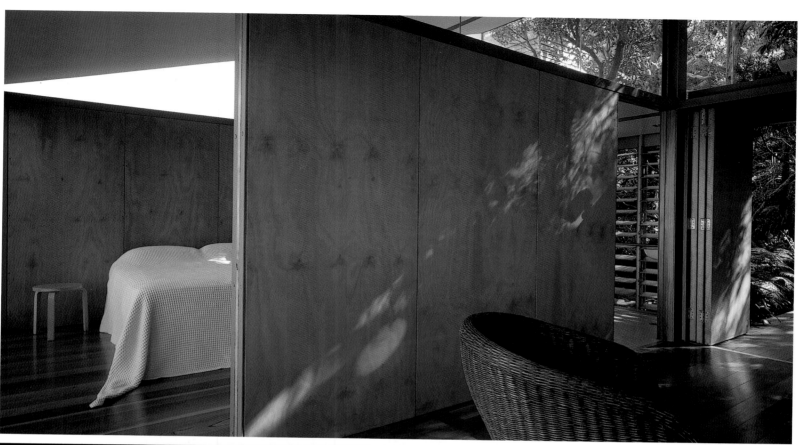

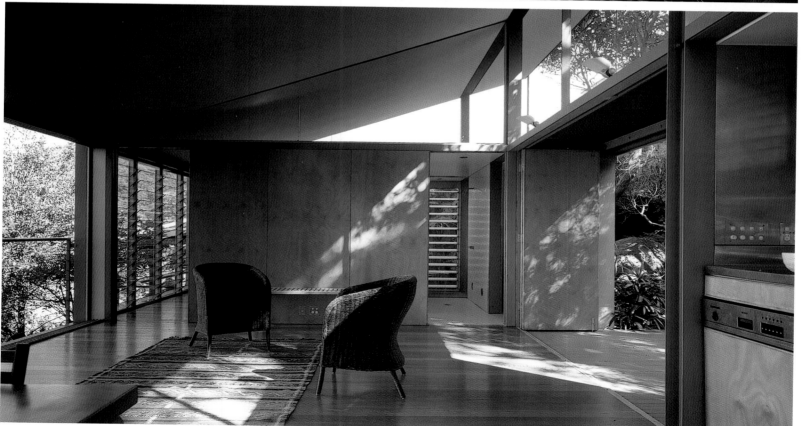

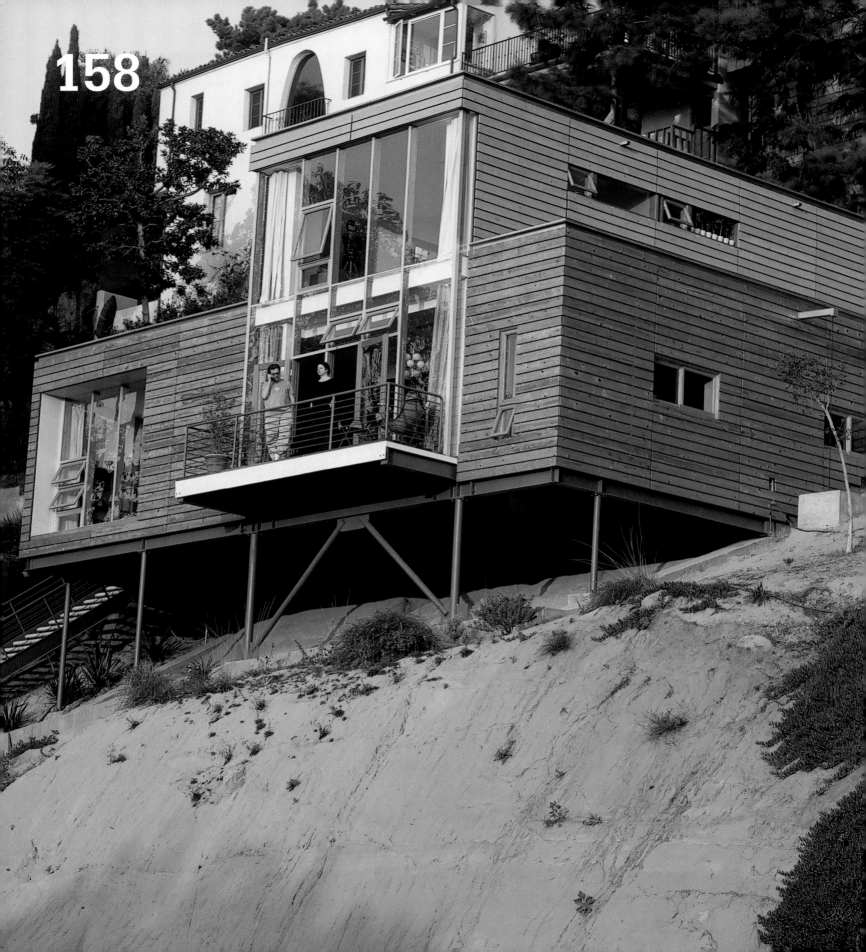

Architect: **Lorcan O'Herlihy Architects** Collaborators: **Michael Poirier, Mariana Boctor, Danika Baldwin, Kevin Tsai**

Location: **Silverlake, California, United States** Area: **2,002 square feet** Date: **2000** Photography: **Undine Pröhl**

Lexton MacCarthy Residence

Page 162:
Despite the small size of the house, the open plan creates a sensation of spaciousness. The wood that covers the exterior is echoed inside in the floor, window frames, and dividers.

Page 165:
On the upper level, translucent panels let light into the bathroom.

This building and the hill on which it sits are isolated from the rest of the setting to establish an architectural dialogue around this project. The California slopes have provided opportunities for several generations of architects, notably Frank Lloud Wright, Rudolph Shindler, Richard Neutra and John Lautner, to create new forms that adapt to the topography and transform the spaces of the house. In line with this tradition, the site of the Lexton MacCarthy house offers a marvelous panoramic view of Los Angeles and suggests a formal strategy that the architects have developed into an abstract play of positive and negative.

The house is positioned on a hill with a steep slope that created great difficulties in terms of planning and building. Retaining walls, excavations, and site grading are typically the most labor-intensive and costly aspects of these types of projects. The distance between the carport and the house itself was the first challenge of the project. The limited area that could be built on was another major determinant of the structure's placement and interior layout. It consists of two intersecting rectangular sections, one horizontal and the other vertical. The first is conceived as an open, bright space that allows for flexibility and contains the living room, dining room, and kitchen; the vertical section houses the master bedroom, which enjoys a magnificent view of the city.

This exercise proposes an innovative language in the management of wood elements. The overall simplicity of the composition permits and demands more attention in the use of materials, proportions, and finishes. While the general plan reflects modern reticence, the wood siding is in the style of the light California architecture.

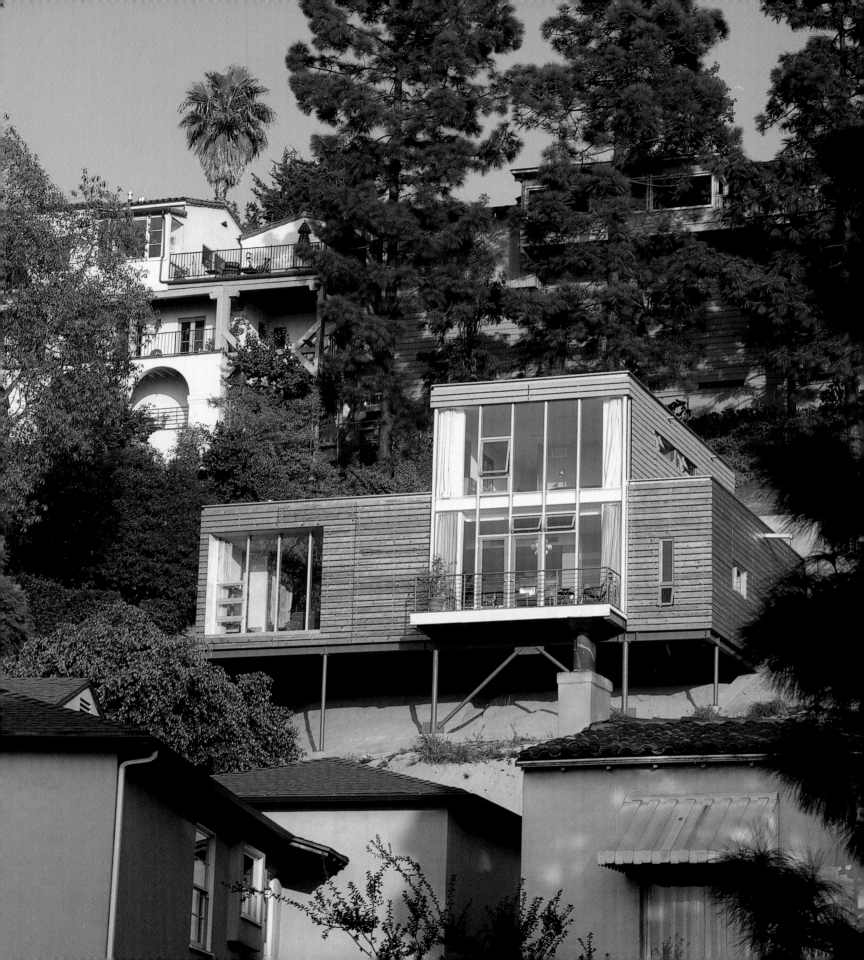

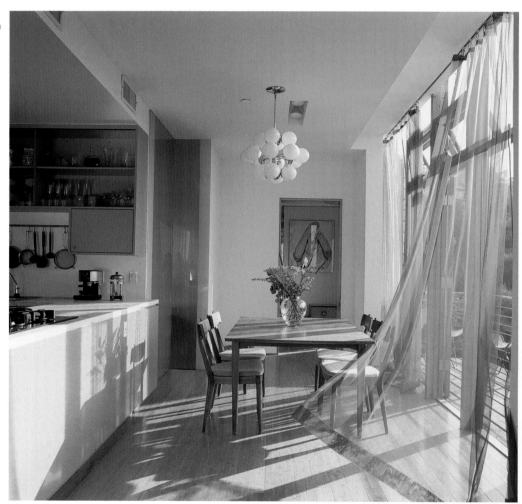

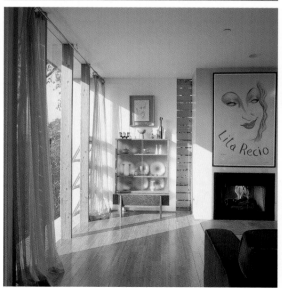

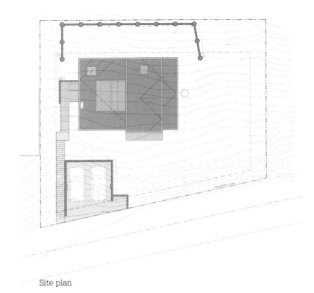

Site plan

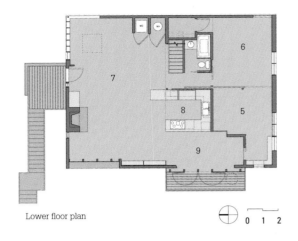

Lower floor plan

⊕ ⊢─── 0 1 2

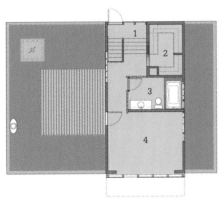

Upper floor plan

1. Staircase
2. Closet
3. Bathroom
4. Master bedroom
5. Study
6. Bedroom
7. Living room
8. Kitchen
9. Dining room

Front elevation

Lateral elevations

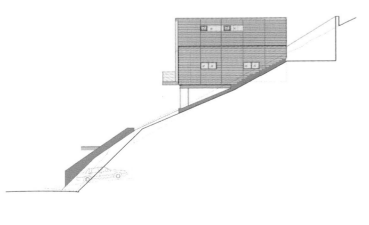

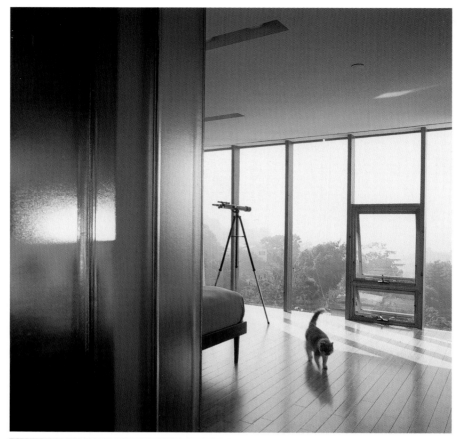

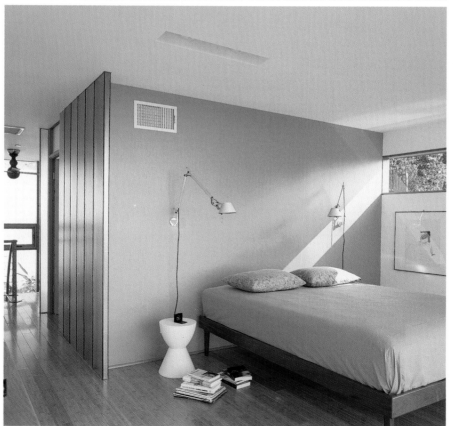

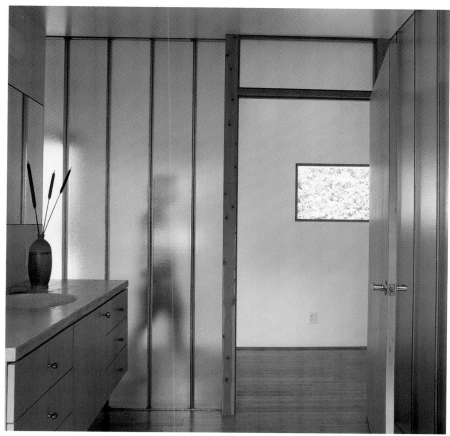

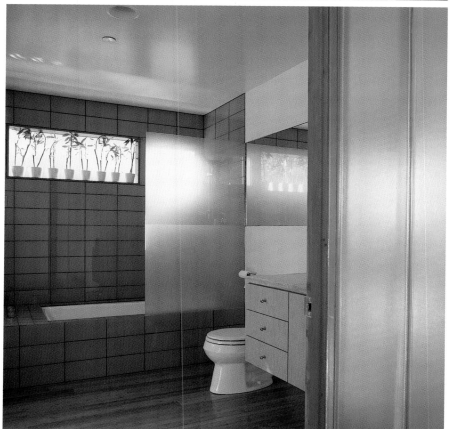

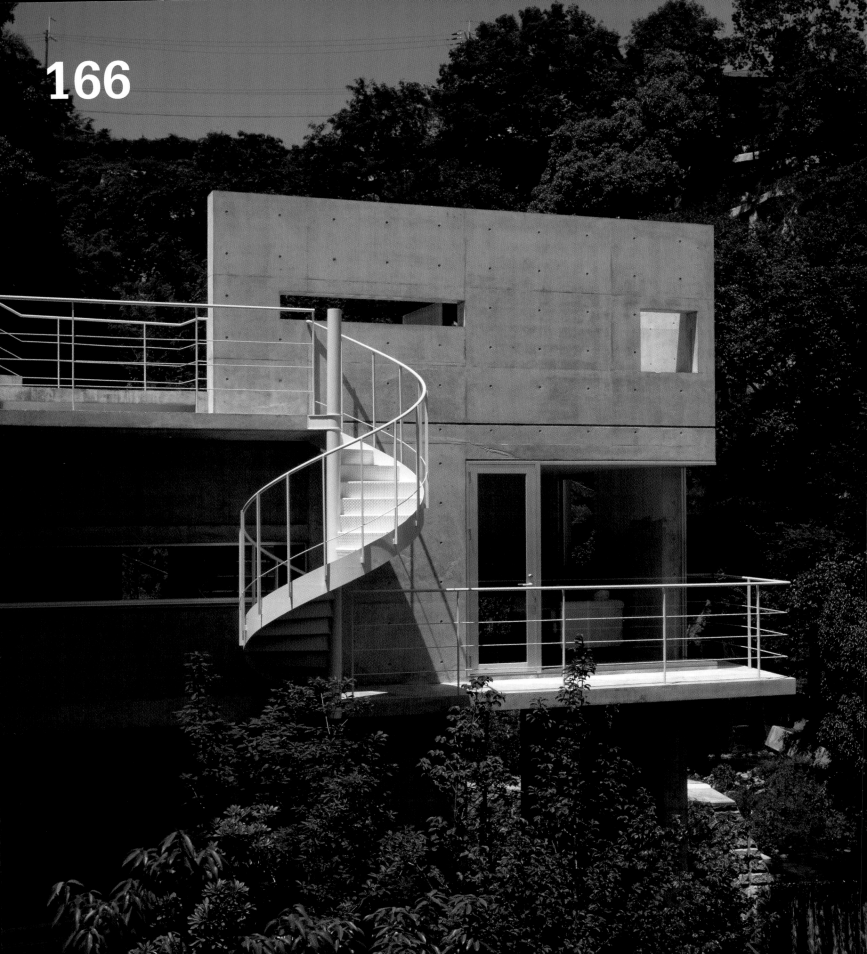

Architect: **Kiyoshi Sey Takeyama / Amorphe**

Location: **Nishinomiya, Hyogo, Japan** Area: **3,000 square feet** Date: **1998** Photography: **Yoshio Shiratori / ZOOM**

Edge House

Page 170:
The succession of open and closed spaces, and their variety and placement, create a labyrinthine effect that invites exploration of the structure as well as the natural setting.

Page 172:
The interior is characterized by clean lines and multiple opportunities for contemplation of the exterior, created by the different sizes and shapes of the windows. Low ribbons of glass, vast windows, and skylights help enrich the atmosphere in every room.

The varied climactic conditions of this region of Japan were the source of inspiration for this project, with its great compositional richness and emphatic language. After studying the physical conditions of the site—including its topography, the dense surrounding vegetation, the stream that runs through the lower portion of the area, and the view of the hillside forest that faces it—the designers drew up a complex, diverse plan that plays with the perception of up, down, inside, and outside. The intention was to create and enhance the area's natural diversity through a variety of spaces that stimulate perception.

The plan is flexible, on different levels, with open and closed multipurpose spaces. Part of the house can be seen as a solitary refuge under a starry sky or a vast hall for a large party. From the entrance, the visitor sees the house as a bridge over unexplored terrain, with the constant presence of vegetation, the deep valley, and the river in the distance. The living room is a volume suspended in the air, opening onto a balcony and extending out to the upper terrace and the forest by means of a spiral staircase. In contrast, the entrance to the most private part of the house is down below, where the bathroom is partitioned off only by a glass wall, which lets in the morning light through the other interior patio.

The materials, such as unfinished concrete, metal, and glass, enhance the contrast with the natural setting while adapting to the conditions of the site. Vast concrete surfaces give the structure rigidity, protect it from the wind, and provide shade to certain areas throughout the day. The metal serves as a very light, flexible element that connects the different levels, while the glass ensures that the natural setting is always present in every corner of the home.

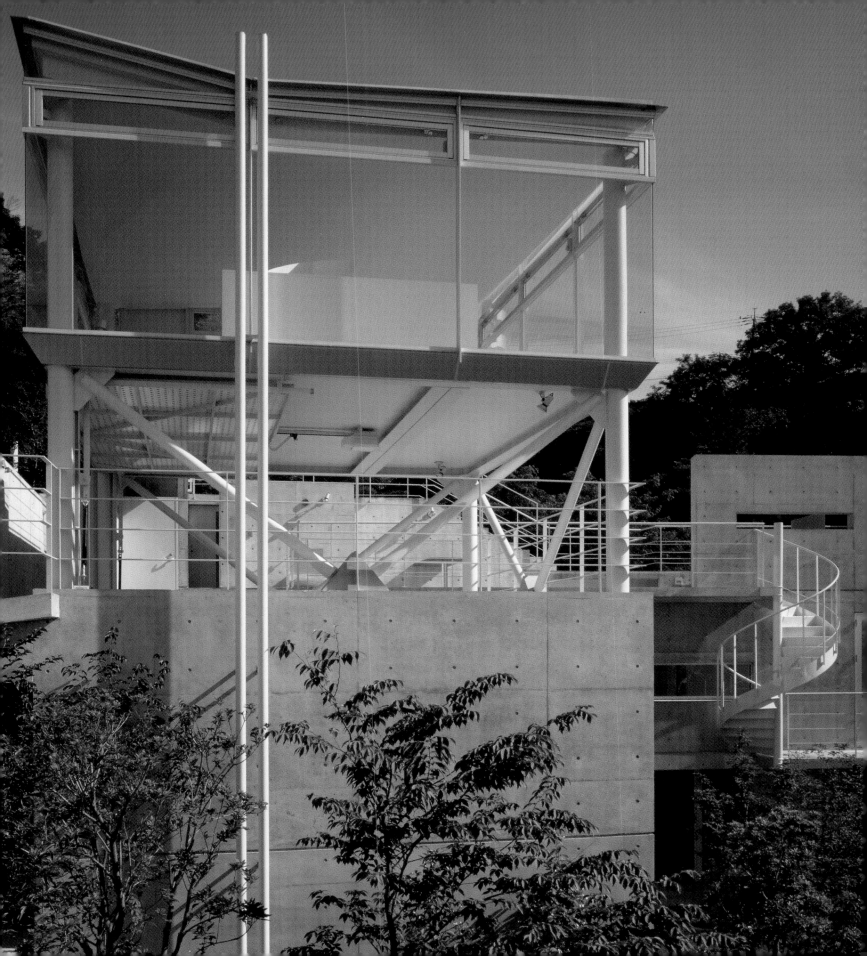

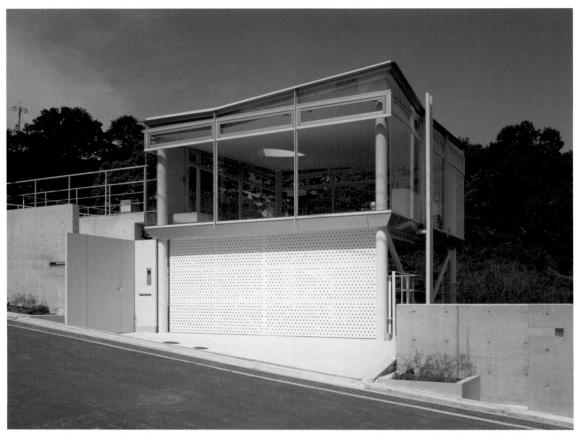

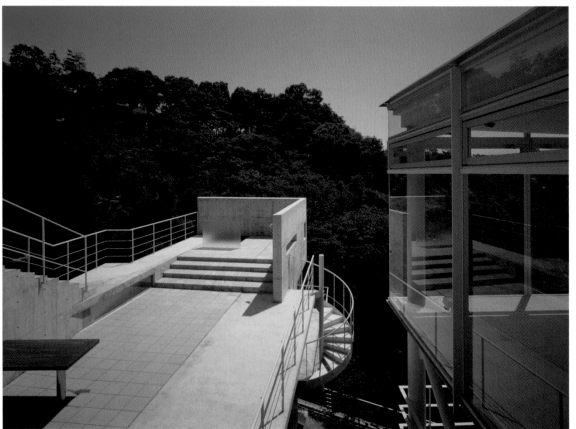

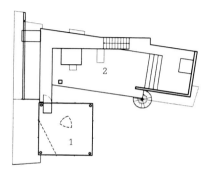

Roof plan

1. Terrace
2. Study
3. Bedroom
4. Living room

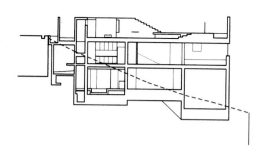

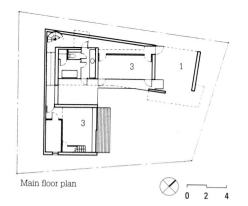

Main floor plan

0 2 4

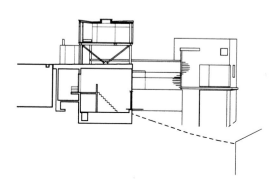

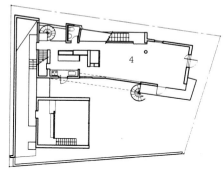

First floor plan

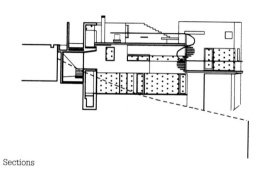

Sections

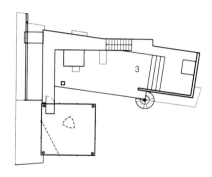

Second floor plan

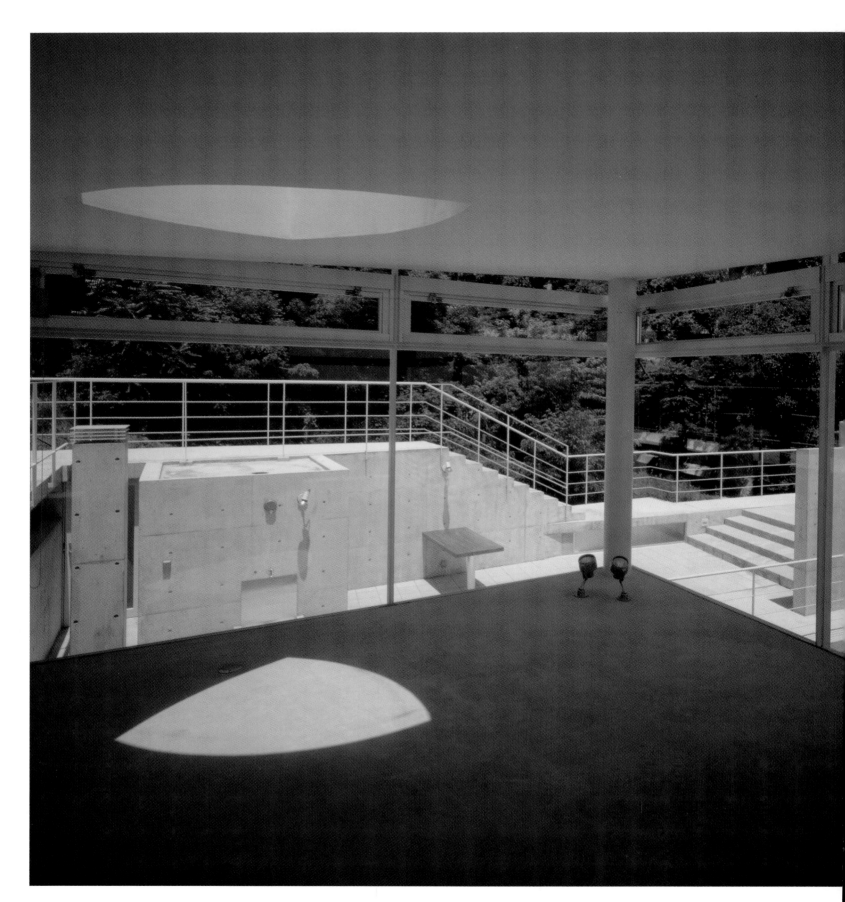

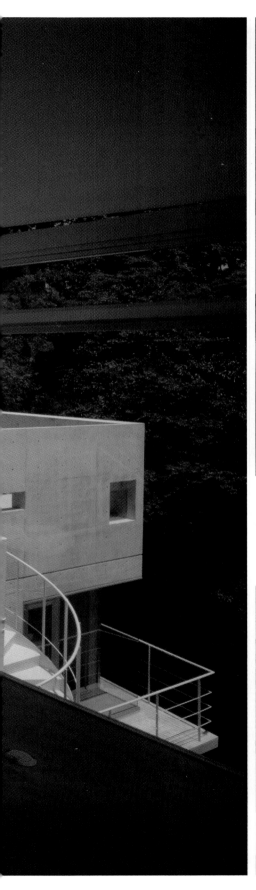

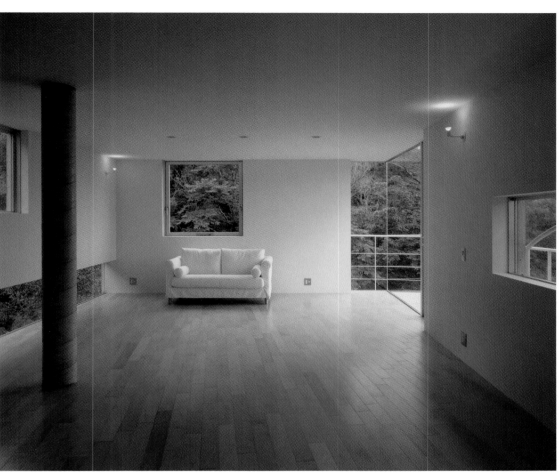

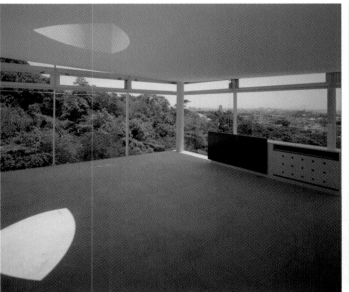

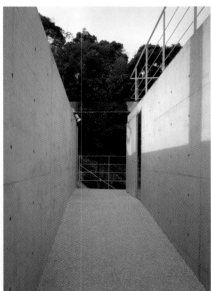

Directory

House in Dafins
Marte.Marte Architekten
Totengasse 18, 6833
Weiler, Austria
T. +43 5523 52587
F. +43 5523 52587 9

Emery Residence
Denton Corker Marshall
49 Exhibition Street,
Melbourne, Victoria 3000, Australia
T. +61 3 9654 4644
F. +61 3 9654 7870
dcmmel@dcm-group.com

Le Goff Villa
Rudy Ricciotti Architecte
3 Pl. Estienne d'Orves
Bandol, France
T. +33 4 94 29 52 61
F. +33 4 94 32 45 25

Bundeena House
Clark Pearse Architects
Room 16, 94 Oxford Street,
Darlinghurst, NSW 2010, Australia
T. +61 2 9361 4657
F. +61 2 9361 6327
clarkpearsearchitect@bigpond.com.au

slope . house hintersdorf
lichtblau . wagner architekten
Creditanstalt Blz 1100 Ktnr 09743412000
Vienna, Austria
T. +43 1 54 518 54-0
F. +43 1 54 518 54-4
office@lichtblauwagner.com
www.lichtblauwagner.com

Tennessee River Residence
buildingstudio
431 s. main Street, Second Floor,
Memphis, TN 38103, United States
T. +1 901 527 3086
F. +1 901 527 3025
www.buildingstudio.net

Agosta House
Patkau Architects
1564 West 6th Avenue,
Vancouver BC V6J 1R2, Canada
T. +1 604 683 7633
F. +1 604 683 7634
www.patkau.ca

Crystal Unit and **Y House**
Katsufumi Kubota / Kubota Architect Atelier
1-8-24 Imazu-cho,
Iwakuni, Yamaguchi 740-0017, Japan
T. +81 827 22 0092
F. +81 827 22 0079
kubotaaa@ymg.urban.ne.jp
www.urban.ne.jp

Lomac Residence
Safdie Rabines Architects
1101 Washington Place,
San Diego, California 92103-1726, United States
T. +1 619 297 6153
F. +1 619 299 6072
www.safdierabines.com

Tree House and **Cliff House**
Van der Merwe Miszewski Architects
163 Bree Street,
Cape Town 8001, South Africa
T. +27 /21 4235829
F. +27 /21 4235823
vdmmarch@iafrica.com

Cascades Lake House
Eric Cobb Architects
911 Western Avenue # 318
Seattle, Washington 98104, United States
T. +1 206 287 0136
F. +1 206 233 9742
ecobb@cobbarch.com

Berman House
Harry Seidler & Associates
2 Glen Street,
Milsons Point, NSW 2061, Australia
T. +61 2 9922 1388
F. +61 2 9957 2947
hsa@seidler.au
www.seidler.net.au

House in Fuchs
Herman Kaufmann
Sportplatzweg 5, 6858
Schwarzach, Austria
T. +43 5572 58174
F. +43 5572 58013
office@archbuero.at
www.kaufmann.archbuero.com

villa man-bow
Satoshi Okada Architects
16-12-303 Tomihisa-cho, Shinjuku,
Tokyo 162-0067, Japan
T. +81 3 3355 0646
F. +81 3 3355 0658
satoshi@okada-archi.com

Sutterlüty House
Dietrich & Untertrifaller Architekten
Arlbergstrasse 117, 6900
Bregenz, Austria
T. +43 5574 78 888-0
F. +43 5574 78 888-20
arch@dietrich.untertrifaller.com
www.dietrich.untertrifaller.com

Helio Olga House
Marcos Acayaba
Rua Helena, 170 CJ143 04552-050,
São Paulo, SP, Brazil
T. +55 11 3845 0738
F. +55 11 3849 1045
macayaba@uol.com.br

Beach House
Klein Dytham Architecture
Deluxe, 1-3-3 Azabu Juban, Minato-Ku,
Tokyo 106-0045, Japan
T. +81 3505 5330
F. +81 3505 5347

Hischier Burgener House
Steinmann & Schmid Architekten
Rebgasse 21A,
Basel 4058, Switzerland
T. +41 61 686 9300
F. +41 61 686 9301
www.steinmann-schmid.ch

Kronenberg Beach House
Alexander Tzannes Associates
63 Myrtle Street,
Chippendale NSW 2008, Australia
T. +61 2 9319 3744
F. +61 2 9698 1170
tzannes@tzannes.com.au

Lexton MacCarthy Residence
Lorcan O'Herlihy Architects
5709 Mesmer Avenue,
Culver City, CA 90230, United States
T. +1 310 398 0394
F. +1 310 398 2675
loh@loharchitects.com

Edge House
Kiyoshi Sey Takeyama / Amorphe
2F Koki Bldg. Teramachi Nijo Nishi-iru,
Nakagyo-ku, Kyoto 604-0935, Japan
T. +81 075 256 9600
F. +81 075 256 9511
amorphe@nn.iij4u.or.jp

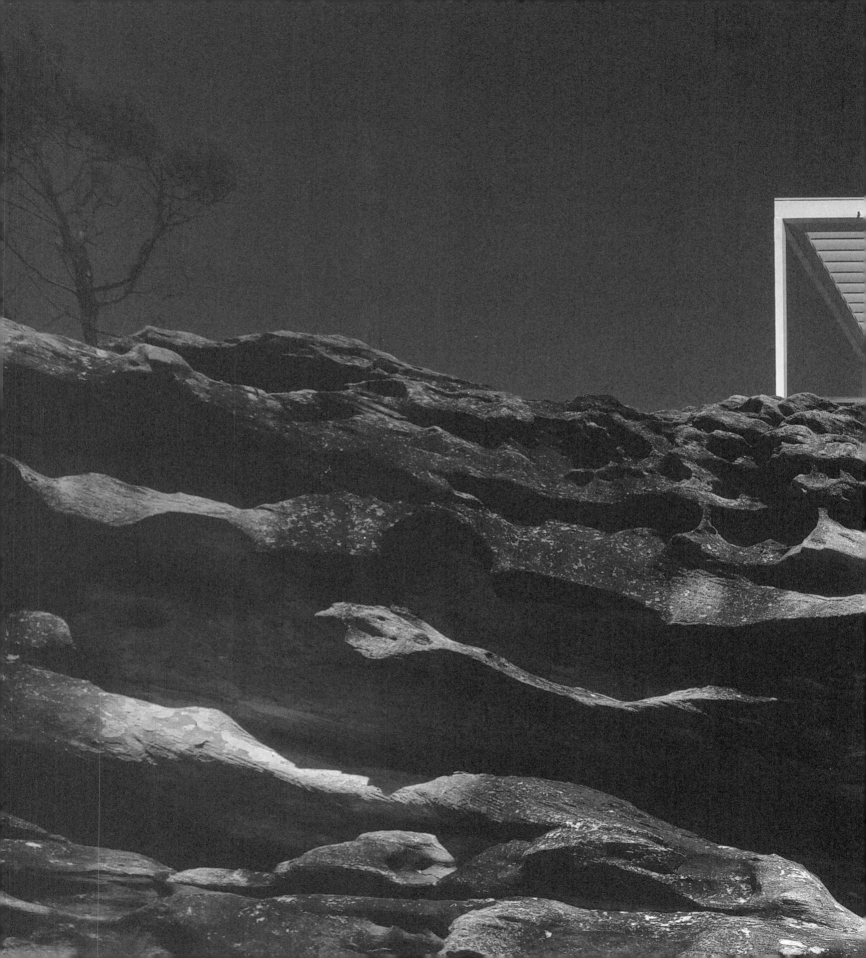